Approaches to Art History

Diana G. Scott

City College of San Francisco

KENDALL/HUNT PUBLISHING COMPANY
4050 Westmark Drive Dubuque, Iowa 52002

Copyright © 2007 by Kendall/Hunt Publishing Company

ISBN 13: 978-0-7575-3887-2
ISBN 10: 0-7575-3887-8

Printed in the United States of America
10 9 8 7 6 5 4 3 2 1

For my husband Robert and daughter Katie and
In memory of my mother and father

CONTENTS

PREFACE

Approaches to Art History is designed to assist beginning art history students in developing critical thinking and visual literacy skills. It is intended as a supplement to the main art history textbooks and is meant to offer a broad overview of the many essential components that comprise the discipline of art history. Chapters 1, 2, and 3 introduce students to the background and scholarship in the field, summarizing the main concepts and thinking on the subject of aesthetics and the multitude of possibilities for viewing and assessing art. Chapters 4–7 provide a brief outline of the fundamental ideas and concepts that compose the cultural and stylistic periods of Western-European art from prehistoric through modern times. These chapters are meant to be read in conjunction with the weekly lectures and assigned reading in the textbook. However, it is my hope that regardless of the class, students will read all of the chapters so that they can gain perspective and appreciate the complex connections and richness that comprise Western-European artistic and cultural traditions. Chapter 8 presents some basic survival skills and suggestions for managing information, taking tests, and writing papers. I have tried, in this chapter, to directly and clearly address the concerns that most students have when they take their first art history class. Here are useful ideas and strategies for being successful and developing skill-sets that will help students feel confident and in control of the information and assignments. Chapters 9 and 10 define a variety of art techniques, materials, and terms that often appear in lectures and textbooks. An understanding of materials and techniques and art terminology will greatly enhance comprehension and appreciation of the works being considered, and will also furnish the student with a fortified vocabulary to make the

job of analyzing and writing much easier. It is my hope that *Approaches to Art History* will help students develop their capability to "see" the details and nuances in art and in life, to broaden their critical thinking skills, and to expand their ability to articulate their ideas and insights. With these goals in mind, this book is for all my incredible students at City College of San Francisco. I hope that it will be as inspirational to you as you have been to me.

I would first and foremost like to thank Robert Scotellaro for his unflagging encouragement and belief in me and this project, for his profoundly skillful, insightful, and tireless editing, and for his great sense of humor under any and all conditions. Thanks to both Robert and Katie for their patience in putting up with my many months of distraction as I worked on the manuscript. And thanks to Katie for her perseverance in accompanying me on those endless museum and archeological site excursions. I want to express my gratitude to my colleagues in the Art Department at City College of San Francisco for inspiring me with their dedication to teaching excellence and student success, and especially to Dr. Maria Cheremeteff for her advice and encouragement. Thanks go out also to Marta Fuchs-Winik, who located books and read preliminary chapters, to Dr. Frank Forcier, who first prompted me to write this, and to Michael Gregory for his wit, humor, and support. Many thanks to Shirley Gregory and to all my family and friends who put up with postponed plans, abbreviated phone calls, and my many months of unavailability as I worked on this.

1

Visual Language

Art renders accessible to men of the latest generations all the feelings experienced by their predecessors and also those felt by their best and foremost contemporaries . . . [Art] is a means of union among men, joining them together in the same feeling . . . Art is a human activity consisting in this, that one man consciously by means of certain external signs, hands on to others feelings he has lived through, and that others are infected by those feelings and also experience them . . .

Leo Tolstoy, "What Is Art" c. 1896

The impulse to create, to visually express one's perceptions, beliefs, and desires, can be traced back to the earliest human beings. While they were still living in caves, thousands of years before they developed structures for shelter, early humans were creating paintings and sculptures of tremendous power and beauty. Yet in our world, so solidly based on progress in science and technology, in our industrialized, mechanized and computerized world, art may seem a dim backdrop to more important undertakings.

For many, the study of art or the making of art may seem at best a benign, if useless pastime, and at worst a colossal waste of time. Yet throughout human history, art has been a medium that has defined cultures, encompassed and elevated religion, reflected hopes, dreams, and desires, and rallied nations. The power of art—its symbolic meaning, its cultural identity, its embodiment of the essence and values of society,

1

its role in preserving histories, its representation of the greatest hopes and deepest fears of humanity—gives it tremendous power. So much so, that governments have debated the very definition of art, tried to regulate it, suppress it, destroy it, and at points, to destroy the artists who created it.

What is this power that art has? How can works of art stir such great passion and emotion, national pride, outrage, offense, or sublime pleasure? How can art influence governments to support or suppress it and to spend taxpayers' monies to debate its definition and meaning? How can art elicit our deepest feelings, move us to tears or laughter, or rally a nation? Considering the power that humans have invested in the visual language of art, and the role art has played in conveying so much to so many people across every culture and spanning the entirety of human history, it seems appropriate, important, and maybe even essential to take a closer look.

History is a dynamic evolution, not simply a series of isolated events and individual achievements. The present is built upon and interacts with the history that preceded it. No one creates in a vacuum. No matter what field we are in, we all draw reference to the knowledge of and influence from the past, learn from it, reflect, recoil, or embellish, but always evolve and move forward. Whether we use our creative energies to negatively react against the past, or use past ideas as an inspiration for new endeavors, we are continually interacting with the past in one way or another. We build on the triumphs and missteps of the past. Art is a visual record of those high and low points in human history, and more than any other study of history, art history is unique. The works from the past are physically here with us in the present.

There is a one-on-one communication that occurs between the artist and the viewer, even though they may be separated by thousands of years and distinctly different cultures. Although the art of the past is removed from the lives that created it, and much of it is physically damaged, the forms still embody the experiences and attitudes of the people who created it. The Egyptian who carved the sculpture over 4,000 years ago that currently resides in our local museum, might be telling us a story of the power of his gods, a belief in an afterlife, or an abiding faith in the everlasting glory of the empire. Contained within that Dutch still life of flowers and fruit is a tribute to the wealthy patron who commissioned it, and a cautionary tale to all about the fleeting vanities of this life.

Art is a continuum that visually traces the dynamic evolution of human history through time and culture, making it possible for us to glimpse the life experiences, visions, and perceptions of those who preceded us. Through art we can come to better understand the past and the variations of time and place. We can reach beyond our own cultural limitations to appreciate the diversity of ideas, values, and traditions. The history of art around the world is the visual chronicle of the world in many places across time. When seen all together, it displays an amazing array of human experience and expression. Major differences can be found in art of the same time period but different cultures, as well as art of the same location done at different times. Yet common subjects and themes found throughout the world reveal our shared humanity.

Certainly we celebrate the uniqueness and diversity of culture, but the intrinsic underpinnings of all humanity (its needs and desires) are similar more often than not. In that sense a broader, more inclusive view of art might serve to highlight our similarities rather than our differences.

Pablo Picasso wrote:

> Painting isn't an aesthetic operation; it's a form of magic designed as a mediator between the strange, hostile world and us—a way of seizing the power by giving form to our terrors as well as our desires.

Looking back to the earliest artistic endeavors—to the cave paintings from prehistoric times—scholars speculate that these works were made by early humans to help them cope with and shape their environment, to assist them in controlling the often capricious forces of the natural world, to give visual voice to their desires for a safe and bountiful hunt, to establish clan affiliations, and for appeasement to the forces of nature. (Refer to Prehistoric Art in Chapter 4.)

Art had physical form, yet it contained spirit. Art, as both process and object, was a kind of magic for early humans. We might think of it as the practical technology of the day. It was a way of controlling the uncontrollable environmental factors and bringing them in line with the hopes, needs, and desires of the community. Indeed, art has played this role throughout history—filling the gap between what we know and what we feel, and between what is provided and what we think we need.

For our cave-dwelling ancestors, the animal images on the walls deep within the interior recesses of the caves brought hope and belief in successful possibilities, and faith that powerful supernatural forces could come to their aid. The desire to believe, the faith in the unknown, and the comfort of ritual are not unique to humans living thousands of years ago. The visual evocation of forces outside our physical realm can be seen in the images of gods and saints throughout human existence and remain with us to the present. Indeed, the value of art lies not only in the visual satisfaction it can provide, but in its emotional rewards as well.

For prehistoric humans, art was the modern technology of the times. But in today's technologically expanding societies, we tend to think of art as an isolated entity. Yet science and the arts serve humanity in complementary ways. Science seeks and finds answers to problems and questions related to our physical world. It forms the basis of technology. Art helps foster our emotional growth, and gives viable, satisfying form to our world.

Jacob Bronowski, the 20th-century mathematician, historian, and humanist wrote: *Every animal leaves traces of what it was; man alone leaves traces of what he created.* Indeed, imagination is our special advantage. And through imagination art is created. That visual expression encompasses the limitless story of what it means to be human. And in that sense, art can be seen as a measurement, an indicator of the ebb and flow of society and culture. It is a reflection of the society in which it was created.

It visually comments on the standards, attitudes, morals, politics, and spiritual beliefs which define that society. The art of each culture records and reflects who the citizens of that society were and what their relationship was to their surroundings, to their gods, government, and to each other. Art comments on the beauty and the excesses of that society.

As a visual expression of an idea or an experience, we can learn a great deal about ourselves and the world around us (contextually and figuratively), where we came from and where we are going, through the study of art. Art is a reflection and expression of the human condition. The study of art is the study of that condition, and it is a standard by which we can measure our own humanity.

Most of us have seen images of Greek sculptures either in the media or at a museum. For many, these objects appear as dry, idealized statuaries in marble— common depictions with an eye-numbing sameness. We think "if you've seen one, you've seen them all," or "of what possible interest or importance are they to me?" Perhaps the interest lies in the understanding. Every one of us has a story, and every piece of art has a story as well—a history, uniqueness, or something important for us to know or understand.

The sculpture entitled *Gallic Chieftain Killing Himself* is dated 220 B.C.E. That is 200 years before the birth of Christ or before the "Common Era." Here we have an image created by the Pergamon Greeks. Many Greek settlements were established in the ancient world with the rise to power of Alexander the Great. He set about to conquer the ancient world and spread Greek culture throughout it. One of the richest and most important of these settlements was in Asia Minor (now modern day Turkey) at a site called Pergamon.

Because of their wealth and power, nomadic tribes were constantly attacking Pergamon in an effort to carve out territory and acquire riches for themselves. One of the most powerful of these tribes was the Gauls. Although the Gauls were defeated by the Pergamon Greeks, they were such a powerful enemy that the Greeks erected a monument in tribute to their valor at Pergamon. This piece was the elevated central element on a high platform with a sculpture at each of its four corners.

Here we see the chief of the Gauls. He knows that his tribe has been defeated. He is running from the battlefield looking behind him at his pursuers. He holds the dead body of his wife by her arm as she hangs limply at his side. Rather than allow his wife to be captured and made a slave, he has killed her. But even in death, he does not want to leave her body alone behind on the battlefield, so he struggles to drag her along as he runs. He glances behind at his pursuers as he plunges a sword into his own chest. He will die with dignity and nobility, a free man—not a slave. And he and his wife will be together as in life—so too in death.

The Greeks saw these scenes of heroic acts by their mortal enemies and were so impressed, they felt compelled to erect a monument to memorialize the Gauls. Once we know the story behind the image, this is no longer a dry piece of chiseled rock, but

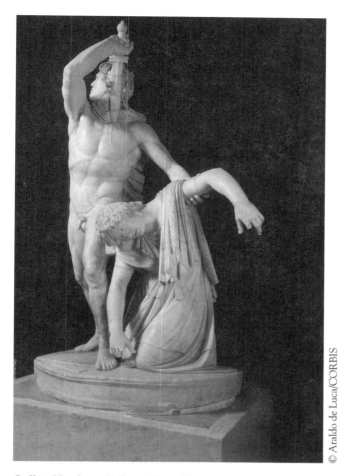

© Araldo de Luca/CORBIS

Gallic Chieftain Killing Himself, 220 B.C.E. Roman marble copy of Greek bronze, Museo Nazionale Romano, Rome

an impressive and meaningful testament to the human spirit, to a loving bond, to courage, and to acts of nobility.

It is enlightening and even comforting to know that people so long ago shared the same admiration for this man as we do today. We may ask ourselves how we would behave in similar circumstances, and in knowing this story perhaps we have learned something about ourselves and our own values and potential.

In so many ways art can lift the viewer beyond what is ordinary and merely mortal to a contemplation of the sublime. A cathedral at once elevates the spirit with its all-encompassing grandeur, and at the same time humbles us with its enormous scale—its allusion to something greater than ourselves. Throughout history humans have built places

of worship to honor their God/gods, to give meaning to this earthly existence, and to provide hope in the face of their impending mortality. To visually express these ideas, they have constructed elaborate shrines, temples, churches, and mosques. All create sacred, artistically adorned spaces in which to contemplate the larger context of their existence.

One of the most influential and significant buildings to express these ideas is the *Pantheon*. Built in Rome about 118 C.E., the *Pantheon* was dedicated to the seven Roman planetary gods. Upon entering through the Greek-influenced portico, the visitor steps into a domed space that creates the illusion of being contained within a perfect sphere. Resting on a circular drum the dome rises 143 feet from the floor and is 143 feet in diameter. At one time the coffered (recessed indentations) ceiling was covered in gold leaf. At the center of the dome is an oculus (a circular opening) 30 feet in diameter.

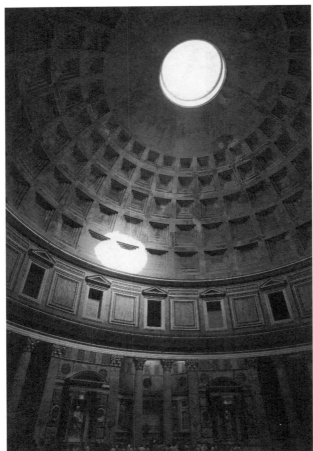

© 2007 Jupiter Images Corporation

Pantheon (Interior), Rome, 118–125 B.C.E.

One can imagine walking into this interior space, looking up at the golden ceiling representing the heavens and through the oculus to heaven itself, and feeling the grandeur and majesty of the cosmos. The effect might surely be a sense of oneness with universal forces, and of our smallness, as individuals, within a grander scheme.

The building of the great cathedrals of the Middle Ages is yet another example of the passionate desire to reach the heavens and know the divine. The constant striving for greater and greater height produced structures that visually rush toward the heavens, symbolically representing the desire for communion with God and the heavenly realm.

Ordinary sunlight is elevated to a heightened beauty through stained glass windows into the clear, pure, and dazzling light of the divine. That colored light is reflected onto the stone support columns and walls. The weightiness of the structure is transformed into the ethereal space of the heavens where the radiant light of the spirit converts this temporal world to the celestial realm. Sitting within a space such as this, regardless of our religious beliefs, allows the spirit to be uplifted, to imagine, and to hope. We can perceive powers greater than our own, take comfort in trying times, and feel a sense of connectedness. These colossal architectural structures speak to a high art born of a spiritual dedication and exaltation. Places such as these remind us that, regardless of our beliefs, we can experience a sense of awe and wonder, contemplate our existence, find strength and comfort, and be emotionally elevated and inspired.

Small truths, transient moments, and quiet revelations can also be conveyed through the visual language of art. Shen Zhou, a 15th-century painter in China during the Ming dynasty, describes just such insights in his beautiful horizontal scroll entitled *Watching the Mid-Autumn Moon*.

One must imagine holding the rolled scroll with the right hand and slowly unrolling to the left. Gradually, the painting reveals itself. On the right is a simple landscape with broad leafy trees overhanging a simple structure where Shen Zhou and his friends are sharing food and drink. One side of the thatched structure is open and looks out over a riverbank. Gradually, as the viewer continues to unroll the scroll, it reveals a vast expanse of light ink wash where sky and water indiscriminately mix. There is nothing but this empty space. We keep unrolling, and still there is nothing. Finally, at the very end, we see the reward. At the far upper left corner a full moon,

© Burstein Collection/ CORBIS

Shen Zhou: *Watching the Mid-Autumn Moon*, 1427–1509, Ming Dynasty, China. Ink and light color on paper (11" × 52"), Boston Museum of Fine Arts, Boston

just rising, shines in the pale light of early evening. We realize that Shen Zhou and his friends are also waiting for that moon to appear.

The simple act of marveling at a full moon is completely understood, conveyed in clear ink washes on paper. We are reminded that this common miracle, so often taken for granted, is indeed something to marvel at, to treasure. It is a universal experience regardless of where we live or what century or millennium we inhabit. But there is more here too. The title *Watching the Mid-Autumn Moon* gives the painting another meaning. Autumn is a season toward the end of the year, where nature winds down getting ready for the dormancy of life that winter brings. Autumn is also the metaphorical "late" season of a person's life, beyond youth and well into middle age.

Shen Zhou was about 60 years old at the time he painted this scroll. He was in the "autumn" of his own life. And now, he stands in awe of this miracle of a full moon rising above the water. He pauses to look, admire, and appreciate this moment. Perhaps he has not always done so, but now he understands that the moon will continue to rise in the sky each night long after he is gone. The poem he added to the scroll defines and illuminates his intent:

> When young we heedlessly watch the mid-autumn moon,
> Seeing this time as all other time.
> With the coming of age respect has grown,
> And we do not look lightly
> Every time we raise the deep cup to celebrate the feast.
> How many mid-autumns can an old man have?
> He knows this passing light cannot be held . . .

Shen Zhou is talking about himself and his own existential experience, and in doing so, he touches a universal truth that speaks to the beauty and melancholy in our own lives.

Art can function as a moral indicator, forcing upon us the varied nuances and realities of our times, along with the social responsibilities that our historical context imposes upon us. One of the strongest examples of the power of art to summarize a period, document events, and insist that we evaluate the political and social landscape of the times, is the German Expressionist movement in the early and mid-20th century. Responding to Germany's involvement in World War I, and later to the downfall of the Weimar Republic and the rise to power of the Nazi regime, the Expressionists created powerful evocations of war and degradation, documenting a period in time that still haunts us today.

Although most of the Expressionists were against the war, many were conscripted to serve in 1914. Some saw the war as a kind of poetic initiation into manhood, a notion short-lived once confronted with the shock and squalor of trench warfare. When they returned home their art reflected the horrific scenes of carnage and inhumanity they had witnessed.

Otto Dix (1891–1969), one of the great German Expressionists, created stark black and white etchings of rotting corpses caught in the barbwire of the trenches dur-

ing World War I. The images are of gruesome, twisted skeletons—part bone, part decaying flesh. We might imagine that his horrifying imagery elicits scenes spawned from the realm of nightmares. But it was an all-too-authentic reality he reflected. Dix's portrayals of trench warfare are almost photographic in their depiction of the actual corpses left to rot in the barbed-wire fences of World War I.

In the 1930s, the work of the German Expressionists was banned by the Nazis and labeled "Degenerate." Expressionist works were confiscated from museums, private collections, and the artists themselves. They were put up for ridicule in an exhibition called Entartete Kunst (Degenerate Art). Later, these same works of art were taken to Switzerland and auctioned off to support the Nazi war machine. Artists were arrested, deported, or sent to concentration camps.

In 1932 Max Beckmann (1884–1950) painted a triptych (a three-panel painting) entitled *The Departure*. It is the allegorical tale of the departure of "freedom" from Germany as the Nazis took over the government and began to repress the freedoms the German people had taken for granted. Beckmann writes about the middle panel:

> The King and Queen have freed themselves of the tortures of life—they have overcome them. The Queen carries the greatest treasure—Freedom—as her child in her lap. Freedom is the one thing that matters—it is the departure, the new start.

In their works, the Expressionist artists are cautioning us as to the grim realities of war, and the torture and repression that occur when freedom is suppressed. Beckmann warns us to pay attention, to cherish liberty as our most valued possession.

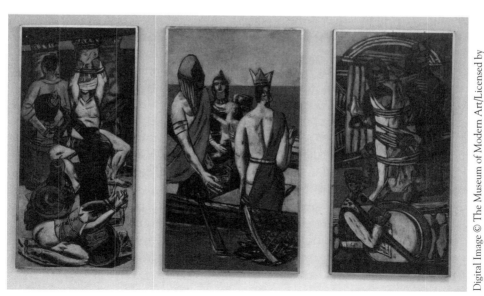

Digital Image © The Museum of Modern Art/Licensed by SCALA Art Resource, NY

Max Beckmann *"The Departure,"* 1932–1933, oil on canvas, The Museum of Modern Art, New York

Clearly the Nazi government was paying attention to works such as these, and it was threatened by them. So much so that in the very act of repressing them, the Nazis were inadvertently paying the Expressionists a substantial and telling compliment. They were indicating that these works really matter, that art can have a powerful impact on society, and that the free-thinking and free expression found in Expressionist work is the very antithesis of a totalitarian system. Through their work, Beckmann, Dix, and others like them were cautioning us not to forget the lessons of the past so that we might have a better future.

As you approach art, be observant. Try to place yourself in the historical context. Look at art from the perspective of the past, and then view it again from your own time frame and through the prism of your own experiences. Consider and evaluate what you are seeing. In this way the art will come alive, be more substantive, and take on a more objective as well as a personal meaning.

Aside from bringing us closer to the human experience, the study of art can teach us lessons that are essential to our lives today, in this present moment. The world demands from us an ability to think independently and creatively in order to compete in whatever field we pursue: computers, advertising, business, accounting, medicine. The ability to see the elements and arrange them to our own best advantage, to look for the possibilities in any given situation, to creatively problem solve, to see connections where others cannot, to create new opportunities, to function in a variety of modalities, are the lessons and skills that one learns from the study of art. The study of art is the study of how to see the world independently and creatively, and appreciate its limitless nuances.

Through the study of art we develop critical thinking and analytical skills. Art forces us to look beyond the obvious, to ask penetrating questions, to see variances and shades of gray. It helps develop the ability to formulate a persuasive argument and to convincingly represent a point of view. Through the study of art we learn to have flexibility in our thinking, and begin to understand that there are often no right or wrong answers, but simply perceptions. We learn to have opinions, trust our viewpoints, and provide viable explanations.

Evaluating and analyzing a work of art goes beyond the "I like it" or "I don't like it" cursory response. The study of art requires us to look at the work from many different angles and perspectives to assess our responses and to investigate all of the various aspects that go into it. Think about painting, for example. What are the elements of a painting? There are only two elements: color and the surface it's placed upon. So, what makes one painting different from the next? It is the way the artist handles the elements of form. Such things as subject, line, depth, color placement and value, light, modeling of the figure, and many more distinctive factors go into distinguishing one painting from another and making each unique. When we interpret, evaluate, and analyze a work, we are taking into account all these and other elements to determine not only the way a picture looks, but how we respond to it.

To be able to communicate our thoughts and ideas both verbally and in writing is a powerful skill. The study of art helps us develop the skills to evaluate and meaningfully articulate our views. It gives us the power to voice our opinions, create persuasive arguments, and possess versatility and flexibility in whatever field we choose. To think creatively, independently, and analytically, these are the lessons of art. These lessons are dynamic tools to take along for any journey in life.

2

Aesthetics: A Brief Overview

The terms *aesthetic and aesthetics* come up again and again in the study of art history. Therefore, it is essential to understand the definition of each word within the many contexts of its meaning and use.

The word *aesthetic* comes from the Greek work *aisthētikos*, which refers to a sense of perception or perceiving. We can use the word aesthetic to describe personal attitudes about art involving both the thoughts and emotions that make up one's understanding or perception of what is pleasing on an individual basis. For example, one might prefer modern furnishings for the décor of a home. Then it could be said: Her *aesthetic* leans more toward modernism. The term can also be used to signify a particular group of works or features that tend to have similar characteristics. For example, the "machine aesthetic" could be used to describe works of art, objects, or architecture that have clean lines, strong geometric forms, and bare surfaces.

The term *aesthetics* refers to a branch of philosophy that studies the arts and seeks to establish general principles of art and beauty and the criteria for artistic judgment. Given the meaning of the original Greek word *aisthētikos*, we might think of aesthetics as a study of the way we perceive and respond to art. However, its meaning is broad, nuanced, and complex, and has interested scholars from many disciplines, ranging from history to anthropology, and art history to philosophy and psychology.

A definition of the term aesthetics as defined in the *Random House Dictionary of the English Language*, 2nd edition, 1987 is:

> *aesthetics*: 1. the branch of philosophy dealing with such notions as the beautiful, the ugly, the sublime, the comic, etc. as applicable to the fine arts with a view to

establishing the meaning and validity of critical judgments concerning works of art and the principles underlying or justifying such judgments.

The philosophy of aesthetics deals with the study of the arts, what constitutes a work of art, and how we evaluate it. It involves judgment of the validity of a work of art based on ideas of what is considered to be artistically worthy and accomplished. It takes into consideration a variety of compositional elements, as well as context and meaning, and seeks to critically assess and judge the work according to a set of artistic principles that justify the assessment.

As one might imagine, determining what constitutes "good" art can be a wide-ranging endeavor depending on who is defining what "good" art is. There are several approaches to the question: the objective point of view, the subjective point of view, and a combination of the two.

Objective theories are based on an assumption that there are certain standards in art upon which all works of art can and should be judged. These standards remain unchanged regardless of time and place, and hold that there are fixed judgments that are applicable to any work of art. Conversely, the *subjective* approach holds that judgment is personal and therefore variable, and that all individual responses are equally valid. In this approach, the value of the work is in the response of the viewer rather than the work of art itself. Somewhere between these two viewpoints is the approach that the value of a work of art is derived from the interaction between the objective and the subjective; that a work of art can be judged by certain intrinsic qualities within the object itself *combined* with the personal response of the viewer.

We all have notions of what constitutes a work of art and what good art is. These ideas are based on our own cultural influences, our exposure to art, our education, our belief systems, our personal life experiences, and perhaps our religion. So when we approach a work of art, we bring along certain ideas, expectations, and preconceived notions. The work of art provides its own sociocultural background as well. It embodies certain ideas and expectations born of the time and place in which it was created. It brings a variety of cultural concepts of beauty and/or artistic worthiness to the dialogue. Of course, what is considered to be beautiful or artistically appealing and worthy in one culture may be considered displeasing in another. This is where establishing absolute standards can become problematic.

The Greeks

We can begin the history of aesthetics in Western-European thought with the Greeks. They asked themselves important questions about what it means to be human; about what constitutes goodness, truth, and beauty; and they used art and architecture to express their ever-expanding understanding of these ideas.

Any approach to ancient Greek thought about the arts must begin by stressing how different Greek conceptions of the aesthetic were from some influential modern conceptions. In modern aesthetics it is common to think of the aesthetic as a domain clearly bounded off from the ethical and practical. . . . For the ancient Greeks, this was not the case. Poetry, visual art and music were all taken to have an ethical role . . . and a citizen's interest in them was understood to be an interest in pursuing questions about how best to live. Aesthetic innovations were to be assessed for their contribution to human action and practical (usually communal) self-understanding. This attitude was reinforced by the civic institutions in which the arts were embedded; the major dramatic festivals of Athens were civic religious festivals at which citizens gathered together . . . they characteristically saw in the performance an occasion both for the moral education of the young and the communal exploration of tensions and complexities in civic norms of excellence. Because of this view of the goal of art, aesthetic assessment was, like Athenian social assessment, a democratic business; every citizen was encouraged to engage in aesthetic/ethical reflection.

One sign of the thoroughgoing unity of the aesthetic with the ethical can be seen in the Greek word *kalon*. Usually translated as "beautiful" in some contexts, as "noble" or "fine" in others, it is in reality a univocal word, giving evidence of the Greek belief that only what is ethically fine is pleasing to behold and that visible beauty is a sign of excellence.

<div align="right">

Martha C. Nussbaum: "Classical Aesthetics," *The Dictionary of Art*
(Jane Turner, editor), Volume I, p. 175: Grove Art, NY and Macmillan, London: 1996.

</div>

The idea that art can teach ethics and virtue, and that a contemplation of that which is "beautiful," "noble," or "fine" can be morally uplifting, gives us the basis by which to discuss Classical Greek art of the 5th and 4th centuries B.C.E. These images are most likely familiar, but they are worth looking at closely and with some degree of analysis, for it is the aesthetics of the Greeks that sets the tone and standard for Western-European art in subsequent centuries. It is fair to say that virtually all the art that followed drew reference to Greek art in one way or another, either by using it as a model and inspiration, or by consciously rebelling against and rejecting it.

Look at the introductory pages of your text for images of Greek sculptures from the 5th and 4th centuries B.C.E. or on page 179 here. If you were going to describe them, what sorts of adjectives would you use? You might characterize them as seeming rather elegant, refined, restrained, well-proportioned, visually balanced, intellectualized, and idealized. If you see these qualities in the sculptures, you have basically defined the *aesthetics* of the Greeks during this period of time.

The Greeks believed that "man [humanity] was the measure of all things," and that we were made in the image of the gods. They understood that although we are not perfect, our goal should be to strive for perfection both of the mind and the body. They expressed this goal in the physical perfection of the human form. Here we have perfectly proportioned bodies, symmetrical features, calm and controlled expressions,

and relaxed, confident poses. The Greeks of classical times struck a balance between realism and idealism. We call this the *Classical Ideal*. This model became the standard upon which Western-European aesthetics were based.

The Greek philosopher Plato (c. 427–347 B.C.E.) wrote his theory of Forms in his most famous work, the *Republic*. Here Plato speaks of issues of justice, government, morality, and ethics in a systematic philosophy. He puts forth that there is an *ideal* for every earthly object and idea. These ideals exist in the realm of pure, unchanging, and eternal Forms, which reside outside the sphere of our physical senses. He posits that this world we live in is only an imitation or shadowing of the perfection that perpetually exists beyond this earthly realm. However, Plato encouraged a striving for perfection in all matters, and believed that a contemplation of that which is beautiful, noble, and excellent will, in fact, uplift and ennoble the viewer. He writes in the *Republic*:

> The man who has been properly nurtured in this area will be keenly aware of things which have been neglected, things not beautifully made by art or nature. He will rightly resent them, he will praise beautiful things, rejoice in them, receive them into his soul, be nurtured by them and become both good and beautiful in character.

So, for Plato and for the Greeks of classical times, there were absolute, immutable, and *objective* standards that were embodied in their art. Standards of thought and behavior were embedded in the images. These elevated, balanced, measured, proportioned, and idealized images reminded the viewer of the requirements made upon the Greek citizen to obtain balance and measure in his own life. At the same time, the contemplation of these perfected images was thought to improve, enrich, and ennoble the viewer's personal character.

Aristotle (384–322 B.C.E.) studied with Plato, but took a somewhat differing view. Although he still maintained that art was designed to teach standards of ethics, he believed in more direct observation of the natural world. Aristotle advocated *mimesis*. The word mimesis means representation and/or imitation. For Aristotle, this does not mean that one must "literally" represent an object in all its exact particulars, but rather nature, in its refined, generalized, and perfected form. However, this view relies on the artist's ability to observe the natural world and then to translate it to a more idealized representation. Thus, intervention and judgment on the part of the artist is implied and required as to the particular arrangement of elements to complete the idealized standard.

Standards based on classical models have been the guiding principle for deciding the worthiness of art throughout much of Western-European history. And, for many, works like these encompass a tradition that is clear, concise, and easily understood. However, if one decides that these are the objective standards by which all art should be measured, then how would we rate a work of art such as an African mask? What would be the criteria of evaluation?

Clearly, the powerful and emotive abstractions and distortions that are intrinsic to the aesthetics of African cultures would not hold up under the scrutiny of a rigid set of objective standards based on classical models. This would be true if we were to

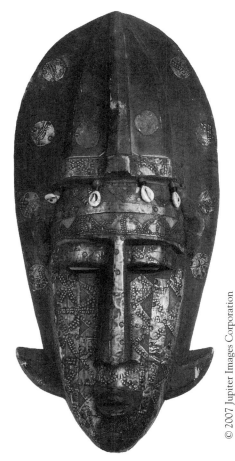

© 2007 Jupiter Images Corporation

African Mask.

apply this set of classical aesthetic principles to any number of nonwestern artistic traditions. Asian, Oceanic, and Native North or South American art would suffer negative judgments according to classical standards. Similarly, much of the art of the Middle Ages, as well as the vast body of modern art, would not fare any better under these standards of measure. So adhering to a single set of aesthetics disallows and eliminates almost everything but a tightly composed group of artworks and renderings.

The Middle Ages

During the Middle Ages writing on aesthetics was mostly done by theologians. Although the Old Testament in the Bible has a prohibition against "graven images," Christian thinking on the subject leaned toward the Platonic idea that images could

be a beneficial tool for moral and ethical enlightenment. Scholars of the Middle Ages in Western Europe felt that art could and should be used for teaching biblical lessons to the illiterate. Ideas about good and evil, right and wrong, morality, ethics, the road to salvation, and key stories from the Old and New Testaments were made available to the masses through the visual arts. Furthermore, images were used as a "vehicle" for prayer. It was thought that the contemplation of a divine image could help the congregation toward more focused worship and the individual to a more intense and heightened personal spiritual experience.

In light of these purposes, images in the Middle Ages were not particularly required to meet the standards of "classical" beauty. In fact, much medieval art moved

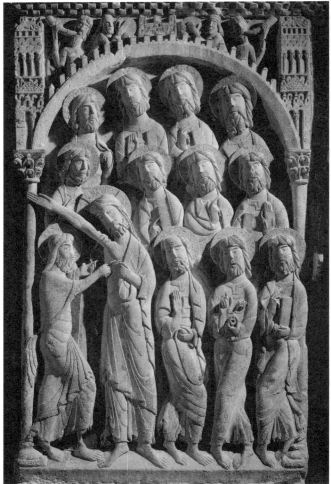

© The Art Archive/CORBIS

The Incredulity of St. Thomas from Santo Domingo de Silos, Spain, c. 11th–12th century C.E.

away from naturalism and idealism toward a "spiritualization" of the subject matter. There was a concerted effort to alter forms away from "pagan" models of the temporal world to images that were evocative of an *otherworldly realm*. The kingdom of heaven and the history of salvation are shown in somewhat abstracted forms. There is a recognizable physicality, yet a clear spirituality that shifts the image from its ties to classical models and focuses on the altered state of the heavenly realm.

In *The Incredulity of St. Thomas*, Christ has appeared to St. Thomas after the crucifixion. Thomas doubts that this is really Christ, and while the apostles look on, he pokes a tentative finger into the wound in Christ's side to verify his true identity. The artist has described the human figures with simplified pared-down elements of form, elongated bodies, oddly cross-legged stances, and drapery conceived as flattened abstracted design elements independent from the body beneath. Although this would not meet the standards of classical art, it does meet the needs and serves the standards of the Middle Ages, clearly delineating between the physical and spiritual spheres.

The Renaissance

Many scholars of Western-European art history begin the Renaissance in the early 14th century with the work of Giotto. Giotto was the first artist, since ancient times, to move away from the "spiritualization" of the image and rely much more on direct observation of nature, taking the biblical stories and "humanizing" them with a more realistic and representative rendition of the human form. The word "Renaissance" comes from the Italian *re nascere* which means "rebirth." Artists and scholars of the 14th, 15th, and 16th centuries gradually moved away from the aesthetics of the Middle Ages toward a rebirth of "classical" ideas, which were based on the observation and idealization of nature.

Renaissance thought on the subject of aesthetics is complex. Both Platonic and Aristotelian thought were revived in two main areas: spiritual beauty and synthetic beauty, respectively. Ideas of spiritual beauty were manifest in Renaissance thought in the philosophy of Neo-Platonism. Plato's idea of perfected forms, nonexistent in this world, but somewhere manifest in an otherworldly realm, were combined with his treatises on "love" as a journey of the spirit. Writers at the time envisioned the contemplation of physical beauty as a vehicle for a connection with divine spiritual beauty. Thus, the world of the physical and the world of the spiritual were connected in an ongoing cycle between earth and heaven.

In Botticelli's *Birth of Venus* (see Chapter 3) the goddess of physical love and desire washes onto shore on a seashell. Tall, elegant, and nude, she modestly covers herself with her long golden tresses. Personified winds blow her to shore, while goddesses await her arrival with flowered cloaks to immediately cover her. Here Venus, new to the world, has just been born as a fully grown woman. But she is pure, virginal, and modest. A Neo-Platonist viewing Botticelli's *Birth of Venus* might contemplate her extreme physical beauty, innocence, and ultimate divinity as "queen of physical

love." In doing so, he would be directed to a thoughtful consideration of perfected and divine heavenly love embodied and encompassed by the Virgin Mary as Queen of Heaven. So, in Neo-Platonic thought, we see the rebirth of pagan ideas and ideals within the parameters of Christian concepts.

Another branch of Renaissance thought, synthetic beauty, leaned toward Aristotle's concepts that the artist should imitate nature, but try to organize and represent it in its most perfected forms. Synthetic beauty assumes that there is no "perfect" form of anything in our physical world. Therefore, in order to create the perfected image, whether it is landscape or human, one must combine the best parts of a number of different images from a variety of subjects and thus synthesize the many into the singular and perfected final configuration. Thus, an artist would combine his/her own estimation of nature, with examples from antiquity, and perhaps even images from the finest painters of the day, until the completed arrangement was distilled from various sources into the perfect embodiment of that form.

Renaissance thought on the subject of art was related in 1435 by Leon Battista Alberti (1404–1472) in his treatise on the subject of painting entitled *Della Pittura (On Painting)*. Alberti gave an overview of the newly discovered science of linear perspective, and wrote that a painting should be like a "window" to another world, fully formed and as believable as the viewer's own. He further advises that a great painting should contain *istoria*, meaning "history" or "history painting." Great paintings should be reinterpretations of familiar and ennobled subject matter designed to move the viewer emotionally while elevating the viewer intellectually and spiritually.

Giorgio Vasari (1511–1574) established a "history of art" in his book *Lives*, published in 1550. Vasari gives biographies of the artists beginning with Giotto in the 14th century, and ending with the lives of the great High Renaissance artists of his time, namely Leonardo da Vinci, Michelangelo, and Raphael. In their work, Vasari sees the ultimate manifestation of beauty, proportion, nobility, spirituality, truth, goodness, virtue, and even divinity. Vasari's rendition of the progression of Renaissance art and the rebirth of the classical (in its improved form) found within the body of art of da Vinci, Michelangelo, and Raphael, will become the example for later studies in art history.

The 17th Century

Subjective theories on the nature of art began to emerge in the 17th century. Art of the Baroque period (17th century) is, for the most part, made up of a number of styles that can be relatively identified by geographical regions. Certainly, standards of aesthetics based on classical forms and Renaissance ideas continued to be considered in academic settings and scholarly discourse. So too was Aristotle's view of the nature and function of the artist to observe the world and represent it in its most generalized and idealized forms rather than in its particular details.

However, much of Baroque art was considerably more expansive and exaggerated, filled with movement, emotion, and drama. The Italian painter Caravaggio used mod-

els culled from the streets, thus bringing the great themes of Christianity into the realm of everyday life while infusing them with divinity through his use of dramatic and mysterious lighting. The Northern Baroque painter Peter Paul Rubens re-created the emotion and drama of the Christian stories, as well as ancient myths, through the use of strong colors and swirling, passionate brushstroke.

However, French Baroque art leaned decidedly toward the calm grandeur of the "classical." In this regard, of particular note was the establishment in France of the Académie Royale de Peinture et de Sculpture (Royal French Academy of Arts) in 1648. Dominated by Classicism, Académie scholars established a hierarchy of subject matter. History and religious painting ranked as the most important subject matter, while genre painting and still life rated on the low end of possible subjects to render. Methodical rules of painting were established, and the hierarchy was supported emphatically in academic circles.

However, the establishment of rules also engendered debate about such rules. Ancient norms of classicism, the cool intellectualizing of the form and emotion, were challenged by painters and theorists who saw value in the subjective and the emotional. While students in the Académie were strictly trained in precise methods of drawing, others, outside of the strictures of academic painting, were seeing color and brushstroke as more important than drawing. So the great artistic debate of the Baroque period was line versus color, which translated to intellect versus emotion. Art as it had always been understood was changing. The subjective sentiments of both the artist and the viewer were being factored into the aesthetic landscape of the times.

The 18th Century

In the 18th century the British Empiricists took the view that experience, especially of the senses (i.e., personal perception), should be the source of knowledge.

David Hume

David Hume (1711–1776), a Scottish philosopher, suggested that the concept of beauty lies solely in the perception of the beholder: "Beauty is no quality in things themselves: it exists merely in the mind which contemplates them; and each mind perceives a different beauty." Although on the surface this may seem to embrace a subjective approach completely, Hume goes on to theorize that not all individual perceptions can be trusted. He suggests that our initial perceptions about a work of art can change as we discuss it with other observers, and that, in fact, it is essential to come to some objectively agreed-upon conclusions about a work of art. These conclusions occur in the process of having a dialog about a work of art. With discussion, our opinions can change toward a more generally agreed-upon view within the context and conventions of acceptable social mores.

Furthermore, Hume believes that there are certain "objective" critics who have been educated properly and are "fit" to make such judgments. Those would be people deemed to possess sensitivity, experience, good sense, and freedom from prejudice. Obviously, this is problematic, as it would be rather difficult to determine who possesses these qualities and to what degree they possess them. Who qualifies, definitively, for the task, and who would determine that?

Whether we agree with Hume or not, he does open the door to an acknowledgment of the legitimacy of individual judgment and discernment with regard to art. Furthermore, he suggests that judging art with thought to its larger societal context is also an important determinant to consider.

Immanuel Kant

The German philosopher Immanuel Kant (1724–1804) felt that a more comprehensive and ordered approach was necessary in evaluating the nature of aesthetic judgment.

> His philosophical system is like a piece of architecture: everything has a place, and relates precisely to every other element. For instance, there are three ways of thinking, feeling, and of being conscious; that is, of knowing, desiring, and being aware. These are set out in his three critiques on Pure Reason, Practical Reason, and Judgment. As you would imagine, it is in the judgment wing of his "building" (of his critiques) that beauty is to be known. He constructs an "analytic of the beautiful" as part of his commentary on judgment.
>
> Kant's explanation of how we come to terms with the beautiful is not particularly complicated, although it is quite ingenious. Agree with Kant that we have several distinct—that is, separate—capacities in our minds: the cognitive, the ethical, and the judgmental. For the time being, set aside the ethical or moral. That leaves us with the ability to judge or be imaginative on the one hand, and the ability to be rational or cognitive on the other. In order to understand, we have to put these two capacities—the imaginative and the cognitive—in gear, make them work together. The imaginative mind allows us to perceive, to experience, to take in the world through our senses. The rational part of our mind gives us the ability to subject this "manifold" in perception (all the intake) to concepts. Every rational human has the ability to make sense of the world.
>
> Vernon Hyde Minor, *Art History's History* (2nd edition), p. 94, Prentice-Hall, 2001

Thus, in Kant's view, the interaction of free imagination (which is essentially subjective) and cognitive faculties (which are essentially objective) interact to produce the aesthetic feelings and judgments that one makes about both art and nature. He goes further by emphasizing that a person must come to the work of art with a "disinterest." This does not mean "uninterested." By "disinterest" he means being "impartial" and without preconception—merely being open to the experience. Part of Kant's contribution to aesthetic thought lies in the organization and structure that he gives to the subject. His discussion and acknowledgement that both subjective and objec-

tive faculties are required to formulate aesthetic judgments will have a powerful effect on subsequent theoretical constructs on the subject.

Georg Wilhelm Fredrich Hegel

Another German philosopher who has had a great influence on ideas of aesthetics and on the development of art history is Georg Wilhelm Fredrich Hegel (1770–1831). Hegel's ideas are complex, but in brief overview, he concerned himself with the idea of "spirit," a force that guides the universe. This spirit can be found in art, religion, and philosophy. The sensuous physical manifestation of spirit is expressed in works of art whose role is to reveal truth.

Hegel divides the history of art into three categories: Symbolic, Classical, and Romantic. He sees these stages as representing the development of the human spirit. The Symbolic stage refers to preclassical times with references to such art as the sculpture and monuments of the Egyptians. He sees spirit and truth attempting to be expressed in their artworks, however inadequately. Hegel designates the second stage of the development of the spiritual in art to the Greeks of Classical times. Here, in the perfected and idealized human forms, he sees the embodiment of the ideal without distortion. However, even with the Greeks, he feels the expression of the spirit to be limited. The third most mature stage in Hegel's philosophical construct on art and spirit is Romantic. That would encompass all post-Classical art, namely Christian art. He feels that here art becomes truly "spiritualized" and focuses on the inward notions of spirituality through outward representations of divine concepts. For Hegel, art is a vehicle used to promote a higher consciousness and oneness with universal laws of divine invention. The higher function of art is to get to truth, and to reach a higher consciousness.

Hegel believes that a work of art is a series of symbols that, when understood, can lead us to an understanding of the people and the culture that created it. He goes further by postulating that it is within works of art "that nations have deposited their profoundest intuitions and ideas; art is thus often the key, and in many nations the sole key, to their philosophy and religion." Thus, Hegel brings us closer to a modern notion of the nature and function of art as a visual repository of the history, religion, and philosophy of a people.

In seriously considering the art of preclassical cultures, Hegel also expands philosophical thought beyond the confines of classicism and paves the way for scholars to embark on studies of these civilizations. Hegel's contributions to the history of art and aesthetics were foundational to an expanded concept of the nature of art. His theories influenced later thought on the subject, giving art a power and potency to contain the "spirit" of the culture in which it was created. Furthermore, in developing his ideas of Symbolic, Classical, and Romantic art, he introduced the idea of the evolution of style, which would have lasting effects on the developing discipline of art history.

At this point in our discussion, it is clear that an entirely objective approach to art (i.e., establishing a rigid set of standards by which all art should be judged) is not a satisfactory approach. Similarly, a completely subjective approach gives us no basis by

which to understand art or the creative process, as it provides no common ground for discussion. If we merge our cognitive and imaginative faculties with a certain amount of "disinterest" or openness and impartiality, as Kant suggests, along with Hegel's idea that art contains the "spirit" of a culture and an evolution of style within that culture's development, it gives us a start for viewing art with a *combined* approach. Certainly both philosophers subscribed to the notion that there are ideals of beauty that everyone can and should be able to agree upon. However, they, along with Baroque theoretical questioning about the nature of art and the creative process, open the door to alternate ways of thinking about art.

The combined approach to aesthetics is somewhere between the extremes of the objective and subjective approaches, and stems from an interaction between the subjective response of the viewer and the intrinsic qualities of the art object itself. With this approach, each culture within a period of time and place forms its own standards for what is aesthetically pleasing, and these are the standards by which the artwork is judged. We acknowledge and understand the standards and values of aesthetic measurement created and held important within the culture. We take into consideration the context in which the work of art was created—the meaning and the use it was put to. We evaluate our responses to it within these parameters. It is in this way that we can remain open to the variety of visual forms and expressions of art regardless of where and when they were created, and regardless of our own cultural preferences or biases.

So, aesthetic judgments are not about "good taste" or simply what is "beautiful." If a work of art is capable of delighting you in some way, engaging your intellectual or moral sensibilities, or evoking a powerful response or mood, then it can be a successful work. It can be said to be "working aesthetically." If a work of art is representative of the cultural "spirit" of a people, or the "spirit" of a particular artist, for that matter, then it can be said to be "working aesthetically." Aesthetics, then, is the study of all the problems associated with the character, creation, perception, and evaluation of art "with a view to establishing the meaning and validity of critical judgments concerning works of art and the principles underlying or justifying such judgments."

The history of aesthetics does not stop here. However, it is during the 18th century that the development of the academic discipline of art history begins. Now the study of aesthetics expands beyond the realm of philosophy to include considerations specific to art history. The history of art history certainly involves aesthetic judgment, but is more concerned with the development of art within each culture and the cataloging and stylistic characterization of works of art. So, we will reserve the rest of the discussion of aesthetics in the 19th, 20th, and 21st centuries to the next chapter on approaches, methodologies, and the development of the discipline of art history.

BIBLIOGRAPHY

Crawford, D. W. *Kant's Aesthetic Theory*. Madison, WI: University of Wisconsin Press, 1974.

Hume, D. *Of the Standard of Taste and Other Essays* (trans. John W. Lenz). New York: Bobbs-Merrill, 1965.

Kant, I. *Analytic of the Beautiful* from *The Critique of Judgment* (trans. Walter Cerf). New York: Bobbs-Merrill, 1963.

Minor, Vernon Hyde. *Art History's History*. Upper Saddle River, NJ: Prentice-Hall, 2001.

Norton, D. F. (ed.). *The Cambridge Companion to Hume*. England: Cambridge University Press, 1995.

Nussbaum, M. C. "Classical Aesthetics," *The Dictionary of Art* (Jane Turner, editor), Volume I, p. 175: Grove Art, NY and Macmillan, London, 1996.

Paolucci, H. (trans.). *Hegel: On the Arts Selections from G. W. F. Hegel's Aesthetics or the Philosophy of Fine Art*. Smyrna, DE: The Bagehot Council, 2001.

Plato. *Republic* (trans. Paul Shorey). Cambridge, MA: Harvard University Press, 1987.

Podro, M. *The Critical Historians of Art*. New Haven and London: Yale University Press, 1982.

Price, J. V. *David Hume*. Boston: Twayne Publishers, 1991.

Vasari, G. *Lives of the Artists* (Betty Burroughs, ed.). New York: Simon and Schuster, 1946.

3

Art History: Development and Methodologies

The 18th Century

Johann Winckelmann

Art historians credit the early development of the discipline to the 18th-century scholar Johann Winckelmann (1719–1768). Winckelmann lived during the same time period as Hume and Kant, but he approached the study of art from a more practical view rather than the purely philosophical view of contemporary philosophers of his time. Many art historians consider Winckelmann to be the "father of art history." Indeed, he was the first scholar to attempt an organization of the art of the past based on historical context and culture, rather than focusing exclusively on lives of the artists, as Vasari had done.

Winckelmann, a scholar of antiquity and archeology, looked at art through the lens of history. In his pivotal book *History of the Art of Antiquity*, published in 1764, he set out the parameters of the theories that would subsequently influence the emerging discipline of art history. Winckelmann proposed that the development of Greek art was intimately tied to the development of Greek culture taking into account society, politics, ethics, education, and even climatic factors. It is easy to see that Winckelmann's ideas would later influence Hegel's ideas that the art and the history of a culture are intimately linked.

Winkelmann divided the art of ancient Greece into successive periods that were each characterized by separate and distinct styles. He thought of the development of

Greek art as organically perfecting the form of the human body, in ever more mature and satisfying ways, as Greek civilization developed. Winckelmann likened the rise and fall of the ancient Greeks to the life cycle and development of a human being. Thus, early Greek art (the Archaic Period) was compared to childhood, Classical art was likened to maturity, and later Greek art (Hellenistic) was portrayed as old age and decline. He felt that Hellenistic art represented the degeneracy of the form and balance of Classical art into an excess of drama and passion that signaled the decline of Greek civilization. He theorized that this trajectory of the rise and fall of any civilization could be seen in the art of that civilization as it goes through developing early stages to a mature stage, then inevitably, into its decline.

One of his major contributions to the discipline of art history lies in the way he set about grouping works of art into categories based on stylistic traits. In trying to understand the artistic production of ancient Greece, he looked for similarities in the "formal" elements of artwork created during the same time period. In this way, he was able to group and organize the history of Greek art into periods or "styles" based on similarities in the handling of elements such as line, shape, design, and modeling within each time frame. Subsequent art historians continue to follow this model in attempting to organize, categorize, and understand artistic works through time and culture.

The apex of Greek art, for Winckelmann, was the Classical period of the 5th and 4th centuries B.C.E. Here he felt that Greek art and culture had reached its finest moment. In extolling the virtues of the Classical period (". . . the most distinctive characteristics of the Greek masterpieces are, finally, a noble simplicity and quiet grandeur, both in posture and expression,") he insisted that artists and scholars of art use these works as the highest available models by which to measure art and beauty.

Winckelmann was mostly displeased by the deviance of Baroque painting, with its unbridled passion, movement, drama, and emotion, from classical aesthetics. However, the academic paintings of Nicolas Poussin, the French Baroque painter, would more fully suit his tastes. In Chapter 2, French Baroque painting is mentioned as the antithesis of Baroque painting produced in the rest of Europe. Poussin's style is characterized by the same "noble simplicity and quiet grandeur" that Winckelmann so admired in works from Classical Greece. The idealized figures, balanced compositions, and intellectualized themes of Poussin's paintings would contribute to a classical revival (Neo-Classicism) of the late 18th and early 19th centuries, set in motion and fostered by Winckelmann's writings.

The 19th Century

Alois Riegl

The Austrian art historian Alois Riegl (1858–1905) added to both Winckelmann's and Hegel's ideas about the function of art and its role in culture. Like Winckelmann and Hegel, Riegl saw a certain ordered development in the art of any particular society, and

the link between the history of a culture and its art. However, he did not phrase this development in terms of strictly "classical" aesthetics as Winckelmann had. Nor did he subscribe to Hegel's ideas of progressions of the "spirit" in the development of art.

However, like Hegel, Riegl saw the "spirit" of a civilization being visually manifested in its artistic output, but Reigl was far less mystical, and without the religious overtones present in Hegel's ideology. Riegl used the word *Kunstwollen* which means "will to art" and denotes a society's "will" or "energy" to create. The will or energy to create art, according to Riegl, was dictated and controlled by the needs of the society, which were not necessarily framed upon classical models. *Kunstwollen* describes the "universality of the artistic striving while leaving full scope to the infinite variety of styles and ideals" (Gilbert, p. 547). This idea is rather important because it allows for 19th-century art historians to begin to analyze art within the construct of the culture that produced it with less of the aesthetic bias of classicism.

The 20th Century

Art history, in both theory and practice, was further developed in the late 19th and early 20th centuries by two men who brought major contributions to the discipline. They were the Swiss art historian Henrich Wölfflin (1864–1945), and the English art critic and museum curator Roger Fry (1866–1934). Each in his own way helped to develop fresh approaches to the analysis of art and style, and to further the development of art history as an academic discipline.

Style

Henrich Wölfflin

Henrich Wölfflin, seeing the potential to utilize the advancements in photography, created a lecture format that is still used today in art history classrooms. Wölfflin brought early slide projectors into the classroom. Lecturing in a darkened room, he could show his students enlarged images of works of art, many views of the same object and (using two projectors) compare and contrast works of art with each other. In this way, Wölfflin was able to better observe nuances and details: find similar characteristics between works of art from the same period, geographical location, or artist; and discern patterns of style through comparison. And, he was able to demonstrate these ideas and concepts directly to his students right there in the classroom, thus helping them to develop strong analytic and critical thinking skills through direct demonstration.

Wölfflin also developed theories about culture and artistic style being integral. Although some would disagree with his ideas, he brought major concepts to the dialogue that are important to consider and useful when evaluating works of art. In his book *Principles of Art History*, published in German in 1915 and English in 1932, Wölfflin provided a model for the analysis of art based on five points of comparison

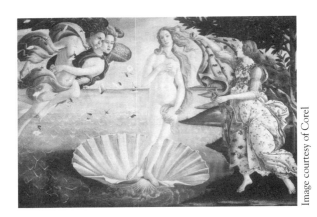

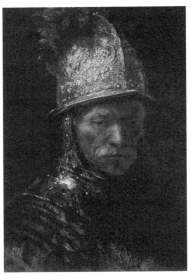

Sandro Botticelli, *Birth of Venus,* 1485, tempera on canvas, (68" × 110"), Uffizi, Florence, Italy.

Rembrandt van Rijn or school of Rembrandt, *Man with Gold Helmet,* 1650, oil on canvas (26" × 19"), Germäldegalrie, Staatliche, Berlin.

between Renaissance art (late 15th/early 16th century) and Baroque art (17th century). The points of comparison are: *linear* vs *painterly, plane* vs. *recession, open form* vs. *closed form, multiplicity* vs. *unity,* and *absolute* vs. *relative clarity.*

Using the two works of art illustrated above, we can briefly discuss how these five points of comparison are manifest. *Linear* refers to the clarity of line contained within a painting. In the Botticelli work, the outlines of the figures are precise and tangible, delineated, clearly visible, and understood. In the Rembrandt piece, the edges of the figure are not defined by line, but by the use of light and shadow created by soft, blurred brushstrokes. Attention to the edges is less important and the figure is defined by loose, rich, *painterly* brushstrokes.

In the contrast between *plane* vs. *recession*/Renaissance vs. Baroque, Wölfflin defines Renaissance painting as setting up a series of flat planes that are constructed as parallels to the picture plane (the flat surface upon which the picture is painted). These planes logically recede into the imagined depth of the picture. This can be seen in the Botticelli painting as we see the clearly created foreground, middle ground, and background. The figures are firmly established in the foreground and are arranged horizontally across the canvas and parallel to the picture plane. Then we see a sequence of planes in the areas of land on the right that jut out into the water in a series of parallel shapes getting smaller as we are visually taken into the middle ground and background of the picture. In contrast, the Baroque piece is con-

structed asymmetrically and at a diagonal to the picture plane. This can be observed in the positioning of the subject's shoulders which appear at an angle and are diagonal to the picture plane. This is what Wölfflin defines as *recessional* in the second pair of opposites.

The third pair of opposites is *open* vs. *closed form*. The Rembrandt piece would be considered an open form as the diagonal construction and undefined background give it a more limitless space which is bounded only by the frame of the picture. On the other hand, the Botticelli piece seems more box-like, symmetrical, and self-contained. It is orderly and structured in such a way that we clearly understand the boundaries of its space.

The fourth pair of opposites is *multiplicity* vs. *unity*. Here, Wölfflin encourages a look at the details of the paintings and how they "work" independently as well as toward the whole. He asserts that in Renaissance art the individual components of the piece have degrees of independence apart from the work as a whole. For example, in the *Birth of Venus* each part of the arm of the nymph on the right seems to be strongly defined as an individual part of the body that can also be seen as part of the whole, but is not thoroughly subordinated to it. Likewise, the body of Venus herself can be anatomically divided and viewed individually as separate and clearly delineated anatomical parts (thigh, knee, shin, foot), while also being viewed as part of the full figure. In the *Man with the Gold Helmet,* there is a sense of unity whereby all the parts are subordinated to the entirety of the whole. All the parts of the figure seem to more easily "merge" and be immediately seen as part of the entirety of the piece. Much of this has to do with the "painterly" mode of representation—the soft, blurred edges. Every part of the painting works toward a unification of the subject without any parts being seen as individual components.

Finally, there is the concept of *absolute* vs. *relative clarity*. This has to do with the way in which the figures and the objects are modeled. In the Renaissance piece textures and shapes are created with precision and solidity. In the Baroque piece there is a lack of explicitness. The figure seems to recede into darkness, and the light is handled almost like stage lighting. It is used to simultaneously reveal and conceal, at the artist's will, in order to achieve the mysterious, introspective quality. Therefore, in comparison, the Botticelli painting has a crispness and clarity of imagery in contrast to the Rembrandt painting which evokes more mood, drama, and emotion.

Wölfflin's theory of opposites creates a convincing argument for stylistic categories linked to culture and context based on similar and consistent handling of the "formal" elements of a work of art. However, it also raises many questions. For example, must all works of the 16th century be linear with closed form? Must all works of the 17th century be painterly with open form? Certainly there are exceptions to all of his points of comparison. However, what he does is to create a format by which we can begin to look at and analyze works of art with specific tools that help us to see consistencies of style and link style to various trends and factors within time periods and cultural movements.

Formalism

Roger Fry

Like Wölfflin, Roger Fry also considered the "formal" elements (line, depth, color, composition, etc.) that go into creating a work of art. However, Fry believed that we should analyze a work of art only on the basis of its formal elements, unfettered by considerations of culture or time frame. He believed that a work of art has little connection to the artist who created it, or to the context in which it was created. Fry took a strictly *Formalist* viewpoint. His understanding was rooted in Kant's philosophy of "disinterest," "impartiality," and "neutrality" on the part of the viewer. Like Kant, he believed that the aesthetic comprehension of beauty is rooted in the subjective experience alone, apart from culture, origin, artist, and context.

Fry felt that art and the history of art has its own internal logic. Instead of viewing art as a product of the age in which it was created, or as part of a cycle of "early," "mature," and "decline," he viewed Western-European art as developing on a continuum. This continuum moved from naturalism to ever more abstract formal elements. In part, Fry's theories are an attempt to justify and explain modernism and trends toward abstraction. Fry neither discouraged nor encouraged naturalism. If a work of art imitates (represents) the natural world, it is purely incidental and not necessary to our subjective understanding or response to the work. Thus, the avenue for totally abstract works, non-objective art (art without recognizable subject matter), was given legitimacy. In essence, an abstract work of art does not suggest what the viewer "should" see or feel, thus allowing for a liberated subjective experience for the viewer.

Fry considered our "subjective" responses to a work of art to be strictly connected to the formal elements contained within the work, rather than the content. Within his formalist approach, a work of art would be analyzed purely by how the various elements of form contribute to the overall composition and therefore to the work's aesthetic appeal. "Formal elements" are the artist's visual tools. Such things as line, shape, space and depth, color, light and shadow, balance, order, proportion, visual rhythm, repetitive pattern and shape, brushstrokes, mass and volume, and texture are some of the "formal elements" that the artist uses to create a work of art, and what we respond to when we view it.

Fry's approach to analysis was based on these elements exclusively. He felt that consideration of the culture in which the work was created, cross-cultural influences, the life or psychology of the artist, history, or any other factors outside the artwork itself were inappropriate in understanding, judging, or responding to the work. The way that the formal elements are utilized and arranged, and a consistent handling of the formal elements, would then determine stylistic designations and groupings.

Clement Greenberg

The idea that art, and its progression through history, has its own internal logic (independent of culture) was embraced and further refined by the formalist art critic of the

mid-20th century, Clement Greenberg. Greenberg traced "modernism" as a linear progression toward greater and greater abstraction and non-objectivity, beginning in the mid-19th century with the Realist painters. He observed that since the mid-19th century, artists had been moving away from the imitation of nature and more toward theories of style. Artists at the time asked the question, "What is the true nature of painting?" They answered it by defining painting as *patches of color on a flat surface.* In other words, the true nature of the canvas is two-dimensional. It contains only height and width. The illusion of a third dimension (depth) is simply that—an illusion. Therefore, if painting is to remain "true" to its nature, it must emphasize those things that are intrinsic to it: patches of color on a flat surface.

The trajectory of this theory, according to Greenberg, was for painting to move toward an ever-increasing emphasis on the flatness of the canvas and paint applied to the surface as abstract shapes, colors, and lines that are nonrepresentational. Therefore, painting becomes "self-referential." That is, it represents only those "formal" elements that reference painting: colors, shapes, and lines on a two-dimensional surface. Painting that is representative of three-dimensional space (an attribute of sculpture, not painting) and objects in the natural world (which cannot possibly exist on a flat surface) are counter to this concept. Greenberg writes in his book of selected essays from 1961 entitled *Art and Culture:* "Content is to be dissolved so completely into form that the work of art . . . cannot be reduced in whole or in part to anything not itself."

Greenberg's profound influence on art history and art criticism became known as *Modernism.* Strict adherence to his theories became almost requisite in order for artists to get their work exhibited. This remained the case through the mid-1970s.

An alternative to Greenberg's ideas, *Post-Modernism,* began in the mid-1960s and continued to gain momentum throughout the 1970s. Initially it was used to describe developments in architecture that, while maintaining Greenberg's modernist ideas, also began to incorporate classical and neoclassical motifs. By the 1980s these anti-modernist tendencies expanded into all the arts and were manifest in a much more pluralistic and inclusive attitude. The line between traditional arts and crafts was blurred while imagery, techniques, and materials were combined more freely without the theoretical constraints that had once been so strictly imposed.

Apart from the Formalist and Stylistic perspectives of art history and the analysis and interpretation of works of art, there are many concepts that scholars have developed in viewing, evaluating, explaining, and critiquing art. The following is a brief overview of some of these approaches.

Marxism and Sociological Approaches

Karl Marx (1818–1883) and Friedrich Engels (1820–1895) are best known for their work on the *Communist Manifesto* published in 1848. In it they outline the struggle between social classes based on the production of goods and the methods of production. They divide capitalist society into two basic classes: the bourgeoisie (owners of

the means of production) and the proletariat (the workers who produce the goods). The opening line to the introduction of the *Communist Manifesto* reads: "The history of all hitherto existing society is the history of class struggles." Marx and Engels advocated a socialist/communist structure whereby the means of production and the products produced were owned, and the profits shared, by the proletariat. The thrust of Marx and Engels's theories was a reform of capitalist economic structure into a communist organization of labor and division of profits.

In writing about art, Marx viewed artistic production in social and economic terms. Artistic production was controlled by the social conditions in which an artist lived. His or her access to education, contact with wealthy patrons or the church, and free time to pursue art were all tied into the social class of the artist. Most often these opportunities would be reserved for those born into the bourgeoisie—those who controlled the economic means of production. Workers, however talented they might be, would not have the time or the means to pursue creative endeavors.

In Marx's view, the Industrial Revolution and the ever-increasing industrialization of Europe had alienated humans from their spiritual needs and robbed them of the joy and pride of individual productive labor. He wrote that mechanization, such as a factory worker experienced, "degrades him to the level of an appendage to a machine" and "destroys every remnant of charm in his work and turns it into a hated toil" (Osborne, p. 281).

A strictly Marxist approach would lead to a limited view of art within the confines of class struggle and economic factors. Certainly with the breakup of the Soviet Union and the destruction of the Berlin Wall in the late 1980s and early 1990s, the Marxist ideologies of communism and socialism have largely failed as a practical application. However, in terms of art historical theory and the consideration of cultural and contextual factors in making, using, and perceiving art, Marxism has had a far-reaching influence that still informs the art historical dialogue. Marx's ideas, in an expanded context, have led to many important perspectives on art. Specifically, a *sociological* approach to art grew out of Marxist theory, and takes into account the social, political, religious, and economic factors in which works of art are conceived, produced, perceived, and utilized in any given society. Thus, "context" becomes extremely important in discussing and analyzing a work of art, and formalism is secondary.

In the sociological approach, economic factors such as patronage and the relationship between the artist and the patron are considered. Artwork as a commodity for trade and as a status symbol in the social order is examined. Seventeenth-century Dutch still life paintings often depict the wealth of objects owned by the patron. The ability of the patron to buy art by more well-known artists also contributes to his economic stature.

Often, content is related to economic factors. For example, the Industrial Revolution of the 19th century had a huge impact on Karl Marx, but it also had a great influence on the subject matter of painting. Artists began to depict the industrialization of Europe and its negative effects on the working class. Subject matter began to

change from idealized and romanticized scenes to images of the working poor. A sociological reading of art has its base in Marxist ideology, but vastly expands upon it.

Feminism

In the early 1970s with the rise of the Feminist Movement as a political and sociological force for the equality of women in every facet of society, feminist art historians began to investigate the role of women in the arts. It may seem odd to us today, but in 1970 the major art history texts used in colleges and universities contained little or no work by women artists. The "canon" of art, that is the major works of art considered by art historians to be so important to the development of culture, was dominated by male artists. These were accepted as the most significant contributions to Western-European art. And, until the 1970s no one asked, "Where are the women artists?"

Feminist art historians, like art historians influenced by Marxism, place art within the context of the social and cultural milieu in which it was created, and view a formalist approach as only a small part of the total evaluation of art. Feminist art historians very specifically focus on the contributions of women in the arts. In the 1970s they began to ask important questions and to excavate for answers which were often obscured by time, neglect, misappropriation of works of art to male artists, gender stereotypes, and prejudice against women artists.

Feminist art historians have been dedicated to unearthing information about women's contributions to the arts, while trying to discern why there has been a dearth of women artists over the course of history. In her pivotal 1971 essay entitled "Why Have There Been No Great Women Artists?", Linda Nochlin sets the tone for feminist inquiry as she provides answers and direction for further investigation of the question. Nochlin points to such obstacles as lack of access to proper training, as few women were allowed to attend art academies or do drawing studies from the nude figure. She cites societal expectations around marriage and family life, the patriarchal structure of economic power and control, the view that women were the property of a father or husband, the "cult of genius" developed in the Renaissance and associated with male artists, and the strong prohibitions surrounding expectations placed upon women and their diminished role in the world of men. Nochlin also points out that most of the women who did become famous artists, or were able to support themselves with their art, were usually born into a family where there was a male member who was already an artist and willing to train the woman.

Feminist art historians have greatly contributed to our knowledge of art history through extensive research. They have discovered major women artists whose work had been forgotten or neglected over time. They have uncovered works of art by women artists that had been attributed to more well-known male counterparts. Feminist art scholars have documented the contributions of women patrons, looked at representations of women over time and within different societies, encouraged publishers

to include the work of important women artists in their texts, and encouraged museum curators and gallery owners to exhibit the work of women artists.

Another aspect of this line of investigation and scholarship has been to look at the division between the fine arts and crafts. The historical placement of painting, sculpture, and printmaking as the "fine arts" has created a hierarchy in the art world that has been elitist and exclusionary. Pursuits such as weaving, quilt making, and embroidery have traditionally been considered to be "women's crafts," done in the home and symbolic of domesticity. Therefore, these endeavors have been relegated to a lower status. As Patricia Mainardi writes in 1973 in her article "Quilts: The Great American Art," "Women have always made art. But for most women, the arts most highly valued by male society, have been closed to them for just that reason. They have put their creativity instead into the needlework arts. . . . Needlework is the one art in which women controlled the education of their daughters, the production of the art, and were also the audience and critics." The arts traditionally thought of as "domestic" have been the areas where women have traditionally had control and artistic freedom.

The line between the "high" or "fine" arts and "crafts" has become increasingly blurred in the decades since the 1970s, and some would argue, nonexistent today. With the proliferation of mixed media work as an accepted mode of expression (that incorporates a variety of methods and materials) the options open to the artists and the visual experiences offered to the viewer have expanded tremendously. The extent to which the traditional lines between arts and crafts have been blurred or dissolved has been due, in large measure, to the pursuit of feminist scholarship.

Iconography/Iconology

Erwin Panofsky

Erwin Panofsky (1892–1968) was one of the most influential art historians of the 20th century. In his book *Studies in Iconology* (1939), he developed an iconographic approach to the study and interpretation of art that has influenced generations of art historians. Basically, *iconography* is the study of the images and subject matter in a work of art and the interpretation of their symbolic meanings. In Christian art, for example, the image of a lamb with a halo indicates Jesus Christ as the "lamb of God." *Iconology* refers to the larger traditions within a society into which the subject matter, the mode of representation, and iconographic meanings fit. An iconological reading of the symbolism of the lamb with a halo would extend to the idea of ancient sacrificial ritual, Christ as a "sacrificial lamb," stories of sacrifice in the Old Testament that prefigure the crucifixion in the New Testament, and so forth.

Panofsky developed a three-part system for understanding works of art. He termed these *pre-iconographic*, which refers to a primary level of comprehension based solely on the images and without any necessary knowledge of the artist, context, or intent. The second level was called *iconographic*. This is the level in which the images

are understood within the context and meaning of the particular time frame and culture in which the work of art was set. It involves the symbolic or secondary meanings of the images. Panofsky called this "disguised symbolism." Panofsky specifically studied Northern Renaissance art and determined that many of the ordinary objects in those paintings had secondary meanings or "disguised or hidden symbolism." Oftentimes, this would indicate ordinary objects imbued with religious significance. For example, a vase of white lilies would call to mind the purity of the Virgin Mary, or the removal of shoes would indicate that the subject is standing on holy ground. Members of any given society would understand secondary meanings based on cultural conventions and tradition. Lastly, the *iconological* element refers to a synthesis of several factors including the "intrinsic meaning" that the work has within the larger context of society, cultural precedent, prevailing styles of both the artist and the time frame and location, the relationship of artist to patron within that time frame, as well as prevailing themes and even texts that are contemporaneous with the work of art.

If we were to apply Panofsky's methodology to Botticelli's *Birth of Venus*, a pre-iconographic interpretation would be: In the center of the painting is a tall nude woman with long golden hair, standing on a seashell in the ocean. A female figure with a cloak is on the right, while on the left are a male and female figure hovering in the air. The iconographic interpretation would expand on this: Here we have Venus, the goddess of love, arriving on a shell out of the sea from which she was born. The west wind god, Zephyr, and the breeze goddess, Aura, gently blow Venus toward the shore of her island home of Cyprus. A nymph of the Hours, perhaps Flora, goddess of spring, waits with a cloak to cover her. We would then proceed to the secondary symbolism tied to Neo-Platonic thought as described in Chapter 2. To understand the work from an iconographic interpretation would require us to know something about Neo-Platonic theory and Greek mythology.

A full iconological reading would include all of the above and would also take into consideration such things as the Neo-Platonic teachings at the time, an understanding of Christian concepts, the reign of Lorenzo d'Medici in Florence, the ancient Greek statue entitled *Aphrodite of Knidos* by Praxiteles, upon which the image of Venus is based, various writings about the work of art as it was viewed at the time it was created, the place of Greek mythology in the literature and culture of 15th-century Florence and how the Florentines viewed themselves as a modern version of ancient Athens, the poetry of the Roman poet Ovid, and Homer's *Hymn to Aphrodite*:

> I will sing of stately Aphrodite, gold-crowned and beautiful, whose dominion is the walled cities of all sea-set Cyprus. There the moist breath of the western wind wafted her over the waves of the loud-moaning sea in soft foam, and there the gold-filleted Hours welcomed her joyously. They clothed her with heavenly garments . . .

Panofsky's methodology has been exceedingly useful to art historians as it has encouraged scholars to look carefully at works of art and to consider secondary meanings.

These meanings would not necessarily be accessible to us today, but would have carried implied messages for people in the society at the specific time the work was created, and would have been accessible to the viewer then. It has encouraged art historians toward deeper research into original texts and documents to gain a more comprehensive understanding of societal symbols and cues. This has led to a fuller range of components in analyzing, judging, and perceiving the richness and complexities in art.

Semiotics: Structuralism, Post-Structuralism, Deconstruction

Semiotic studies in art come out of linguistics and the study of language, both spoken and written, and how language is a communication through signs and symbols (letters and words). Semiotics in art comes out of the work of Swiss linguist **Ferdinand de Saussure** (1857–1913) and the American philosopher **Charles Sanders Peirce** (1834–1914). Semiotics includes Structuralism, Post-Structuralism, and Deconstruction.

Saussure developed structural linguistics, whereby the "structure" of language is deemed to contain two elements, the "signifier" and the "signified." The signifier is the word as spoken, or as represented by a series of marks on the page (i.e., letters). The signified is what the word means. Saussure continues this train of thought by pointing out that the relationships between words and the things they represent are arbitrary and abstract. There is no logical connection between the signifier (word) and the signified (meaning), other than what we all agree upon. A string of letters that represents a word has no real connection with the object. This string of letters, C-A-T, does not look anything like a cat. The relationship between the two is designated and arbitrary, yet we comprehend the connection by general cultural agreement. Peirce's semiotics was less rigid in this regard and saw a somewhat more natural relationship between the image and the meaning.

Structuralist theory, applied to disciplines other than structural linguistics, arose in the 1950s and 1960s. Applied to art, structuralist theory considers the work of art as a visual system of signs and tends to de-emphasize the role of the artist in giving meaning to the image. It relies more on the understood meaning the images have within the context of the general cultural milieu. The decoding of the signs (images) within a work of art opens up a comprehension of their importance and their role within a society. Then, if one looks at the cultural signs "outside" the work of art (in literature, film, music) and how those relate to the signs "within" the work, one can construct a larger and more comprehensive picture of what the artwork means in the larger cultural context.

In the *Birth of Venus* a structuralist may make the point that the painting does not function independently from its place within the context of its time frame, nor is it purely a product of the artist's independent imagination. Its meaning is framed

within the structure of the society in which it exists. Therefore, its "signs" or "codes" of lines, colors, and arrangements of shapes all work in concert to give the painting meaning. Further decoding (interpreting) of the work can be seen in the traditional organization of the picture space that adheres to Renaissance ideals and would affect the comprehension of the work by both Renaissance and contemporary viewers.

Post-Structuralism is tied into *deconstruction*. Basically Post-Structuralism is a reaction against Structuralism's belief that there is an underlying detectable "structure" to a work of art. Post-Structuralism maintains that meaning is ambiguous, arbitrary, and indeterminate. Therefore, interpretation and communication through reliable "signs" is called into question. Post-Structuralist theory looks less at "meaning" and more toward the creation and use of "signs" and "symbols."

Deconstruction, developed in the late 20th century, is associated with the French philosopher **Jacques Derrida** (b. 1930–1998). Deconstructivist theory postulates that the general consensus of the meaning of an image (or words) within a culture changes over time. Changing historical perspectives modify our impressions, judgments, and opinions. Therefore, images and their definitions and significance are flexible and changeable and thus unreliable. Deconstruction is:

> an analytical strategy . . . to which all cultural "constructs" (art, architecture, literature) are "texts." People can read these texts in a variety of ways, but they cannot arrive at fixed or uniform meanings. Any interpretation can be valid, and readings differ from time to time, place to place, and person to person. For those employing this approach, deconstruction means destabilizing established meanings and interpretations while encouraging subjectivity and individual differences. (Kleiner and Mamiya, p. 1096)

The relationship between the represented image, the meaning of the image, the associations we bring to the image, and the word used to describe the image is often illustrated with Rene Magritte's painting *The Treachery of Images*. Here we have a picture of a pipe. It is rendered in realistic terms so that we can almost feel the smooth glossy texture of the wood. Yet, as Magritte writes below in French "This is not a pipe." And, indeed, it is not a pipe. It is a picture of a pipe and thus is removed from the reality of its actual usage and function. The word p-i-p-e is simply an abstract group of "signs" on the canvas that have no relationship to the actual object either in shape or usage. The "treachery" is the believability of object that is rendered so carefully that we might believe that we are looking at an actual pipe, yet it is simply color and shape on a flat surface. We cannot always believe what we see, and what we see is not always the reality of the situation.

Banque d'Images, ADAGP/Art Resource, NY

Rene Magritte, *The Treachery of Images,* 1928–1929, Los Angeles Museum of Art.

Biography and Autobiography

This approach uses the life of the artist to understand the artist's work. Biographical information can often provide useful insights into a particular artist's work, and into the psychological underpinnings that motivate the artist and may be expressed in his/her creations. Understanding the life and personality of the artist can give us some direction in interpreting the work. Biographical particulars can be gleaned from texts written by or about the artist found in notebooks, letters, memoirs, articles, diaries, and journals. Furthermore, biographical and autobiographical information can often be discovered in portraits and self-portraits.

For example, the letters written by Vincent Van Gogh to his brother Theo give us insight into his methods, influences on his work, and his intentions. Vincent writes to Theo about his painting *The Night Café* painted in 1888: "I have tried to show the terrible passions of humanity through the use of red and green." Here we have the artist explaining the use of strong intense colors to describe a lonely scene of a mostly deserted café late at night. The few inhabitants are slumped over the tables as the proprietor hovers like a ghost next to the billiard table. Rather than wonder at the garish, discordant colors that disturb our sensibilities and create a claustrophobic space, we are able to clearly understand the message that the artist was trying to convey.

Paul Gauguin's self-portrait from 1889 shows the artist's head floating between a field of red and another of yellow. Above his head hovers a halo, and next to his head are two apples. A snake is entwined around his fingers. Gauguin is telling the viewer that he is both a saint and sinner, a descendant of Adam and Eve (the apples) caught between good and evil.

Gathering biographical information from a photo, text, painting, or sculpture is yet another useful way of understanding and evaluating artists and their works. It is one of many methods that can provide additional insights into the multitude of factors that inform an artist and his or her creations.

BIBLIOGRAPHY

Adams, L. S. *The Methodologies of Art*. Boulder, CO: Westview Press, 1996.

Atkins, R. *Art Speak*. New York, NY: Abbeville Press, 1990.

Barrett, T. *Interpreting Art*. New York, NY: McGraw-Hill, 2003.

Broude, N. and Garrard, M. D. *Feminism and Art History: Questioning the Litany*. New York, NY: Harper and Row, 1982.

Chadwick, Whitney. *Women, Art, and Society*. New York, NY: Thames and Hudson, 1990.

Fernie, E. (ed.). *Art History and Its Methods*. London, England: Phaidon, 1995.

Fishman, S. *The Interpretation of Art*. Berkeley, CA: University of California Press, 1963.

Hess, T. B. and Baker, E. C. *Art and Sexual Politics*. New York, NY: Macmillan, 1973.

Kleiner, F. S. and Mamiya, C. J. *Gardner's Art Through the Ages*. 12th edition, Belmont, CA: Thomson-Wadsworth, 2005.

Nochlin, L. *Women, Art, and Power and Other Essays*. New York, NY: Harper and Row, 1988.

Osborne, H. *Aesthetics and Art Theory*. New York, NY: E. P. Dutton, 1970.

Plato, *Republic* (trans. Paul Shorey). Cambridge, MA: Harvard University Press, 1987.

Podro, M. *The Critical Historians of Art*. New Haven and London: Yale University Press, 1982.

Potts, A. *Flesh and the Ideal: Winckelmann and the Origins of Art History*. New Haven, CT: Yale University Press, 1994.

Preziosi, D. (ed.). *The Art of Art History: A Critical Anthology*. Oxford, England: Oxford University Press, 1998.

Price, J. V. *David Hume*. Boston: Twayne Publishers, 1991.

Vasari, G. *Lives of the Artists* (Betty Burroughs, ed.). New York: Simon and Schuster, 1946.

4

The Ancient World

This chapter provides an introduction to the art of Western Europe beginning with prehistoric times and continuing through the fall of Rome, the advent of Christianity, and the rise of the Byzantine Empire. For ancient peoples, the connection between an object and its function were inseparable. Thus, aesthetic judgments about a work of art were dependent upon how well the object displayed the intended message or served the purpose for which it was conceived. Although there are exceptions, for the most part artists in the ancient world remain anonymous, their job being to visually embody the ambitions, values, beliefs, and ideals of their respective cultures rather than to seek individual recognition or personal glory. The artwork of the ancient world reflects the ebb and flow of the great civilizations that form the base of Western-European culture.

Each section in this chapter is intended as an introduction to the lecture and the detailed information contained within your textbook.

Prehistoric Art

Prehistoric refers to a time in human history prior to the development of written language or systems of writing. Art historians and archeologists therefore depend on the physical evidence left behind in order to gain access to and assess the meaning and intent of the artistic production of early humans. Because there is no written record, we make assumptions based on the body of evidence from discovered artifacts. However, decoding prehistoric art and its relationship to prehistoric culture is fluid and

continually being reassessed as new discoveries are made and scholars gain greater insight toward new interpretations.

The prehistoric period is divided into the *Paleolithic*, the *Mesolithic*, and the *Neolithic* periods. Paleolithic means "Old Stone Age" and comes from the Greek *paleos*, meaning "old," and *lithos*, meaning "stone." Mesolithic is the "Middle Stone Age," while Neolithic is the "New Stone Age." Scholars differ as to the dates these terms encompass, and as new information is gathered dates will continue to vary, but generally the Paleolithic period covers from 750,000–8000 B.C.E., Mesolithic from 8000–6000 B.C.E., and Neolithic from 6000–1500 B.C.E. (depending on what part of Europe is being considered).

The earliest art that we know of dates to about 35,000 B.C.E. Sometime during the last glacial period, while groups of hunter-gatherers were still living in caves, we see evidence of their artistic endeavors in both painting and sculpture which pre-dates architecture by at least 10,000 years. In other words, painting and sculpture had already attained a high degree of sophistication long before humans began to build structural habitats for themselves.

Paleolithic—Old Stone Age

The hunter-gatherer societies of this period wandered the plains of Europe following the herds and the seasonal vegetation. They lived in the openings of caves or under rock outcroppings. Some of their most dramatic works are the paintings found deep inside these caves. Pictures on the walls and ceilings are located in the most remote areas of the caves, far from the inhabited sunlit entrances.

For the most part, the images are of animals depicted in pigments obtained by grinding minerals into a fine powder and mixing them with fat or some other binding substance. The paint was applied to the walls and ceilings with a variety of methods. The creatures depicted are portrayed with an understanding of form and with dignity and pathos. They display strong, firm outlines and shaded contours to create roundness, dimension, and bulk to the image. Most of the figures are in profile and often incorporate a desire to capture the temperament and physical form of the animal. The high degree of sophistication of many of the images leads some scholars to speculate that artistic production may have taken place far earlier, and that these paintings are the product of an evolved development that further research will someday discover.

There is much speculation as to the meaning of these paintings. Some scholars believe that they were created for hunting magic, as the animals are sometimes shown pierced with arrows and in the throes of death, as if the artist/shaman was trying to create the magic for a successful hunt. Others believe that the images were used for clan affiliations or initiation rites.

Paleolithic sculptures of humans and animals were modeled from bone, antler, horn, ivory, stone, and clay. Sizes range from small hand-held figurines to large relief sculpture. Animal images take on more naturalistic forms, while the images of humans

are usually female and tend to be more abstract. These figures and figurines usually emphasize the female form in a pregnant state with large breasts, stomach, buttocks, and thighs. Again, there are several plausible interpretations of the purposes of these figures that range from fetish objects designed to symbolize magical abundance for a human population trying to survive in the harsh environment, to fertility goddess, earth mother, or goddess cult worship.

Mesolithic—Middle Stone Age

This period is considered to be a transitionary time between the Paleolithic and Neolithic periods. Formerly nomadic groups now began to settle in permanent or semipermanent locations and small agricultural communities began to be formed. This coincided with the receding glaciers that heralded the end of the Ice Age, a warmer climate, and the subsequent abundant growth of vegetation.

Neolithic—New Stone Age

Settling into communities and becoming herdsmen and farmers provided early societies with a secure food supply. Thus, people were not as reliant on the capricious forces of nature, but were able to control and stabilize their environment to a greater extent. During this time pottery, weaving, and spinning techniques were developed, as well as animal domestication, and basic methods of architectural construction in wood, brick, and stone. Cities such as Jericho were begun as early as 7000 B.C.E. and grew into walled and fortressed communities. Also during the Neolithic period the great colossal megalithic structures of the British Isles, such as *Stonehenge*, were built.

Whether a megalithic cromlech or a walled city, these structures required great planning, organizational and engineering skills, and communal cooperation over long periods of time. Thus, the groundwork for the development of the great civilizations of the ancient world was laid.

The Art of Ancient Egypt

The Egyptians established the first large-scale unified civilization in about 3500 B.C.E., and maintained it for over 3000 years. Religion and permanence are the elements that characterize the solemn, ageless art of Egypt and express the unchanging order that, for the ancient Egyptians, was divinely ordained. A belief in an afterlife and the divine kingship of the pharaoh are two factors that inform the art of ancient Egypt.

For the Egyptians, the overall preoccupation in this life was to ensure one's safety and happiness in the next. They believed that from birth on, each person was accompanied by a kind of other self (or eternal spirit) called the Ka. Upon the death of the fleshy body the Ka would live on in the afterlife. However, for the Ka to live securely it needed to recognize its earthly self. Thus, the dead body had to remain intact. Elaborate

embalming and mummification techniques and rituals were developed. Additionally, as far as a person could provide for it, all manner of earthly goods accompanied the body in the burial so that the Ka could be comfortably sustained for all eternity.

For the common person, a burial in the hot desert sands with a few items of jewelry might suffice. The heated sands provided a natural drying of the body and preserved it. However, for royal personages and aristocrats of the court a simple anonymous burial was unthinkable. Tombs were built to house these dead. Without the natural drying properties of the hot sand, the bodies would decay, so mummification techniques using linen cloth strips soaked in natron were used as a preservative. The internal organs were removed and placed in natron-filled vessels called canopic jars. The body cavity was then stuffed with preservative-saturated linen, and the exterior wrapped in natron-soaked bandages. The mummy was then placed in a single coffin or even a series of nested coffins for more important personages. Finally, these would be placed in a decorated stone sarcophagus. Images of the deceased, carved in stone and wood, were placed in the tombs so that in case the mummy deteriorated, the Ka would still have someplace to reside.

Grand tombs located in sacred necropolises (burial areas) and loaded with treasures, furniture, and food were provided for the deceased so that the Ka would live on with every comfort it had known in earthly life. We know a lot about Egyptian royal culture from tomb remains. Aside from the objects left with the mummy, the walls were elaborately painted with prayers, depictions of the deceased performing rituals to help the Ka pass into the afterlife, planting techniques, harvests, cloth weaving, and papyrus paper making. Records of royal reigns and achievements as well as papyrus scrolls and wall images documenting medical practices, administrative decrees, and records of commerce give us a picture of court life and culture.

The most recognizable Egyptian architectural structure is a pyramid. Perhaps the most famous are the three great pyramids at Giza. Giza was a necropolis complex on the west side of the Nile River across from the capital at Memphis. Built during the Old Kingdom, the largest and oldest of the three is that of the pharaoh Khufu. The base of the pyramid is 13 acres and it reaches a height of about 480 feet; 2,300,000 limestone and granite blocks, weighing between 2-1/2 and 50 tons each, were hauled to the building site on hand-pulled sledges rolled over logs, because the Egyptians did not yet have use of the wheel. The finished pyramid was covered in a facing of smoothly polished white limestone.

As one might imagine, pyramids were gigantic advertisements for the vast treasures contained within and were soon robbed. During the Middle and New Kingdoms royal burials were concealed in the cliffs of the Valley of the Kings and the Valley of the Queens. The most famous tomb discovery is that of King Tutankhamun of the 18th dynasty. The British archeologist Howard Carter discovered the tomb in the Valley of the Kings in 1922. Although Tut was a relatively minor king, his burial chambers are the only ones discovered to date that had remained relatively untouched for

more than 3,000 years. Therefore, Tut's tomb has given us a good idea of the opulence and luxury of a royal burial.

The forms and format of painting and sculpture that would remain the standard for the duration of the Egyptian state were established in the Pre- and Early Dynastic periods. Sculpture and painting follow a rigid formula for representing the human figure. Particularly when royalty or important personages are being represented, the person is depicted in a combined profile/frontal/profile view, thus giving the viewer an almost 360-degree view of the face and body. Often, the more important the rank, the larger the figure is in comparison to others in the picture. Paintings and relief sculpture are often organized into horizontal bands (registers), which are separated by groundlines to structure the images and information.

Typically, sculptures are constructed in rigid poses, either sitting or standing. The figures are compact, with limbs close together and a "webbing" of stone between the legs and between the arms and torso. This creates a heavy, cubic, and block-like bilateral symmetry that gives a strong presence and solid, stern immobility to the figure. Meant to be seen frontally, the bodies tend to be conceived in broad simplified planes with some degree of individualization in the faces.

The pharaoh was thought to be a god in human form. It was believed that he had control of the environment and the natural world as well as having absolute dominion over the entirety of Egypt. By the end of the Old Kingdom (about 2150 B.C.E.), the regular inundation of the Nile River had tapered off, and Egypt began to experience drought and famine. The aging pharaoh was unable to protect his empire from foreign invasions. The country became divided and fell into chaos as foreign rulers divided the land among themselves. This is called the First Intermediate Period.

Egypt was finally reunited under a single Egyptian ruler in about 1990 B.C.E. beginning the Middle Kingdom period which covers dynasties 12–14. Within the parameters established by the artistic formulas of the Old Kingdom dynasties, Middle Kingdom art tends to exhibit more of the inner nature of the sitter—giving a somewhat deeper psychological and emotional "reading" when compared to the remote and distanced expressions of earlier works. This is not surprising as Middle Kingdom pharaohs had lost some of the aura of "divinity" that had surrounded Old Kingdom rulers. Thus, artists depict them with a humanity not usually seen in earlier works.

At the end of the 14th dynasty (about 1700 B.C.E.), the Middle Kingdom broke apart, and Egypt descended into another period of chaos known as the Second Intermediate Period. Again, foreign invaders devastated the Egyptian armies and established their own rule. Eventually, matching their armor and weapons to those of their enemies, and developing the use of the wheel to construct chariots, the Egyptians rose up once more to chase their foreign oppressors out of their kingdom and well into Mesopotamia. The 18th dynasty (beginning about 1550 B.C.E.) ushered in the New Kingdom, and a period of expansion as opposed to the earlier isolationist policies of the Old and Middle Kingdoms.

The New Kingdom monarchy of the 18th dynasty reestablished the ultimate role of the pharaoh in the cosmic order of Egyptian beliefs, in part by forming an alliance with the powerful priesthood of Amun-Ra. The priesthood was enriched by the royal court while they reciprocated by upholding the divinity of the pharaoh. Artistically, there was a return to the rigid monumentality and stylistic conventions of Old Kingdom art that reinforced the ideas of timeless, ageless permanence.

However, for a brief period in the 18th dynasty, the radical religious reformer Akhenaten encouraged a temporary loosening of artistic conventions. Akhenaten closed the old temples of Amun-Ra while establishing a new monotheism with the cult of Aten. He established a style that, although still formalized in concept, was more naturalistic, curvilinear, and freer. This style is called the "Akhenaten Style" or the "Amarna Style" (after the location of his capital city).

Upon Akhenaten's death, the religious and artistic reforms he instituted gradually reverted back to the previously established conventions of the Old Kingdom. We see some vestiges of the "Amarna Style" in the art found in the tomb of Tutakhamun (successor to Akhenaten). The softer, more rounded forms, the breaking away from the rigid frontal compact pose, and the more individualized—less idealized features are all influenced by Akhenaten's earlier artistic changes. However, by the 19th dynasty and the court of Ramses II (traditionally the pharaoh during the time of Moses), artistic conventions of Egyptian art had reverted to the standards of the Old Kingdom, continuing in that vein until the advent of Christianity.

The Art of Mesopotamia

Mesopotamia (the modern Middle East) covers the entire territory between the Tigris and Euphrates Rivers, and is bordered on the south by the Persian Gulf and to the North by modern day Turkey (called Anatolia when referring to antiquity). The name is derived from the Greeks and means "the land between two rivers." The art/artistic styles of this region can be divided chronologically by the great empires and civilizations that ruled it at various times.

The earliest of these were the Sumerians who controlled the southern portion of Mesopotamia. Unlike the Egyptians, who ruled with a centralized governmental structure, the Sumerians created a city-state system. Individual cities within the region operated as separate political units, although they were united by a common framework of religious beliefs and language. The organization of Sumerian government within each city-state can best be described as "theocratic socialism." Each city-state was ruled by a deity or deities, who were thought to reside in the temple which was set in the center of the city and built atop a man-made mountain of mudbricks called a "ziggurat."

The idea of "mountain" was an intensely sacred one for the Sumerians, as the waters of the Tigris and Euphrates rivers flowed from the mountains, the earth was conceived as a huge mountain, and the Great Mother goddess Ninhursag (goddess of

the earth) was called the "Lady of the Mountain." The communal effort needed to create such a huge structure that reached to the heavens and provided the "home" of the gods and goddesses of each city-state was seen as a way for humans to connect with their deities and provide a transitional space between heaven and earth.

The temple on top of the ziggurat and the buildings around it not only provided the centralized religious focus of the state, but also served as the administrative center. Citizens labored for the city-state and administrators of the city-state distributed goods and services to the citizens. The ruler was seen as the liaison between the ruling deities and the citizens, and often the fortunes of the city-state were thought to be directly linked to the quality of the relationship between the ruler and the gods.

The Sumerians were masters at working with gold and semiprecious stones displayed in an inlay technique. Sacred objects as well as everyday items were decorated with inlaid patterns. Unlike their Egyptian contemporaries, when depicting the human form they adopted an abstract and stylized format that simplified the human figure into cone and cylinder shapes. Facial features were generalized and simplified with large oversized eyes dominating the face.

The next group to control the region was the Akkadians. They came from the middle area of Mesopotamia, and under Sargon of Akkad, they were able to conquer each of the Sumerian city-states and bring them under Akkadian rule into one united kingdom. Artwork under Akkadian rule shifts to a more vigorous and definitive style, with detailed texturing that produced strong individualized portraits and commemorative historical narratives.

Under the leadership of Hammerabi, the old Sumerian city of Babylon gained control of the region, overthrew the Akkadians, and formed a vast empire. Hammerabi is famous for his codification of the confusing, often conflicting, unwritten laws of the regions over which he reigned. As seen in the *Stele Code of Hammerabi*, Babylonian art tends to be a combination of both Sumerian and Akkadian stylistic trends. Like the Biblical Moses, the stele (an upright commemorative stone with carved relief) depicts Hammerabi atop a mountain receiving the law from the flame-shouldered god Shamash. Below, the law is written in cuneiform (triangular or wedge-shaped characters used in Mesopotamian scripts).

While the Hittite Empire was thriving in Anatolia, the Assyrians from Northern Mesopotamia succeeded the Babylonians in controlling the region. The Assyrians were a warlike people whose artwork emphasizes the conquests of their leaders over the various groups within the area and beyond. In detailed low or bas-relief, the Assyrians developed the art of long narratives, depicting in scrupulous detail their military exploits and ritual lion hunts. Assyrian art is characterized by richly evocative scenes, strong lines, and intricately textured renderings. One of the most enduring of Assyrian forms is the lamassu. The lamassu are gigantic guardian figures with the bodies of a bull or lion, fierce bearded human faces, and huge diagonal wings sweeping across the bodies. They were placed at the entrances to the citadels to ward off enemies and evil spirits.

When Assyria fell in 612 B.C.E., the city of Babylon again flourished for about seventy years before it was finally conquered by the Persians. The revival of Babylon is called Neo-Babylon. This is the Babylon talked about in the Bible and ruled by the most famous king of Babylon, Nebuchadnezzar. Under Nebuchadnezzar, the Tower of Babel (the 270-foot-high ziggurat and temple complex talked about in the Bible), and the Hanging Gardens of Babylon (considered to be one of the seven wonders of the ancient world) were built. The *Ishtar Gate*, a triumphal arch through which worshippers had to pass before beginning the ritual march along the sacred way to the temple complex, was built of brilliant blue and gold glazed and molded bricks creating an elaborate heraldry of Babylonian gods and goddesses.

The Neo-Babylonian Empire fell to the Persians about 539 B.C.E. By the end of the 6th century B.C.E., Persia was the largest empire the world had yet seen. It reached from the Indus River to the Danube River, and beyond the Nile. The Persian Empire was founded by Cyrus the Great, who established the Achaemenid Dynasty (named after Cyrus's mythical ancestor Achaemenes).

The Persian Empire reflected both the diversity of its subjects and the unifying ambition of its rulers. The Persians were brilliant at effecting a synthesis of styles derived from the many areas and peoples within its vast realm. Thus, in Persian art there is an amalgam of design elements that includes a variety of cultural styles brought together as a unified whole. The various designs and images of the palace at Persepolis illustrates this fluid synthesis of stylistic influences.

Persepolis was destroyed by Alexander the Great in the late 300s B.C.E., as a symbol of Greek domination over this once great and expansive empire.

Art of the Aegean

While the Egyptians and Mesopotamians were developing and flourishing, three cultures in the area of the Aegean Sea were also expanding. The art of the Aegean is comprised of three major groups of the Bronze Age (3000–1200 B.C.E.). They are the Cycladic culture which was based on the Cyclades Island of the Aegean, the Minoan culture on the island of Crete, and the Mycenaean culture of the Greek mainland. All three societies are the forerunners of the Greek civilization.

The Greeks regarded these Bronze Age cultures as an "age of heroes." Many aspects of these three Aegean civilizations were passed down to the Greeks as hazy memories and heroic tales passed along over hundreds of years through an oral history of legends and mythology. Many of these tales were finally written down in the 8th century B.C.E. by Homer in his two great epic poems the *Iliad* and the *Odyssey*.

Aegean culture was only discovered in the late 1800s. Prior to that, it was thought that the stories from this area were purely mythological. However, in 1870 Heinrich Schliemann began to search for the legendary city of Troy, the site of the Trojan War from Homer's *Iliad*. He found Troy in Turkey, and was able to substantiate, to a large extent, many of the details in Homer's tale. Later he focused on the Myce-

naeans, discovering Mycenae on the Greek mainland. In 1899 Sir Arthur Evans, again trying to substantiate some degree of fact from Greek mythology, went to Crete and discovered the Palace of Knossos, naming the civilization Minoan after the mythological King Minos.

Most of what we know of these Aegean cultures comes from the archeological evidence. Apparently the people of the Cyclades had no written language, while the Minoans and the Mycenaeans used a written language we call *Linear A*, which was developed about 2000 B.C.E. *Linear A* has never been deciphered, and it is thought that this script encompasses the historical, religious, and cultural records. Later, around 1400 B.C.E., *Linear B* was developed. This has been translated, but it is a script that was apparently restricted to administrative tasks.

The Cycladic islands produced marble sculptures of rigidly standing female figures and male figures usually playing musical instruments. Both are highly schematized so that all the organic forms have been converted into geometric shapes. Triangles, rectangles, ovals, and cylinders dominate the images. Cycladic figures are simplified and streamlined to the point that they almost look modern in their emphasis on pared down structure and minimalist composition.

On Crete, the Minoans built huge multilevel labyrinth-like palace complexes. The largest and most intricate is at Knossos, a short distance outside the modern city of Irakleion. The Minoans decorated their palace walls in true (buon) fresco technique. Minoan frescos are characterized by lively, naturalistic forms done in a fluid, spontaneous, and rhythmic style. The subjects are scenes from palace life and scenes of the natural world. They were particularly fascinated by aquatic life, reasonably enough, as they were a seafaring society. Fanciful renderings of sea creatures appear on walls and pottery, while powerful renditions of bulls both in sculpture and fresco attest to the importance of that animal in ceremonies, rituals, and sacrifices. The Minoan civilization was destroyed in a series of earthquakes occurring between 1700 and 1500 B.C.E., a weakened infrastructure, and the subsequent invasion of the Myceneans.

The society that developed on the Greek mainland is called Mycenaean (after the most powerful of the city-states, Mycenae). The Mycenaeans built great fortified palaces on hills overlooking vast plains in order to defend themselves. Mycenae is entered through the *Lion Gate*; the massive post and lintel gateway is crowned with a corbeled arch incorporating two stone lions in the central triangle. Inside, and to the right of the *Lion Gate* is *Grave Circle A*, an immense circle of gigantic stones surrounding a grave shaft. Perhaps the most impressive Mycenaean structures are the "beehive" tombs. These are conical-shaped domes built with the corbel technique. The *Treasury of Atreus*, named for a mythological hero of the Trojan War, was the largest dome built until the Romans built the *Pantheon* in 118 C.E.

Mycenaean painting and sculpture are clearly influenced by Minoan aesthetics, yet bring to it a more geometric angularity while emphasizing the tension of angles and abrupt changes of plane. This fierce and warlike society is reflected in the vigorous designs, powerful patterns, and dynamic imagery of their artwork.

Mycenaean power began to decline sometime around 1200 B.C.E. as they experienced an economic slump, power struggles and fighting among the palace states, and an invasion of tribes from the north called the Dorians. The Dorian invasions brought an end to the Aegean cultures and ushered in a period of about 400 years (c. 1200–800 B.C.E.) that scholars refer to as the "dark ages." Writing skills were lost, and artistic skills significantly diminished. When the Greeks eventually arose from the ashes of cultural destruction, they would emerge an even greater society, having a lasting impact and influence on every aspect of Western-European art and civilization.

Greek Art

Much of Western-European culture and artistic traditions are based on the principles established by the ancient Greeks, particularly the Greeks of the Classical or Golden Age (c. 480–323 B.C.E.). Under the leadership of the general and statesman Pericles, Athenian troops helped to defeat Persian invaders in 479 B.C.E. Having freed themselves of this threat, the Greeks experienced an "explosion of creativity that resulted in an unparalleled level of excellence in art, architecture, poetry, drama, philosophy, government, law, logic, history, and mathematics" (Strickland, *The Annotated Mona Lisa*, p. 12).

From their early beginnings, the Greeks contributed key knowledge in many areas. Socrates, Plato, and Aristotle developed the academic discipline of philosophy. The playwrights Aeschylus, Sophocles, Euripides, and Aristophanes established the theater arts in both tragedy and comedy. Herodotus became the first historian and set the foundation for historical studies. Poetry, beginning in the 8th century B.C.E. with Homer and Hesiod, continued with Sappho and into the Classical Age with Pindar. Hippocrates, considered the "father of modern medicine," defined the field, summed up previous knowledge, made key medical observations and developments, and formulated medical ethics. Parts of the Hippocratic Oath are still used today. Scholars like Archimedes, Pythagoras, and Euclid (who originated the Golden Section/Mean) had a huge effect on the development of modern mathematics. The scientific disciplines of astronomy, biology, botany, physics, and zoology were vastly expanded by the Greeks. Many of our key concepts in art and architecture, government and democracy, education, and language come down to us from ancient Greece.

Ideas about human dignity and worth—the concept of the self and the value of humanity—led the Greeks to create images of the human form that became the central motif of Greek art from its earliest manifestations in the Geometric period to its latest in the Hellenistic period, and became fixed within the western artistic tradition. Order, reason, logic, beauty, balance, and simplicity were the ideals that Greek society strove for. These were visually manifested in their artistic achievements, and particularly reflected in the endeavors of the city-state of Athens.

Greek art is divided into phases. The *Geometric* period (9th–8th centuries B.C.E.) is the earliest phase that we can positively identify as Greek. Depiction of, and fasci-

nation with, the body in Greek art begins here. In vase painting the figures are rendered in flat, abstracted silhouettes composed of triangles, ovals, and cylindrical shapes contained within registers alternating with horizontal bands of geometric designs. These figures rapidly gain in bulk and movement as the Greeks seek greater naturalism in their art.

The *Archaic* period (600–480 B.C.E.) is the next phase, where all of the general attributes that will become recognizably Greek are being formulated. The definitive style that develops in the Archaic period is representative of the cultural heritage and societal values that lead to later phases of Greek art and profoundly influence the Western tradition.

Sculptures of both the male (*kouros*) and female (*kore*) figures are constructed with the same "arrested walk, stiff frontality, and bilaterally symmetrical poses" as that of Egyptian works. Yet, already the difference is clear. These are free-standing figures, detached from the block of stone from which they were carved, and fully in-the-round. Without the "webbing" of stone between the legs and the torso and arms, they are liberated from the stone and humanized. In learning to master the workings of the body, Archaic sculptors had not yet mastered facial expression, so images from this period display a generic expression called the *archaic smile*.

An example of Archaic sculpture, known as the *Dying Warrior* from the pediment of the *Temple of Aphaia, Aegina,* c. 490 B.C.E., illustrates the final phase of Archaic sculpture and the shift to the Classical period. Here, the elements of the body have been successfully worked out. Notice the details of veins and musculature. Yet, the figure still displays the "archaic smile" even in the throes of death.

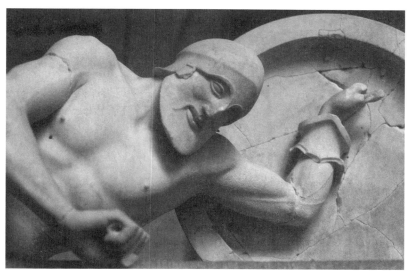

© Adam Woolfitt/CORBIS

The Archaic Smile.

Black-figure and *red-figure* vase painting are developed during this time, each progressively allowing the artist more freedom to naturalistically depict the figure, drapery, and narrative elements. As the Archaic period comes to a close, figures, in both sculpture and painting, become increasingly anatomically accurate, while implied movement and a variety of stances and activities are experimented with.

The *Classical* period (480–323 B.C.E.) is also known as the Golden Age of Greece or the Age of Pericles, after the Athenian leader who championed democracy and encouraged free thinking and artistic innovation. During this time, the Greek understanding of the self was expanding and is reflected in the perfection of artistic expression as manifest in the human form. The goal was to create sculpture that possessed a high degree of naturalism and to combine that with idealism—the *Classical Ideal*. In other words, artists wanted to show the natural human form as it would look if nature were perfect. This goal in art reflects a society where "man is the measure of all things" and must strive to be the very best that is possible, both physically and intellectually.

During this phase, the faces are given a beautiful symmetry and calm nobility. This, too, mirrors societal concern for a certain maintenance of dignity and composure that the Greeks perceived as the proper emotional control necessary under all conditions. The impassive and balanced expression on the faces of works of this period is called *classical calm*.

Classical art is divided into Early Classical (about 480–450 B.C.E.), which is a transitionary phase from the Archaic period, the High Classical (about 450–400 B.C.E.), which is the full-flowering of the Classical style, and the Late Classical (about 400–323 B.C.E.), which refines the Classical phase and begins to introduce some of the attributes that will be seen in Hellenistic art.

Early Classical (also called the "Severe Style") is characterized by sculptures with reserved, remote expressions set in large heavy faces. The body is being worked on and understood, and the contrapposto pose is developed. This pose visually describes the experience that we have of our own bodies in a resting stance, with one leg supporting the weight of the body and the other providing the balance. This is a tremendous breakthrough. Once the Greeks had enough understanding of how the human body works to show it in the contrapposto pose, they had also acquired the skill to show the human body in any pose they wished.

The Classical phase of Greek art develops architecture and the idealized human figure to its peak, and exemplifies the Greek ideals of order, harmony, and balance through mathematical proportions and ratios. Architectural orders, begun in the Archaic period, are perfected in the Classical. There are three architectural orders created by the Greeks: Doric, Ionic, and Corinthian. They are discernable by the unique capital that each possesses. Greek temple architecture is based on a post and lintel system. Like sculpture, the temple structure works with light and shadow, positive and negative space, visual rhythm, and involvement with its surroundings. Meant to be seen from the outside as a type of sculptural mass, peripteral buildings such as the *Parthenon* set the standard for much that will follow.

Late Classical art is a refinement of the previous phase. Here, the proportions are elongated and sensualized. Poses become more complex and contrasting textures are emphasized. The classical calm gives way to a certain amount of depth of feeling in the facial expressions, and the psychology of the figure begins to be hinted at. These attributes pave the way toward the more dramatic and emotionally charged images of Hellenistic art.

The *Hellenistic* phase (323–331 B.C.E.) introduces an expanded understanding of the human psyche and brings elements of pathos, emotion, drama, and psychology into the artwork. Hellenistic art begins with the conquering of mainland Greece by Alexander the Great from Macedonia. Alexander spread Greek culture and art throughout the ancient world as he conquered Asia Minor, Mesopotamia, Egypt, and parts of Europe.

Greek traditions mingled with the artistic traditions of other cultures, and the artwork that developed from this interchange is called Hellenistic. The complexity of the human being as a "whole" is comprehended and depicted. At this point, artists are able to successfully merge the physical, emotional, and psychological aspects of individual and group dynamics (see Chapter 1). Intensely energized movement, compelling empathy, complicated poses, high drama, and technical virtuosity are all aspects of Hellenistic art.

Greece was incorporated into the Roman Empire in 146 B.C.E. Yet, despite the ebb and flow of political power, the rise and fall of states, and the reconfigurations of national borders, Greek art continued to be an essential influence throughout history on the art and architecture of Western Europe.

Etruscan Art

The Etruscan civilization occupied the central part of Italy in the area of Tuscany, although their influence and control extended to the Adriatic. The Etruscan political structure was similar to that of the Greeks in that the Etruscans were organized into independent city-states loosely united by common language and religious beliefs, but were often at war with one another. Emerging about 900 B.C.E., their origins are obscure. Some scholars believe they arrived on Italian soil about 1200 B.C.E. from Asia Minor. Others theorize that they were indigenous to the area and part of or in addition to another ancient indigenous group known as the Villanovans.

Although Roman writers tell us about the rich literary tradition of the Etruscans, most of their writing has been lost, and what does remain has never been satisfactorily translated. Much of what we know about the Etruscan culture comes from tomb chambers where sculptures, scale models of houses and temples, furniture, and wall paintings have been found. Family tombs were underground structures arranged in neatly organized necropolises. Burial practices alternated between cremation and sarcophagus burial. Cinerary urns crowned with the abstract image of the face of the deceased are found along with terracotta sarcophagi decorated with life-size depictions of the bodies contained within.

Etruscan sculpture was influenced by Archaic Greek art. The Greeks had settlements in Southern Italy and Sicily and there is evidence of trade between the two groups. Unlike Greek sculpture, which was created in marble or bronze, the Etruscans worked in terracotta. Like Greek sculpture of the Archaic period, Etruscan sculptures display the "Archaic smile." Yet, unlike their Greek counterparts, there is a liveliness of gesture and a directness of gaze that keeps the figures firmly rooted in our own emotional and psychological space. Sculptures and paintings alike possess exuberance. We see a bold intensity that breaks from the controlled images and stiff frontality of Archaic Greek forms. Additionally, Etruscan images reflect little concern for the harmonious proportions and idealized humanity of Greek art.

Because they were constructed of wood or mud brick, little remains of the temple structures of the Etruscans. Influenced by the Greeks, they created their own unique style of temple architecture that would, in turn, influence the Romans. Temples were set on high platforms with one set of stairs in the front leading onto the platform and a deep portico entrance into the cella. Columns were placed upon the platform at the façade of the temple rather than encircling it, while the cella walls extended the width of the platform. A low, gabled roof was most likely decorated with sculpture, as the pedimental area did not allow enough space for it.

The Etruscans began to lose territory to the Romans who threw out their Etruscan ruler in 509 B.C.E. and established the Republic of Rome. By about 100 B.C.E., Rome had completely absorbed the Etruscan city-states into their Empire.

Roman Art

Almost from the beginning of their rise to power, the Romans were aware of Greek art and were profoundly influenced by it. In 146 B.C., Greece became a province of Rome. Greek marbles and bronzes were imported to Rome to adorn mansions and villas. When the supply ran out, the Romans had copies made. As the Roman poet Horace wrote: "Conquered Greece led her proud conqueror captive." However, Roman art is not merely a slavish copy of Classical Greek forms. Roman art took what it needed from Greek art and made it uniquely its own. For example, the *Classical Ideal* is applied to individual portraits of civic leaders, thus implying, in the elegance of form, a grand magnificence and legitimacy of purpose. Ideas that the Romans held dear, such as concepts of law, state, politics, practicality, attention to duty, disciplined valor, and obedience to authority are expressed through their art and architecture.

Roman art is less idealized and intellectualized than Classical Greek art. It is more secular and functional. Much of Roman art was created to express the imperial role of an empire that stretched from England to Egypt and from Spain to Mesopotamia and Southern Russia. Grand administrative and civic buildings, along with massive public works projects were carried out. Designed to provide visual splendor and organized functionality, these building projects reflected the power and majesty of the Empire in all spheres of public life.

The Romans excelled in feats of engineering skill. They utilized the arch to a greater extent than ever before, and from the arch, developed the dome, the barrel vault, and the groin vault. These forms, coupled with the Roman development of concrete, allowed them to create the architectural structures and utilitarian projects that announced the magnificent empire and were profoundly influential to subsequent Western-European architecture. Domed temples and the rectangular basilica forms became key elements of the Christian church. Coliseum construction, based on the original Roman structures, is still used today.

The Roman Legions were some of the fiercest warriors, expanding territory and wealth with ruthless precision and ambition. However, once conquered, they brought these areas the practical benefits of roads, bridges, sewers, and aqueducts. Roman statesmen sought to raise their deeds to mythological status through political advertisements that took the form of the triumphal arch, the column, the equestrian statue, and busts and life-size statues of emperors, politicians, and military leaders.

Roman portrait sculpture was flexible, ranging from ultra realism to idealism to subtle psychological readings. Often, Roman art not only reflected the personality or

© Image courtesy of Corel

Roman wall painting.

political message of the person being portrayed, it also told a great deal about the state of the empire. As Augustus Caesar united the empire, Rome entered an expansive period of growth. The classical ideals of the Greeks were combined with Roman values to produce a uniquely political art that voiced imperial authority. In contrast, as the Roman Empire began its decline, and assassination became the preferred means for the transfer of power, portraits began to convey the harsh realities and cruel abuses of the times.

Roman artists were capable of creating masterful wall paintings. Walls seem to dematerialize and become "windows" into another fully three-dimensional world. Roman painters mastered tricks of perspective and the effects of light and shadow that created believable effects of recessional depth and rounded "plastic" forms. Although true linear perspective would not be discovered until 1425 C.E., the Romans used such devices as diminutive, overlapping, vertical, foreshortening, and herringbone perspective to create a believable third dimension on a two-dimensional surface.

As the Empire moved into the late 3rd century C.E., it became increasingly difficult to control its vast territories and diversity of peoples. Centralized governmental infrastructure was faltering, Christianity was spreading, and nomadic tribes were battering the borders. By the early 4th century C.E. Rome was clearly in jeopardy. Compelling forces were at work that would change the dynamics of power, crush the Empire, and usher in a new era.

Early Christian Art

In 313 C.E., Emperor Constantine declared Christianity the official state religion. This was a particularly wise political move, as the Roman Legions and the general population were permeated with secret Christian groups unwilling to uphold the notion of the divinity of the emperor and the old order of "pagan" religious practices. However, when Constantine put the *Chi-Rho-Iota* (the first three letters of Christ's name in Greek) on his military banners, these same groups became his most loyal soldiers and supporters, for now they were fighting for God and their religious convictions.

Old artistic and architectural forms were pressed into the service of a new art form: Christian art. In Early Christian art, we see figures that evoke a standard of classical types, but a new aesthetic is at work. Classical norms are only conceptually realized. Figures begin to be distorted and schematized. They suggest human prototypes, but their resemblance to a realistic depiction stops at a certain point. There is an anti-naturalistic tendency in Early Christian art that proves to be one important source for the art of the Middle Ages. For Early Christian artists, the focus was moving away from "life on earth in the here and now" to a contemplation of and a striving for a heavenly "afterlife" as depicted in the scriptures. Therefore, it was the *idea* of a thing, not the reality of it, that became important. Artists were representing a "world of the

spiritual," and therefore consciously wished to depart from visions of earthly reality and precise replicas of the human form that drew too close a reference to "pagan" art.

Early Christian artists expanded the mosaic form. Although used in the ancient world, the Early Christian (and later the Byzantine) mosaics made use of glowing glass cubes (tesserae) in a wide range of colors, rather than the opaque earthtone marble cubes used in earlier mosaics. The flatness of the wall surface was emphasized to achieve an "illusion of unreality"—a luminous realm peopled by celestial beings or symbols. The concern was not with the exact representation of external reality, but rather with such ideas as the biblical history of salvation or the heavenly promise of everlasting life.

The dome and basilica format, so powerfully evocative of the power and glory of the Roman Empire, were now pressed into the service of the Christian church. Domed buildings based on the *Pantheon* model served as mausoleums and baptisteries, while the basilica form, the architectural structure used for official administrative buildings, was translated into church architecture. Adding a *transept* created the "sign of the cross" so that the entire building visually mirrored this ubiquitous Christian symbol. The apse area, used before for the most important business within the building, now became the area where the most sacred ceremonies occurred. Thus, there was a transference of meaning and an association of meaning between this newly embraced religion and the grandeur of Rome at its height of power.

As the Roman Empire began to disassemble in the 4th century A.D. and nomadic tribes invaded, the main routes of trade moved to the east. Emperor Constantine relocated the capital of Rome to the city of Byzantium in the eastern part of the Roman Empire in 330 C.E. He renamed the city and called it Constantinople. (It is now Istanbul in modern-day Turkey.) Constantine felt that the city of Rome was too vulnerable to invasion and upheaval to continue to be an effective administrative center. Again, this was a wise decision as the city experienced several devastating incursions before ultimately falling to nomadic groups in 476 C.E. The eastern part of the old Roman Empire remained securely intact. As Western Europe broke apart, the Byzantine Empire continued on until 1453 when it finally fell to the Ottoman Empire.

As the west fell, the Byzantines continued to view themselves as the surviving eastern part of the Roman Empire carrying on those traditions. In the west, nomadic artistic styles, brought by the invading tribes, the echoes of the great classical civilizations, and Early Christian artistic styles all combined to form the art of the Middle Ages in Western Europe.

Byzantine Art

While Rome was being overrun and conquered, the Byzantine Empire became the center of a brilliant and opulent civilization, combining classical Greek and Roman forms, Early Christian art, and the artistic traditions of the eastern regions such as

Asia Minor and the Near East. The Christian church split into the Eastern Orthodox Church, and the Catholic Church in the west. The Pope, leading the Catholic Church, also became a powerful political figure that crowned the heads of European states. The Patriarch, as the head of the Orthodox Church, was under the leadership of the emperor, much in the same way that the Roman Empire had operated.

Byzantine art moved away from Greco-Roman naturalism, while still retaining such illusionistic devices as shading and shadows. It also embraced Early Christian motifs and aesthetics, adhering to a strict formula designed to maximize the religious message of salvation. Images of saints, called icons, were painted on small wooden panels. These icons were vehicles for meditation through which the worshiper could spiritually communicate with the divine. Lavish mosaics decorated the interiors of churches. With sumptuous grandeur, Christ, saints, and angels were depicted on shimmering golden backgrounds.

In Byzantine art, human figures are rendered in a flat, stiff, and symmetrical manner. They have solemn expressions, small heads and feet, and large eyes gazing straight ahead. Glances and gestures are more important than dramatic movement or three-dimensional form. Symbolic significance is important as these images and icons were designed as a window into the world of the spirit.

The mosaic program within an architectural setting was designed to adhere to strict principles that reinforced religious beliefs and reconfirmed for the worshiper his/her place within the cosmic order of the universe. Images relate to one another through gesture, glance, and placement on the interior architectural components, connecting biblical stories in a hierarchical format. Additionally, the images relate to the viewer through their frontal presentation and the use of inverse perspective.

Because the interior of the church is considered to be a microcosm of the universal order of things, the relationship between the images and the architecture plays an important function. The interior of the dome, covered in golden tesserae, is the dome of heaven where Christ ultimately sits in majesty and dominance over both heaven and earth (the lower parts of the church). The history of salvation is represented on successive elevations of interior architecture, moving up toward the dome as the more important elements of the story are depicted.

The aesthetic influences of Byzantine art on Western Europe would gain prominence during the Middle Ages. One of the most important Byzantine churches is San Vitale in Ravenna, on Italian soil. The mosaics here would provide visual inspiration to medieval artists. Furthermore, crusaders, passing through the Empire on their way back from the Holy Land, would bring icons and other works of art into the west that would inform and stimulate artistic development.

Clarity and visibility are important so that the viewer immediately gets the message. The architecture plays an important role in enhancing this aspect. Furthermore, the church is seen as the physical embodiment of the universal realm on earth where the Christian drama of salvation is played out. The church becomes the microcosm of the macrocosm.

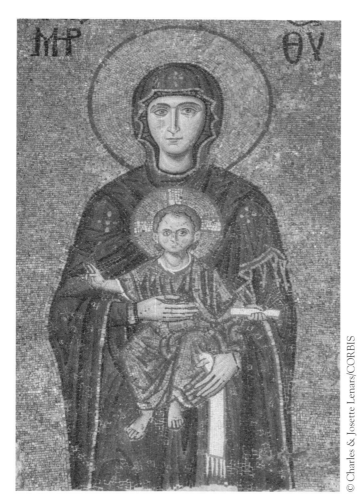

Virgin and Child, Byzantine Mosaic, *Hagia Sophia*, 547 C.E.

DISCUSSION QUESTIONS

1. Analyze the representation of the human form in the prehistoric "*Venus*" figurines and the sculptures from the Cycladic Islands. Describe how shapes are used to construct each. In each case how is abstraction used to express the figure?

2. Describe the significance of the *Palatte of Narmer* both stylistically and historically. Draw reference to visual examples within the work that support your observations and ideas. How does this piece establish stylistic conventions for subsequent Egyptian art?

3. List the general stylistic traits of the Amarna Style. How do these differ from Old Kingdom art?

4. Using the *Step Pyramid of Zoser* and the *White Temple* (or any pyramid and ziggurat) discuss the significance, use, and meaning of the pyramid versus the ziggurat within their respective cultures. How does each express the sociocultural/religious/political context in which it was created?

5. Pick an Assyrian relief to compare with a Minoan fresco. What are the identifying stylistic characteristics? How does each use line to describe the figure? What are the differences? How does each work fit into what you know about the culture?

6. Take a look in your text and compare the Archaic Greek kouros figures with Egyptian sculpture. Pinpoint the similarities and differences.

7. Compare an Archaic kouros with the *Kritios Boy*. Describe the changes in the depiction and the details of the human form. Discuss the change in body position and stance. What aspects of the *Kritios Boy* seem related to the Archaic period and what aspects seem related to the Classical period?

8. Compare the *Doryphorus* with the *Augustus of Primaporta*. How is the Classical Ideal of the Greeks combined with Roman values? What is the outcome? What aspects of Augustus are idealized? How does the work imply imperial and divine status? How does the artist attempt to humanize Augustus?

9. Compare the *Doryphorus* and *Augustus of Primaporta* with the *Sarcophagus of Junius Bassus*. How do the figures on the sarcophagus evoke a standard of classical types? Would you describe them as realistic? abstracted? How so? Do you see Christian symbolism? Do you see references to Roman mythology? What is the effect?

10. Compare and contrast the *Parthenon* to the *Pantheon*. How does the *Pantheon* reference Greek temples? How does each utilize interior and exterior space? How does the *Pantheon* create a visual connection between interior and exterior space, and between the upper and lower regions of the interior? How does the *Parthenon* display visual rhythm and integration of the individual elements? How does this compare to the *Pantheon?*

11. Consider Roman wall painting as compared to Byzantine mosaics. How is depth conveyed in each? What role does surface design play? How is the figure modeled? What is the relationship between the figure and the drapery? What illusionistic devices are used in each and to what effect?

BIBLIOGRAPHY

Bandi, H.-G. *Art in the Ice Age*. Praeger, 1953.

Bataille, G. *Prehistoric Painting Lascaux and the Birth of Art*. Skira, 1955.

Boardman, J. *Greek Art*. New York: Thames & Hudson, 1989.

Brilliant, R. *Arts of the Ancient Greeks*. New York: McGraw-Hill, 1972.

Cheremeteff, Maria. *Readings in Art History*. Dubuque, Iowa: Kendall/Hunt 1998.

Frankfort, H. *Art and Architecture of the Ancient Orient*. England: Penguin, 1963.

Freed, R., Markowitz, Y., and A'Auria, S. *Pharaohs of the Sun*. Boston Museum Arts, 1999.

Ghirshman, R. *The Art of Ancient Iran*. New York: Golden Press, 1964.

Giedion, S. *The Eternal Present: The Beginnings of Art*. Pantheon, 1957.

Graves, R. *Greek Myths*. London: Penguin, 1984.

Guintoli, S. *The Art and History of Pompeii*. Italy: Bonechi Press, 2001.

Hawass, Z. *Valley of the Golden Mummies*. Abrams, 2000.

Higgins, R. *Minoan and Mycenaean Art*. Praeger, 1967.

Holloway, R. *A View of Greek Art*. Harper and Row, 1974.

Kahler, H. *The Art of Rome and Her Empire*. Greystone, 1965.

Kitto, H. *The Greeks*. Penguin, 1976.

Kitzinger, E. *Early Medieval Art*. Indian University Press, 1964.

Lehner, M. *The Complete Pyramids*. Thames & Hudson, 1997.

Lloyd, S. *The Art of the Ancient Near East*. Praeger, 1961.

Matz, F. *The Art of Crete and Early Greece*. Greystone, 1962.

Metropolitan Museum of Art, *Treasure of Tutankhamun*. 1976.

Metropolitan Museum of Art, *Women of Ancient Egypt*. 1997.

Michner, J. *The Source*.

Moortgat, A. *The Art of Ancient Mesopotamia*. Phaidon, 1969.

Murray, M. *The Splendor That Was Egypt*. Praeger, 1964.

New York Graphic Society. *The Search for Alexander*. 1980.

Parrot, A. *The Arts of Assyria*. Golden Press, 1961.

Parrot, A. *Sumer: The Dawn of Art*. New York: Golden Press, 1961.

Pollitt, J. J. *Art and Experience in Classical Greece*. Cambridge University Press, 1976.

Pollitt, J. J. *Art in the Hellenistic Age*. Cambridge University Press, 1986.

Poulsen, V. *Egyptian Art*. New York Graphic Society, 1968.

Powell, T. G. E., *Prehistoric Art*. Thames & Hudson, 1966.

Quennell, P. *The Colosseum*. New York: Newsweek, 1971.

Raftery, B. (ed.). *Celtic Art*. New York: Unesco/Flammarion, 1990.

Rasmussen, T. and Spivey, N. *Looking at Greek Vases*. Cambridge, 1997.

Richardson, E. H. *The Etruscans: Art & Civilization*. University of Chicago, 1976.

Russmann, E. *Eternal Egypt: Masterworks of Ancient Art from the British Museum*. University of California Press, 2001.

Shaw, Ian and Nicholson, Paul. *The Dictionary of Ancient Egypt*. British Museum, 1995.

Silverman, D. (ed.). *Ancient Egypt*. Oxford University Press, 1997.

Slatkin, W. *Women Artists in History: From Antiquity to the 20th Century*. 1993.

Smith, W. *Art and Architecture of Ancient Egypt*. Yale University Press, 1981.

Strickland, Carol. *The Annotated Mona Lisa*. Kansas City: Andrews and McMeel, 1992.

Tyldesley, J. *Hatchepsut: The Female Pharaoh*. Viking Press, 1996.

Tuchman, B. *A Distant Mirror*. Knopf, 1978.

Woldering, I. *The Art of Egypt*. New York: Greystone, 1963.

Zarnecki, G. *Art of the Medieval World*. Prentice-Hall, 1975.

5

Medieval and Renaissance Art

The thousand years between the fall of the Roman Empire and the beginning of the Renaissance is called the Middle Ages or the Medieval Period. Sometimes referred to as the Dark Ages, the time range is between 400 and 1400 C.E. Thus, the Renaissance, meaning rebirth, was considered to be a reawakening of art, scholarship, literature, and science. As the name infers, the "Dark Ages" used to be considered by many to be a time of ignorance and squalor, a waiting period in Europe where not much happened and humanity simply survived from day to day as best it could. Scholars now have a much more enlightened view of this period and understand it as a time of sweeping changes that shaped Western-European culture, and laid the groundwork for its flowering in the Renaissance.

The Italian Renaissance was a profound influence on western culture. From the early 15th century and throughout the 16th century, both Italy and Northern Europe experienced a rediscovery of the classical world and drew upon it for inspiration to expand on all aspects of knowledge. Most people are familiar with the superstars of the Renaissance in Florence and Rome: Leonardo da Vinci, Michelangelo, and Raphael. However, in Venice there were also great masters such as Bellini, Giorgione, and Titian. In Northern Europe Jan Van Eyck and Albrecht Durer were two of the artists, among many, whose work established new ways of seeing and depicting the world around us.

The Medieval World

The thousand-year interval between classical antiquity and the Renaissance in Italy (c. 400–1400 C.E.) is known as the Middle Ages. During this time, most of Europe

69

converted from the variety of polytheistic faiths of the Greco-Roman world and the indigenous nomadic groups to the monotheism of Christianity. Christianity was established at the height of the Roman Empire. The Roman opinion of the Christians vacillated between viewing them as a small, insignificant religious sect, a benign albeit lunatic fringe, and a subversive group bent on high treason against the Roman Imperial State. Yet, after the fall of the Roman Empire Christianity spread throughout Europe, becoming the official religion of every monarchy—and a powerful political force to be reckoned with as well. In fact, monarchs were crowned by the Pope and were thought to be the secular arm of God's will on earth.

The western half of the Roman Empire fell to invading nomadic tribes in 476 C.E. The Vandals grabbed the North African provinces, the Visigoths took Spain, the Franks established themselves in Gaul (now Northern Italy, France, Belgium, the southern part of the Netherlands, and Germany), and the Ostrogoths and the Lombards divided the mid- and southern sections of Italy. These areas, once settled, were more like provinces surrounding the Byzantine Empire (the eastern part of the Old Roman Empire) than independent states, and looked to it for commercial and cultural leadership. In the 7th century C.E., Islamic forces took North Africa, Spain, and the Near East from the Byzantines, thus removing their influence in the western Mediterranean. The Byzantines focused their efforts on keeping Islam from annexing more territory, and Western Europe was left to develop its own economic, political, and religious structures.

The Early Middle Ages

The Middle Ages can be roughly divided into three periods: Early Medieval (c. 400–1000), Romanesque (c. 1000–1150), and Gothic (c. 1150–1400). The Early Medieval period is also divided into three time frames: Migratory, Carolingian, and Ottonian. The Migratory period dates roughly between 400 and 800, and was a time of violence and upheaval as various tribes swept through Europe and engaged in vicious power struggles to pick up as much of the old Roman Empire as they could. The Church offered the only cohesive political, spiritual, and intellectual stability, giving the popes great power that would establish the foundation for their authority later in matters of State.

The relative safety of the outer reaches of the old Roman Empire allowed for the establishment of prominent monasteries in the British Isles. These became the "keepers" of knowledge and havens for learning away from the very real dangers of the outside world. Many of these monasteries were also scriptoriums, writing workshops where manuscripts were copied and illuminated. Holy Scriptures, prayer books, psalters, breviaries, and moralized Bibles were illustrated to glorify the word of God, and visually exemplify its spiritual beauty. These early scriptoriums such as Kells, Durrow, and Lindesfarne produced a style of art known as Hiberno-Saxon or Insular. Both terms refer to a specific style of Irish-English manuscript illumination that combines Christian imagery with nomadic floral and geometric designs, Celtic interlace pat-

© Bettmann/CORBIS

St. Matthew, *Book of Kells,* c. 700

terns, and the fantastic creatures of the Animal Style brought to Western Europe through barter, trade, and conquest.

Manuscripts from this period display elaborate and intricate explosions of ornamentation and a density of design. The interlace patterning creates a labyrinth that is full of controlled and modulated rhythm and movement. Spirals and swirls combine with geometric cloisonné designs, human heads, and animals both realistic and fantastic. Certainly artists were aware of the classical past and the possibilities of three-dimensional illusionism. However, Hiberno-Saxon artists created their own motifs and converted conventional imagery into linear patterns more in keeping with their artistic traditions prior to Christian conversion. Figures are rendered in flat, hard-edged lines, and are simplified and abstracted so that details, such as drapery folds, are depicted with repetitive elements that further enhance the visual rhythms.

Carolingian Art

Artistic production in the writing workshops of the north was interrupted by the Carolingian Renaissance. Charlemagne, who had been crowned by the Pope as the first Holy Roman Emperor in 800, ruled from 768–814 and established the first cohesive state, the Holy Roman Empire, since the fall of Rome. Charlemagne, a man of considerable learning for the times, felt that the abstractions of Hiberno-Saxon art were not suitable as instruments of instruction or propaganda. Subject matter depicted with some degree of realism attracted him as he sought to emulate to some degree the art, culture, and political ideologies of Christian Rome. He felt that the revival of Classical models would legitimize his rule. The Carolingian renovation imperii Romani, the renewal of the Roman Empire, included a very clear vision that realistic art could assist his work of political and cultural reconstruction, and be used as a powerful educational tool, giving clear physical form to religious and civic concepts. The lively spontaneity of northern manuscript illumination gradually gave way to more composed images derived from Classical models. Simple forms of three-dimensional illusionism were conveyed through shading as artists attempted to create more solid and less linear figures. Nevertheless, a certain animated quality remains in Carolingian manuscript illumination.

In architecture, Charlemagne's *Palace Chapel at Aachen*, built between 792 and 805 by Odo of Metz, sets the tone for later Romanesque church architecture. Odo of Metz modeled the chapel on Justinian's Byzantine church of *San Vitale* at Ravenna, built in 547. Although both have octagonal domes, at *San Vitale* the interior spaces around the dome merge fluidly with the ambulatory, while at *Aachen* the dome and ambulatory stand as separate units. The interior space at *Aachen* imparts a strong solid geometry with clear structural articulation that would inspire the great churches of the Romanesque period.

Ottonian Art

By 870 the remains of Charlemagne's empire were ruled by his two weak and ineffectual grandsons who were unable to defend it against a variety of attacks from all directions. In 911 the eastern part of the empire came under German rule. The Ottonian kings sought to revive the Carolingian state with all the splendor and grandeur of the past. In 962 Otto I married the widow of a Lombard king and thus extended his rule over northern Italy. He had the Pope crown him emperor that same year. The Ottonian rulers helped build the great wealth of the Catholic Church with generous gifts of land and money in exchange for the loyalty of the bishops to uphold Ottonian rule against any uprisings of the aristocracy. This would give the Church great power throughout the era.

The Ottonian church of *St. Michael's* at Hildesheim (1001–1031), built by Bishop Bernward, set the tone for Romanesque architecture, and is based on the geometric segmentation of *Charlemagne's Palace Chapel at Aachen*. The arrangement at

St. Michael's is based on square schematism; that is, the crossing of the nave and transept form a square which becomes the unit of measurement for the rest of the church. At *St. Michael's*, the nave is equal to three crossing squares. This rational and orderly plan became fundamental to Romanesque architecture, serving to segment the interior space into strong geometric components that lent it clarity and structure. Furthermore, the support in the nave at *St. Michael's* is an alternate support system where two columns alternate with one pier. This, too, set the tone for Romanesque segmentation, forcing the eye to start and stop at regular rhythmic intervals along the nave moving toward the apse.

Ottonian manuscript illumination is characterized by flat picture space, strong colors, and rich surface decoration. Figures are schematized, while repetitive colors organize the composition. Drapery tends to lie on top of the figures as a separate element that is only marginally informed by the body underneath. The lines in the drapery, meant to indicate folds, began to create segmentation to the human form that would become much more pronounced in the Romanesque period.

Romanesque Art

Europe in the middle part of the Middle Ages, or the Romanesque Period, continued to stabilize. Although centralized political authority was still lacking, the papacy provided a unifying force. The international army that responded to Pope Urban II's call to the first Crusade was more powerful than anything a secular ruler could have raised at the time. There was a great spirit of religious enthusiasm reflected in the building of massive churches designed to hold the thousands who traveled from one to the next, making pilgrimages that often began in England and ended at the tip of Spain at Santiago de Compostela. It was during this time that feudalism arose, Mediterranean trade routes were opened with the resulting influence of other cultures on Europe, and a revival of commerce and city growth took place.

To accommodate pilgrimage traffic, large stone churches were built in a distinctive, commonly shared style. Romanesque churches have an overall blocky appearance with groupings of large, simple, and easily definable geometric masses subdivided on the exterior by buttresses, and on the interior by columns, piers, and colonettes. Architects were concerned with providing enough space for the circulation of the congregation as well as the many thousands of visitors, so a gallery space was added above the nave arcade. Called the tribune gallery, it served as a second ambulatory as well as extra support for the vaults of the nave. Like *St. Michael's* at Hildesheim, Romanesque pilgrimage churches were planned in square schematism with the nave being multiples of the crossing and the side aisles flanking the nave being simple halves or quarters of the crossing. The outer side aisles served as an extension of the ambulatory that surrounded the apse with radiating chapels emanating from the apse and transept arms. Squares, cubes, cylinders and semicircles make up the geometric components of the Romanesque church.

Ribbed, barrel-vaulted naves, and groin-vaulted side aisles were common in the early churches. Without Roman concrete technology, vaults were constructed of stone and crude cement. The barrel vaults were heavy and required tremendous buttressing. Because the stability of the vault would be compromised if large windows were cut into them, the interior of Romanesque barrel-vaulted churches remained dark. Once the technology of groin vaulting, already used in the side aisles, was sufficiently developed to use in the nave, the clerestory windows could be expanded and the interior lighted. The exteriors of Romanesque churches are clearly geometric and reflect the width and elevation of the interior. The two-towered façade, the westwork, provided the entrance, with the apse being at the east end of the building.

The portals of the façade and transept arms supported the sculptural program which was defined and contained within the architecture. Used as a teaching tool to a largely illiterate population, the portals were impressive areas to show scenes from the Bible, teach lessons, morals, and values, and to remind the congregation of the heavenly rewards and hellish punishments awaiting them. Romanesque sculpture is characterized by elongated and abstracted forms of humans, angels, devils, and demons. The bodies are compartmentalized and constructed as if hinged at the joints. Drapery forms surface patterns and reiterates the segmentation of the body. The figures are organized in a visually balanced and often symmetrical composition.

Romanesque manuscript illumination is easily recognizable as it contained many of the same stylistic traits as the sculpture. Figures are elongated and compartmentalized, and often defined and segmented by the drapery which appears to possess a life of its own, constructed of repetitive linear patterning. The bodies appear to be hinged at the joints like marionettes. The borders are geometric or floral, the figures flattened and defined by line, and the background displays little or no depth.

Gothic

Gothic society was based on feudalism, but compared to the Romanesque period, Gothic feudalism was relatively ordered and stable. Gradually, the monarchies in England and France began to assert themselves to limit the power of the lesser vassals and of the Church. This was a time when central governments began to form and laws were established. Cities began to thrive, craft guilds were established, and a middle class began to emerge. In the Gothic era technological advances began to increase production and somewhat ease the workload. The spinning wheel, treadle loom, watermill, and windmill were invented. Universities at Oxford, Cambridge, Paris, Padua, and Naples, among others, were established. Marco Polo traveled to China, and exploration by land and sea began. In his writings Thomas Aquinas argued the harmony between faith and reason. St. Francis preached tolerance and empathy, and Dante wrote his *Divine Comedy*.

By comparison to the Romanesque period, this was an enlightened time. The idea that life on earth was just a "waiting room" on the road to heaven or hell was modified. People began to feel that communion with God was more attainable, and there was not the necessity to put aside material needs and desires in order to enter heaven. The concept of a more benevolent, less angry and punishing God became popular, and this was metaphorically communicated in the great cathedrals of the age with the stained glass transforming ordinary light into the ethereal light of divine presence. However, the Gothic period was still an era of incredible lawlessness, violence, and cruelty with the bloody Crusades in the east, and the establishment of the Inquisition in the west. Toward the end of the era several outbreaks of the Bubonic Plague devastated Europe. The rational argument for the existence of God was questioned. The disassociation of faith from the natural world, of viewing God and nature as separate, and of spirituality detached from concrete reality, led to a renewed exploration of the natural world by means of scientific discovery rather than divine explanation, which would lead into the Renaissance.

The term "gothic" was first coined to describe architecture, and it is through architecture that the term is most easily understood. Gothic architecture is distinguished by two factors that allowed for the vast expansion of the great churches of the era: the use of pointed arches and flying buttresses. An early version of the pointed arch had been used at Durham Cathedral in England, but the first full-blown use of it was at St. Denis, a Carolingian royal abbey just outside Paris, remodeled by Abbot Suger in 1140. Abbot Suger was a friend and counselor to the kings of France, whose authority at the time only extended to a small area around Paris known as the Ile de France. Suger set about helping the monarchy establish power over their rebellious nobles and the Holy Roman Empire by forging an alliance between the French monarchy and the Catholic Church.

The kings of France claimed their authority from the line of Charlemagne. Both Charlemagne and his father Pepin had been crowned as kings at St. Denis. Thus, rebuilding St. Denis as a grand pilgrimage church was part of Sugar's plan to make it a spiritual center of France and a center of patriotic emotion. Suger rebuilt the choir and apse area, discarding the heavy vaults and buttressing, and using the pointed arch to allow for the opening up of the wall space to accommodate enlarged windows, filling the interior space with light. He also integrated the old segmented ambulatory and apse area into a continuous flowing interior space.

The pointed arch, supported along the joints, proved to be a very stable structure, allowing builders to stretch the height of the interior space and open up the walls far more than had ever been achieved. This has to do with the height of the crown of the vault and the corresponding arches, which in the pointed vault are all the same height. In the rounded Romanesque vault, the crown of the arch is at a different height than the arches, which then requires far more buttressing to keep the vaulting stable. Furthermore, through the use of flying buttresses, the thrust of the vaulting in

the nave arcade is counteracted with supports between the enlarged windows, transferred over and above the side aisles and into the ground. The flying buttresses were the external scaffolding, left in place, which became an integral part of Gothic cathedral design. It became a sculpture on the exterior of the cathedral that framed the voids, allowing the interior space to have a graceful, weightless quality via the translucent "walls" of stained glass.

Gothic architects strove for a "rush to the skies" and a "rush toward the apse," so the compartmentalization of the Romanesque churches was gradually eliminated. Like the choir/apse area at *St. Denis,* there was an effort to visually integrate the interior space into a more flowing design. The alternating support systems used in Romanesque churches was replaced with a consistent support system in the nave arcades that allowed the viewer's eyes to move rapidly toward the apse. Similarly the elevation of the nave was gradually changed over time to eliminate aspects that would segment the wall space. While Romanesque churches had a three-part elevation—the nave arcade, tribune gallery, and clerestory—Early Gothic interiors had a four-part elevation consisting of the nave arcade, tribune gallery, triforum, and clerestory. The addition of the triforum, three arches forming a blind arcade, was for decorative purposes and served no support function.

As building techniques became more sophisticated, the tribune gallery, which had helped support the nave arcade, was no longer an essential part of the construction format. Thus, Early Gothic four-part construction could be modified into a three-part elevation consisting of the nave arcade, triforum, and clerestory. The visual flow from floor to vaults was greatly increased. Cathedral heights soared while the clerestory area expanded so that much of the walls were replaced with colored glass. *Notre Dame Cathedral* is a good example of a High Gothic remodeling of an Early Gothic cathedral. At *Notre Dame* the early four-part construction was revised to a three-part elevation. However, because the tribune gallery was structurally impossible to eliminate, the triforum was removed so that the clerestory window space could be expanded. *Chartres Cathedral* was designed from the onset as a High Gothic structure. Here, the clerestory windows are as large as the nave arcade, separated only by a small triforum area. The effect is an unbroken expansive rush toward the heavens, supported on the exterior by an intricate exoskeleton of flying buttresses. The vaults are now four-part, rather than the Early Gothic six-part vaults, which also creates a strong visual flow. The enormous rose and lancet windows filled with intricate tracery and jewel-like stained glass transform the heavy stone interior into a prismatic celestial space of divine proportions.

The exteriors of Gothic cathedrals maintain the two-tower facades of the westwork of Romanesque churches. However, the facades are far more ornamented, carved with a multitude of continuous designs and sculpture so that the exterior mass visually reads as a network of decorative stonework. Like the interior space, the solid mass of the façade seems to dissolve within the intricately articulated bands of embellishment. Reflecting their interior vaulting systems, Gothic portals are constructed with a pointed arch, while Romanesque portals are designed using the rounded arch.

Although Gothic architecture in Northern France set the tone and became an international style, the Gothic in Italy was quite different. Instead of the extreme height and large clerestory area, Italian Gothic has a much more horizontal orientation. As seen in the *Florence Cathedral,* begun in 1296, there are no flying buttresses or clerestory windows. The ribbed groin vaults of the nave rest directly on the nave arcade. The side aisles are shallow and the nave bays are extra wide to create the effect of a very wide horizontal and integrated interior space of spacious proportions and solemn grandeur.

The human figure in Gothic sculpture and manuscript illumination is typically graceful and elongated, and without the segmentation of the Romanesque style. Like the interior space of the great cathedrals, the concept of smooth flowing lines remains consistent. Figures exhibit a strongly defined "S-curve" rather than the stiff frontality of earlier styles. There is a pronounced contrapposto pose and a mannered elegance that is more related to compositional arrangement than naturalism. An emphasis on "prettiness" is exemplified in the small doll-like faces framed with curls, large eyes, and tiny delicate mouths. Conversely, there are aspects of Late Gothic style that strive for greater naturalism, taking some inspiration from classical sources.

Late Gothic/Proto-Renaissance

Many divergent artistic tendencies arise in the 14th century. While some scholars refer to this as Late Gothic, others find it more descriptive to call the period Proto-Renaissance in view of the many stylistic innovations that lead into the Early Renaissance of the 15th century. While much of the artwork at the time remained firmly rooted in the Gothic tradition or Byzantine formulas, the late Gothic period did experience a move toward greater naturalistic representation. The 1300s was a time of change in Europe. There was a rise of the middle class as commerce and trade created wealth outside the nobility. The tide of medieval thought was gradually moving away from the absolute power the Church held over human affairs. Philosophers and theologians were retreating from the arguments made by Thomas Aquinas that the existence of God could be rationally proven. Beliefs in the Christian mysteries were becoming acts of faith rather than logically verifiable facts, and as such, the door was opened for pure reason to pursue scientific and experimental thought.

By 1350 over half the population of Europe had succumbed to the Bubonic Plague. There was a simultaneous loss of faith in the Church and a new vision of the individual as an independent force acting on his/her own behalf. Living life well and fully here on earth was beginning to be considered a worthy objective as opposed to the medieval concept of mortal life being a burdensome and dismal stopover on the way to heaven or hell. This attitudinal shift began the breakup of the medieval world and the beginning of the Renaissance. Our ideas and outlooks are much more closely aligned with Renaissance thought. The concept of individual worth, creativity, and self-determination can be, in part, traced back to this "re-birth" of classical ideology. This is not to say that the Pope, the Church, and strong religious beliefs did not hold

great sway in the Proto-Renaissance. But what is clear is that this was coupled with a far more expansive and grander concept of the possibilities for human beings in the second half of the 14th century.

Giotto di Bondone is considered to be the "father" of the western pictorial tradition. Hailed by Renaissance artists as their "true" ancestor, it was Giotto who revolutionized painting by restoring naturalism and an "outward" vision to painting. The naturalistic approach to painting had been minimized in the Middle Ages, as artists looked inward to create a vision of the spiritual and heavenly realm. Giotto stressed firm observation of the details of reality and looked to the physical world for inspiration. In his famous fresco cycle from the *Arena Chapel* in Padua (1305–1306), he painted thirty-eight framed pictures arranged on three levels. The top row depicts the lives of the Virgin Mary and her parents Joachim and Anna. The middle section deals with the life and mission of Christ, while the bottom section illustrates the Passion, Crucifixion, and Resurrection. The three sections rest on figural representations of virtues and vices painted in grisaille (monochrome grays designed to resemble marble sculpture).

In each scene Giotto achieves dignity and balance through the arrangement of figures, strongly modeled forms placed on a firm ground, and a modulated balance of colors. The thin, lithe bodies, elegant "S-curves," flowing drapery, and delicate features of the Gothic tradition have been exchanged for a new realism. Giotto's bodies are three-dimensionally modeled in clear forms that possess bulk and heft. Drapery is molded by the figure beneath it, and faces are reflective of the joy and anguish of real beings. The *Arena Chapel* frescos create a continuous drama that emphasizes human relationships, thus emotionally engaging us with the sacred stories in a direct and powerful way. This new emphasis on the emotional life of the characters allows the audience to become involved with the story in a more direct way than before, drawing the viewer into the drama of the scene, rather than remaining a distanced observer.

Giotto's work is the beginning of a trend toward a more realistic depiction of the natural world and more humanizing tendencies that will expand in the Renaissance. Although his figures are more bulky and thus more believable than other images of the Gothic period, they appear rather stiff, as he has not mastered the intricacies of anatomy. Placed in a very shallow picture space without the benefit of perspective depth or shadow, the viewer is cut off from the distance through the contrived and unrealistic placement of large iceberg-like rocks that form the backdrop in many of the settings. Uniform illumination, where all the scenes are bathed in the same unvarying light, further reduces three-dimensionality. The flaws in Giotto's techniques and understanding would be gradually worked out in the Renaissance where artists would strive to create a fully believable space on a flat surface. However, Giotto's inspired innovations would have a powerful influence and effect on the generations of artists to follow.

If Giotto was considered to be avant-garde at the time, Simone Martini was one of the chief proponents of a more conservative style. The Gothic International Style greatly elaborated and embellished Late Gothic attributes and continued throughout

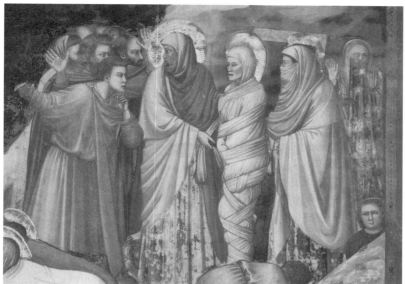

Giotto, *The Raising of Lazarus* (detail), 1305, Arena Chapel Padua.

the 1300s and into the early 1400s. The Gothic International Style was characterized by lavish costume and intricate ornamentation. Splendid settings and radiant colors combined with flowing, fluttering lines and weightless figures. They were suspended in settings that used gold backgrounds to isolate the figures from time and place, thus giving them an eternal context.

The Early Renaissance in Italy

The Renaissance began in the 15th century. It was a time of great expansion in every realm of human endeavor. The establishment of vast European colonial empires followed extensive exploration and discovery. It was a time of deeply felt spiritual changes as the Protestant Reformation was answered by the Catholic Counter-Reformation. Great monarchies gained absolute power, while the possibilities for individual growth, knowledge, and success were largely improved. The shift of emphasis moved away from the history of salvation and the world of the spiritual, to a renewed and avid excitement about the temporal world and our place within it. People of the Renaissance saw history through the lens of human achievements rather than as a record of the divine. Classical antiquity was viewed as an enlightened time where science, mathematics, philosophy, literature, and art had brilliantly flourished. Renaissance society saw itself not as a slavish copy of the classical world, but as its heir desiring to expand and surpass it. As such, the Renaissance, in many ways, was the birth of modern civilization.

The Italian city-state of Florence took the lead in the Quattrocento or 15th century. The powerful Medici family, bankers to the monarchs of Europe, was located in Florence, and in many ways, the Medicis were the unofficial rulers of the city-state. The Medicis were the foremost patrons of the arts. Their support was instrumental in the development of all of the arts and the new humanism that permeated the age. Under the sophisticated taste and patronage of Lorenzo de Medici, known as Lorenzo the Magnificent, the city of Florence became a work of art with public sculpture and buildings commissioned for the glory of the city and the House of Medici. Lorenzo's Neoplatonic Society gave Michelangelo his early training with a humanist education. The Humanists advocated the study of all of the liberal arts using classical texts, reviving Greek philosophy and integrating it with Christianity, and stressing the concept of self, individual dignity, and human worth.

One of the most important technical developments in the 15th century was linear perspective. The Florentine sculptor and architect Filippo Brunelleschi discovered this mathematical method of projecting depth onto a flat surface sometime around 1415. In what is called "one-point perspective," a single point (called the "vanishing point") is placed on the horizon line. All the orthogonal lines (the imaginary parallel lines that begin in the foreground of the picture plane and recede into the depth of the picture) meet at this single vanishing point. Using linear perspective combined with atmospheric, overlapping, and diminutive perspectives (see Chapter 10), one can create a drawing or painting of strikingly believable three-dimensionality. Artists were fascinated by the potential inherent in the application of linear perspective. They experimented with the possibilities of perspective techniques applied to a variety of representational challenges.

The painter Masaccio is considered to be the artistic heir to the stylistic innovations first begun by Giotto. Using linear perspective, he created illusionary effects that had never been seen before. At the small church of *Santa Maria Novella* in Florence, he painted a fresco in 1428 entitled *The Holy Trinity* that seemed to open up the wall to a fully realized three-dimensional world within. He convincingly dissolves the wall, painting two Ionic columns, flanked by Corinthian pilasters that frame a coffered barrel vault that seemingly recedes into the space of a believably rendered Renaissance chapel.

Like Giotto's figures, Masaccio's are solidly modeled and grounded, but now he controls the flow of light, which comes in from the right, so that the figures cast consistent shadows to the left. The single light source illuminates parts of the figures leaving other parts in shadow. The artist models them with chiaroscuro, a technique of subtle tonal gradations of light and dark to produce the illusion of volume and mass. A consistent light source, chiaroscuro, and the use of linear and atmospheric perspectives gives Masaccio's fresco, *The Tribute Money* (1427, Brancacci Chapel, Florence) an unprecedented naturalism in the figures, drapery, and landscape. Despite these innovations, Masaccio has not fully comprehended human anatomy. His figures and drapery appear stiff and the action uncomfortably frozen.

Public art in Florence, particularly sculpture, needs to be viewed within the political context of the times. Italy was not a single united country as it is today. It consisted of a number of city-states ruled by powerful aristocratic families. Florence was economically powerful, but militarily weak. The city was often under attack from Milan and Naples. The Florentines likened themselves to the ancient city-state of Athens, also commercially powerful, militarily weak, a leader in all aspects of knowledge and culture, and which eventually came under attack by the rival city-state of Sparta. The public art, funded by the Medici, as well as a variety of guilds and private patrons, often took on a political meaning beyond its surface identity. Florentines would have understood this at the time and taken comfort in the rallying force of the implied message.

The most renowned sculptor of the Quattrocento in Florence was Donatello. His work displays an understanding of anatomy that had not been present since ancient times, while incorporating the emotional and psychological tensions inherent in the subject matter. He was the first sculptor since antiquity to fully comprehend and utilize the contrapposto pose and to create life-size, totally freestanding images of the human form. Donatello articulates the body with an understanding of the bone and muscle structure underneath the skin, thus creating believable rounded body masses.

His sculpture of *St. Mark* (1411–1413, marble, 7'9") is placed in a niche on the exterior of *Or San Michele* in Florence. Unlike the jamb statues of the Gothic era, this immense work could easily stand by itself and does not need architectural support. The details, down to the veins in the hands and feet, are fully modeled, while the folds of the drapery are completely determined by the shape of the body underneath, rather than by patterns imposed from the surface. *St. Mark* is portrayed as powerful, not only in his physique, but in the concentrated strength conveyed in his expression. He seems to look outward at the dangers around him while summoning up his inner resources.

Donatello's nude bronze sculpture of *David* (1425–1430, 62") is an icon of the Early Renaissance. It is the first sculpture since ancient times to be fully conceived as freestanding. The contrapposto pose, the interplay of textures, the unabashed sensuality of the figure set it apart from earlier pieces. The Biblical David was an allegory meant to symbolize Florence. David was weak, yet loved by the Lord. With God's help he was able to defeat the giant Philistine Goliath, just as the Florentines continued to ward off the Duke of Milan and the King of Naples, thus remaining free and independent.

Piero della Francesca continued in the tradition of Giotto and Masaccio. His paintings set the figures into triangular hierarchical arrangements that Leonardo would develop into the standard organizational and compositional component of painting in the High Renaissance. His dedication to the science of perspective would also be influential, as his solid, heavy, and immobile figures were placed in carefully constructed and mathematically accurate settings. The heavily constructed work of Piero della Francesca offers a counterpoint to the lighter more linear work of Sandro

Botticelli whose *Birth of Venus* is discussed in Chapter 3. The elegance of Botticelli's work can also be seen in Perugino's *Christ's Delivery of the Keys to St. Peter,* 1482. Both of these trends of the 15th century would be carried forth into the 16th century in the work of the three masters of the age: Leonardo, Michelangelo, and Raphael.

Architecture in the Early Renaissance was defined by two great 15th-century architects and scholars: Filippo Brunelleschi and Leone Battista Alberti. Brunelleschi, as mentioned earlier, is credited with discovering mathematical perspective. A brilliant inventor, engineer, and architect, Brunelleschi reinvented church buildings, moving away from the basilica format to domed-style structures that incorporated classical motifs. His *Pazzi Chapel,* 1430, is the epitome of balanced modulation and rhythmic elegance. Clean, clear lines and strongly defined repetitive elements such as fluted pilasters, arches, and circular windows replace the elaborate overabundance of Gothic decoration, and set the tone for later Renaissance buildings. Brunelleschi's solution to building the dome on the *Florence Cathedral* solved a construction and engineering problem that had plagued the city. Finished by about 1436, the dome became one of the great architectural feats of the 15th century. He constructed the dome with an inner and outer shell connected by eight ribs and internal struts between the two. It was an innovative solution to a daunting architectural challenge.

Alberti was one of the great intellects of the 15th century, and truly a "Renaissance man." An architect, sculptor, painter, theorist, scholar, and humanist, it was Alberti who first recorded, with cogent explanations, mathematical perspective. He wrote several series of books on painting, architecture, and sculpture, as well as books on antiquity, horses, and family ethics. His building projects summarize 15th-century architectural aesthetics in their rhythmic colonnades, arches, and arcades, and their visual references to classical antiquity.

The High Renaissance

The High Renaissance in Florence and Rome began about 1500 and ended with the death of Raphael in 1520. The three most celebrated artists of the period were Leonardo (Leonardo da Vinci, 1452–1519), Michelangelo (Michelangelo Buonarroti, 1475–1564), and Raphael (Raffaello Sanzio, 1483–1520). By the end of the 15th century Florence was losing its leadership of the Renaissance as the Medici family was ousted from the city by an angry mob under the influence of Girolamo Savonarola. Savonarola was a Catholic monk who viewed the Medici as heretical in their extravagant lifestyle and Neoplatonic philosophy. Italy was a battleground for foreign powers. After Savonarola was executed, Florence was taken over by a line of the Medici family under Spanish protection, then by Alessandro de Medici under the protection of the Austrian-Hapsburg Empire. So it was that in the 16th century Rome became the seat of the High Renaissance. The Church, seeking to elevate the city to its former grandeur and to counteract the Protestant Reformation, became the major patron of the arts. It paid to beautify the city, St. Peter's, and The Vatican.

It was in the Cinquecento or 16th century that the "cult of genius" made super-stars of artists. Individuals of great talent were thought to be set apart from ordinary mortals, to be divinely inspired. The concept had a profound effect on 16th-century artists. It spurred them to take on vastly ambitious projects and competitions, while igniting the competitive aspects of patronage as well. Thus, artists became the cultural heroes of their time, and well-to-do families vied with each other and the Church to commission them.

Leonardo was the oldest of the three and the first to reach such lofty heights. He was a complex and multitalented individual. He believed that art and science are inti-mately connected, and as such, he set out to learn as much about both as he could. We know a great deal about his thoughts and observations as he left thousands of pages of writings and drawings in his notebooks. Every aspect of the natural world interested him, flowers and plants, animals, and the human body. In fact, Leonardo studied the body as never before. Although he was trained in Florence by the sculp-ture Verrocchio, at the age of 30 he went to work for the Duke of Milan as a military engineer. Part of the deal in working for the Duke was that he would be supplied with bodies which he could dissect. In 1508 it is said that he obtained over fifty bodies for this purpose. His study of blood vessels led him to a rather sophisticated understand-ing of the circulatory system, while his meticulous drawings of a fetus developing in the womb are textbook-accurate.

Aside from his extraordinary artistic skills, Leonardo produced architectural drawings and designs for sewers, elevated walkways and pedestrian malls, flying machines, parachutes, helicopters, armored tanks, and diving bells among other things. His talents and curiosity were so extreme and diverse that it seems they often kept him from completing projects. Paintings were left unfinished as he would get dis-tracted by other interests. His experimentation with pigment compounds is one major factor in the early disintegration of his *Last Supper* fresco. Nevertheless, Leonardo's contributions to the history of art are profound. Although he left less than twenty paintings when he died, they are some of the most influential and beloved in all of Western-European art.

Leonardo wrote that "a good painter has two chief objects to paint: man and the intention of his soul." Certainly in his paintings he has achieved these goals. Aside from the physical details that are descriptively accurate, the longing and desires of the human soul are also depicted. It is conveyed in the misty expression of the *Mona Lisa* that has consistently fascinated viewers from the time of its completion. The "inten-tion" of the soul is seen in the looks of longing and the extension of the arms in his painting *The Virgin and St. Anne*. And certainly in the *Last Supper,* we see the apostles searching their own soul's intention as they ask themselves if they will be the one to betray Jesus.

Part of Leonardo's ability to produce these effects is through his *sfumato* tech-nique. The word means "smoky" or "gone up in smoke" and it refers to the way he achieves the hazy, blurred effect in his paintings that lends mystery and emotion to

them. Sfumato is achieved through the use of oil paints laid on in thin translucent glazes. Colors glow through the various layers of glaze. This is combined with careful chiaroscuro. Very minute modulations of light and shadow, through subtle tonal gradations of color, are applied without defining outlines to create this evocative effect.

Michelangelo's interest was only to investigate the beautiful structure of the human body which he felt expressed the "life of the human soul." He often called human beings the "mortal veil of divine intention." He thought of himself first and foremost as a sculptor. He likened the process of carving a figure from a block of marble to lowering the water from a figure in a bath, and felt that every block had a figure within it just waiting to be released.

Growing up absorbed with art, he was placed as an apprentice to the artist Ghirlandaio at the age of 13, then taken in to the palace of Lorenzo di Medici at the age of 15. It was here that he met many of the Medici who would become his future patrons. At the age of 23 he completed the remarkable *Pieta,* and in 1501 he was given the task of finishing an abandoned 13-high block of marble that had been earmarked for the *Florence Cathedral* to become a statue of *David.* When it was finished in 1504 it was immediately recognized as a masterpiece and placed in the Palazzo Vecchio, again as a symbol of the Florentine Republic.

Michelangelo's *David* is not yet the triumphant hero, as Donatello's version had been. Here he is shown in anticipation of the event. His intense gaze surveys his surroundings. His furrowed brow denotes his careful weighing of the situation. He seems to be readying himself psychologically for the action to come. Michelangelo had just spent time in Rome where he had been deeply impressed with the emotionally charged and heroically rendered sculptures from Hellenistic times. His *David* successfully combines the rich drama of that style with the contained balance and sophistication of Renaissance aesthetics. In speaking of the power of sculpture and of his love of it over painting he wrote:

> . . . the nearer painting approaches sculpture the better it is, and that sculpture is worse the nearer it approaches painting. Therefore it has always seemed to me that sculpture was a lantern to painting and that the difference between them is that between the sun and moon.

In 1508 Pope Julius II called Michelangelo to Rome to paint the ceiling of the Sistine Chapel. Reluctantly he left the partially finished marble *Tomb of Pope Julius II* to paint the 5,800 square foot ceiling. Never having worked in the fresco technique, and painting on a scaffolding 70' high, he finished the ceiling in only four years. The program of decoration is hugely complex and filled with hundreds of figures arranged for their symbolic and biblical significance. At the crown of the vault nine scenes from the book of Genesis are depicted. Surrounding these and seated on thrones are twelve massive figures of sybils and prophets who were thought to have foretold the

coming of Christ. The thrones are separated by piers embellished with twenty-eight sets of putti painted in griselle. Seated on the pier capitals are nineteen figures. The lunettes and triangular sections above them contain figures representing the forty generations of the ancestry of Christ while the pendentives depict other important scenes from the Bible.

The titanic scale and scope of the decorative program is breathtaking. A close look reveals that each part of the ceiling is drenched in detail and color. The bodies are modeled with light and shadow and with a full knowledge of anatomy. Massive as they are, it is the emotional life of the figures that personalizes them. Each figure possesses emotion which helps connect the viewer to the image. Each figure grouping is linked through gesture and glance and immersed in the psychological dynamics of the scene. What Giotto began in the early 14th century, Michelangelo fully conveys in the early 16th century. The power of his work lies so much in his own deeply felt passion. His images are imbued with it. Thus, we feel the excitement as God eagerly rushes toward Adam to give him the "spark" of life. And, we are saddened at *The Deluge* scene when a father struggles to hold the limp body of his already dead son away from the rising waters as Noah's Ark floats safely in the distance.

As if sculpture and painting were not enough, Michelangelo was also an architect. He supervised the reconstruction of *St. Peter's Cathedral* and redesigned the *Capitoline Hill* in Rome, among many other architectural projects both large and small. Thirty years after he started the *Sistine Ceiling* program, he was called back to paint the wall behind the altar. The mood of the *Last Judgment* is distinctly different than that of the ceiling. Now it is an angry Christ that condemns the lost souls to eternal damnation. St. Bartholomew, who had been martyred by being flayed alive, holds his skin in his hand. The face on the skin is Michelangelo's own.

Raphael's paintings sum up and convey the artistic aura and intellectual mindset of the times. His work possesses a synthesis of the stylistic tendencies and innovations of the late 15th and early 16th centuries. There is the elegance of line and precise perspective renderings of his teacher, Perugino. These are coupled with the beauty of Leonardo's pyramidal constructions and chiaroscuro modeling along with the strong forms and dynamic poses of Michelangelo. Yet, Raphael's style is his own. His idealized subjects exist in the clear rarified air and timelessness of Humanist thought and ideologies. Raphael's work epitomizes the best hopes and dreams of the age. His *School of Athens* (1510, Vatican) is thought to be the quintessential statement of Humanist values and Renaissance ideals.

Bramante (Donato Bramante, 1444–1514), was the great High Renaissance architect in Rome in the early Cinquecento. One of his most influential buildings, *The Tempietto*, 1504, was built over the spot that St. Peter was supposed to have been martyred. Instead of articulating a flat wall space, Bramante constructed a domed building, creating an organic structure with little ornamentation, yet it is visually exciting. His emphasis is on the interplay of light and shadow and solids and voids created with the visual rhythms of the multiple vertical forms in the colonnade,

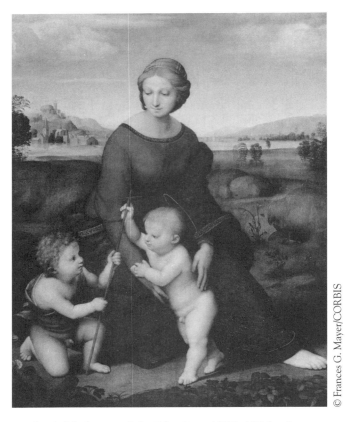

© Frances G. Mayer/CORBIS

Raphael, *Madonna of the Meadow,* 1505–1506, oil on wood, (44" × 34").

balustrade, and pilasters that modulate the drum and dome. Like the work of the great painters, his building exhibits the values of High Renaissance art and architecture: order, clarity, lucidity, simplicity, harmony, and proportion.

In Venice the art of the High Renaissance took on a different look. Whereas the Florentine and Roman schools were concerned with intellectual themes, epic adventures, noble battles, and lofty concepts of religion and heroic subject matter, the Venetian school focused more on the beauty of nature, emotion, sensuality, and the warm golden glow of afternoon light. This philosophical dualism goes back to the age of Classical Greece where the dialogue between intellect and emotion was represented by the two gods Apollo and Dionysus. Apollo, the Greek god of the sun, intellect, reason, and logic (those aspects considered "masculine"), was juxtaposed to Dionysus, god of wine, sensuality, worldly pleasures, and intuition (those aspects considered

"feminine"). These opposite forces were carried into the Baroque era in the debates that arose between these two schools of thought.

The Venetian Renaissance is best exemplified in the work of Giovanni Bellini (c. 1430–1516), Giorgione (Giorgione da Castelfranco, 1478–1510), and Titian (Tiziano Vecellio, 1488/90–1576). Bellini exemplifies the "Venetian" style in his Madonna paintings. His figures are plastically modeled with softened edges and rounded forms that are set aglow in a golden afternoon light. Shadows smooth the junctures between the planes of the face. Sensual textures are emphasized such as soft curls of hair and the sheen of material. Bellini's mythological scenes, set into the lush abundance of a pastoral landscape, contain the same soft lighting and richly saturated colors of his Madonna paintings. Based on scenes from the works of the ancient Roman poet Ovid, the sensuality and emotion of the lighting, modeling, subject matter, and color would be influential in the Baroque and Rococo styles to come.

Giorgione, a student of Bellini's, created a sensual and lyrical evocation of both the figure and the landscape. The light in Giorgione's work sets the mood. Whether the landscape is bathed in the golden glow of a late afternoon, or the lowering depths of an oncoming storm, he depicts an atmospheric quality that creates the tone of the picture. Georgione's female figures are rounded and voluptuous, the shapes in the landscape often mirroring the curve and volume of their bodies. Idyllic and dreamlike, the landscape is the stage into which figures are set. It is idealized with feathery leaves and softly rounded contours.

Titian, also a student of Bellini's and an assistant to Giorgione, dominated Venetian Renaissance painting after Giorgione's death in 1510, and is considered to be the greatest of the Venetian Renaissance painters. Titian's brushwork is expressive and free. Moving away from the frontal pyramidal construction, which organized the picture into a very stable composition, Titian experimented with oblique angles and views, which added movement and liveliness to his works. Relying less on preliminary drawings and sketches, he modeled his figures with color and brushstroke to create the forms, building up the canvas with layers of translucent glazes. His *Venus of Urbino*, 1538, set the standard for the depiction of the reclining female nude in western art. Titian's use of light, shadow, and color to shape the figure and create sensuality of texture and tone were greatly influential to later painting styles.

The great architect of the Venetian Renaissance was Andrea Palladio (1508–1580). Palladio's work and his writings had a profound influence on the architecture of his times and for centuries to come, particularly his treatise on the subject entitled *Four Books of Architecture*. His most important building, the *Villa Rotonda*, 1566–1570, was a country residence built on a hill overlooking the city of Vicenza. It is organized around a central square crowned by a dome. On each of its four sides is a portico designed as a classical temple porch screened by ionic columns. Palladio calculated the proportional relationships of the villa rooms according to the harmonic

relationships within Greek musical scales in order to endow the building with a sense of calm rationality, order, and formal clarity.

The Northern Renaissance

Fifteenth-century painting in Northern Europe was much more rooted in Late Gothic tendencies than was the art of Italy in the 15th century. The interest that Italian artists had in the art of antiquity was not shared in the 15th century by Northern artists, nor could it be. After all, the Italian artists lived and worked among the ruins of the Classical world. Examples of the "classical ideal" were everywhere. They were exposed to the idealized forms, measured proportions, and balanced compositions of Greek and Roman art. Theoretical treatises on art and architecture were abundant and accessible and dealt with aspects of mathematical perspective, anatomical structure, color, and technique.

In the meantime, Northern artists exhibited an observation of their surroundings that brought a clarity and detail to their paintings not seen in Italian works. With scrupulous exactness they focused on the smallest aspects of everyday life. The Gothic International Style, with its meticulous accuracy in depicting the opulence of pattern and design along with the use of brilliant colors, continued to be influential in panel painting, altarpieces, and book illumination well into the 15th century. Another trend in the North was one of intense realism gleaned from a close scrutiny of the natural world. With less theory and formal guidelines to follow, artists in Northern Europe were free to explore the world of their own perceptions with a precision of detail that produced images unfiltered by the confines of the idealism of classical antiquity.

The development of oil painting in Northern Europe gave artists a new freedom in interpreting the world. Tempera was a quick-drying medium that did not allow an easy mixing of colors. Oil paint dried slowly, could be easily mixed and blended, and could be thinned into glazes to create unprecedented luminosity. Northern artists were able to endow every last detail with maximum concreteness, defining size, shape, color, material, and surface texture. In doing so, everyday objects took on a symbolic significance. There was a deeply reverential attitude toward the physical world as a metaphor for divine truths. The concept of "disguised symbolism" became an iconographic tool used by painters to express sacred ideas—endowing humble objects with a secondary religious meaning, fusing the material with the spiritual. Thus, the commonplace could become transcendental. For example, a shiny water basin is not merely an ordinary household item, but it is also the symbolic representation of the concept of the Virgin Mary as a "vessel most clean" and as a "well of living waters," and thereby becomes extraordinary.

One of the most brilliant of the illuminated books produced in the early 15th century was *Les Tres Riches Heures du John Duc de Berry*, illustrated by the Limbourg Brothers and dating about 1415. In the elaborate depictions of the twelve months of the year, the brothers alternated between lavish paintings of the Duke and his

entourage enjoying the pleasures of each season, and peasants laboring on the Duke's lands at various times of the year. In both cases, the illustrations are intricate and depicted with a brilliance of color that is reminiscent of the stained glass in northern Gothic cathedrals. The details are sumptuous and minutely rendered. In gold leaf and blues, derived from lapis lazuli, nobles are shown in fairy tale-like settings. Elongated and elegant, with decorative linear effects that recall the best of the Gothic International Style, these images are lush and lyrical evocations of wealth and privilege.

Jan van Eyck (c.1395–1441) is considered to be one of the greatest Northern painters of the 15th century. His understanding of the properties of oil paints enabled him to build up layers of finely applied brushstrokes and light-reflecting glazes into images of remarkably precise rendering. His *Man in a Red Turban*, 1433, which may be a self-portrait, is a fascinating study of the details of shape and texture. A clear, warm light reveals, with painstaking exactness, every nuance of line and shadow in the face and every fold and twist in the coiled cloth wrapped around the head.

His much celebrated and studied *Arnolfini Wedding Portrait*, from 1434, is an exquisite representation of the concept of disguised symbolism. Aside from a record of the wedding between two upper-class members of the Italian community in Bruges, it is a documentation of their rank and social status. The authenticity of the setting is represented with scrupulous precision. The couple wears rich, heavy, and stylish garments. Giovanni Arnolfini sports a high-crowned, broad-brimmed beaver fur hat, considered to be the height of fashion at the time. The room is authentic and filled with the atmosphere of the era. Van Eyck, as a witness to the wedding, can be seen in the convex mirror on the back wall, his signature above it. Much of the painting is symbolic; in this case, it appropriately addresses the holiness of matrimony. References such as the removal of the shoes as the couple stands together before God on the holy ground of matrimony, would have been readily available to a contemporary observer.

Rogier van der Weyden (c.1400–1464) painted in Northern Europe at the same time as Jan van Eyck. However, van der Weyden's style was distinctly different. While van Eyck presented a detailed but impassive realism, van der Weyden rendered his painting in a much more emotionally expressive way that gave deep feelings to his religious themes. Drama and pathos dominate van der Weyden's work. Rather than secondary or disguised symbolism, he stresses human action and drama. His work calls attention to the action at hand and the emotional content of the scene, while still emphasizing the Northern interest in detail and rich surfaces.

By 1500 the influence of the Italian Renaissance had flowed northward and artists quickly began to assimilate its lessons. Several artists had a significant influence on 16th-century Northern European art: Matthias Grunewald (c.1480–1528), Albrecht Dürer (1471–1528), Hans Holbein the Younger (1497–1543), and Pieter Bruegel the Elder (1525–1569). Grunwald's *Isenheim Altarpiece*, 1510–1515, depicts Christ's crucifixion in gruesome detail. The devastated body looms larger than life on the outer panels of the altar. The flesh, already discolored as it decomposes, is studded with thorns that have ripped the body. Rivulets of blood are still apparent as is the pain shown in the twisted

feet and agonized hands. The figure conveys the utter ugliness and cruelty of death in graphic and repulsive detail. Grunewald has convincingly combined the Northern interest in precise details carefully described, with passion and emotional impact.

Albrecht Dürer had been to Italy as a young man, and had returned to his native Nuremberg with a new concept of the artist and his place in society. The unbridled emotion of Grunewald's vision was not suitable to Dürer's taste and understanding of Renaissance innovations. He advocated a more controlled artistic discipline that took into account the formal theoretical foundations and rational standards of Italian Renaissance discoveries in art. Like his Italian counterparts, Dürer wrote treatises on perspective and ideal human proportions. He adopted the idea that an artist was also a gentleman and humanist scholar, and thus he cultivated his intellectual interests, developed a number of artistic techniques, kept careful notes on his processes, and became an international celebrity in his own time.

Dürer was a master in the graphic arts and had a wide influence on the development of both woodblock printing and engraving. In his hands, the woodblock print moved from basic studies of black and white contrasts to flowing lines, subtle details, and intricate effects of light and shadow. He was able to achieve tones and describe textures as beautifully as if he had been painting in oils. This is true of his engraving skills as well. Dürer's ability to capture light and shadow, reflections, minute details, complicated textures, and mathematical perspective techniques revolutionized printmaking and raised its status to a major artistic medium.

Hans Holbein the Younger was a skilled and incisive portraitist, graphic artist, and painter working in Basel at the time of the Protestant Reformation. With Church commissions drying up as the Reformation took hold, Holbein found himself out of work and in danger as iconoclastic riots consumed the city. He left for England where his prodigious skills landed him a job as court painter to Henry VIII. Holbein's work combined Northern precision in the rendering of details with his knowledge of chiaroscuro and other formal elements of the Italian Renaissance. His superb draftsmanship, attention to texture and design, and ability to capture rich colors and the unique ambiance of the world he painted, set the tone for portrait painting for many years to come.

Pieter Bruegel the Elder, a highly educated man whose patrons were wealthy merchants, aristocrats, and humanists, spent his career painting rural landscapes and the peasant folk who inhabited it. Bruegel painted in series, often re-creating the months of the year and the labors and occupations of each month, much in the same tradition as the Limbourg Brothers had done a century earlier. One of Bruegel's great interests was nature, not just as a setting for human activities, but nature as a worthy subject on its own. Men and women go about their seasonal activities, but seem almost incidental to the landscape which is rendered in precise mathematical perspective. Another interest of Bruegel's was the seasonal rituals of the peasant class. These solid figures are heavy and clumsy. They are modeled with simplified broad strokes of color that emphasize a sort of rudimentary and straightforward world of uncomplicated needs, lively enthusiasm, and rough unsophisticated lifestyles.

DISCUSSION QUESTIONS

1. What role did the Irish-English monasteries have on the development of painting in the Middle Ages and why?

2. Describe Hiberno-Saxon art and the influences that helped to develop the style. Give examples to illustrate your statements

3. Compare and contrast the illustration of a saint from a Hiberno-Saxon manuscript to one from the *Coronation Gospels*. What are the differences and how does each express the times in which it was created?

4. Compare and contrast an Early Medieval painting of your choice with a Romanesque painting of your choice. Be sure to draw reference to examples within the works of art to illustrate your points of comparison, carefully outlining the similarities and differences in the formal elements of each work.

5. Pick a Romanesque pilgrimage church and a Gothic cathedral. First describe the general attributes that identify them according to the stylistic period in which they were built. Then describe the progression of change from Romanesque to Early Gothic to High Gothic, using the examples you've chosen to illustrate your points.

6. How does the work of Giotto differ from that of Gothic painters, and why is it important to the development of Renaissance painting? Give specific examples to illustrate your points.

7. From your book pick one example of Early Renaissance painting and one of High Renaissance painting. Track the differences between the two, considering such things as modeling of the figure, treatment of space and depth, drapery, and compositional organization.

8. Compare a Dürer painting and its place in the Northern Renaissance to a Leonardo painting and its place in the Italian Renaissance. What are the stylistic differences between the two?

9. Describe the thematic, iconographic, and emotional content of Michelangelo's *Sistine Ceiling* as compared to that of his *Last Judgement* wall in the *Sistine Chapel*. Illustrate your points with concrete examples from both works. Date each work and take into account the religious, political, and spiritual climate of the times in which each work was created.

10. What are Humanism and Neoplatonism and how are both expressed in the artwork of the 15th and 16th centuries?

11. How are the two Renaissance styles expressed in the paintings from Venice and Rome?

BIBLIOGRAPHY

Bennett, B. and Wilkins, D. *Donatello*. New York: Phaidon Press, 1984.

Bramly, S. *Discovering the Life of Leonardo Da Vinci*. New York: Edward Burlingame Books, 1988.

Bullough, D. *The Age of Charlemagne*. New York: Exeter Books, 1965.

Camille, M. *Gothic Art: Glorious Visions*. Prentice-Hall, 1996.

Cole, A. *Virtue and Magnificence: Art of the Italian Renaissance Courts*. New Jersey, Prentice-Hall, 1995.

Follet, K. *Pillars of the Earth*. New York: Penguin Group, 1990.

Grössinger, C. *Picturing Women in Late Medieval and Renaissance Art*. Manchester University Press, Manchester, England, 1997.

Gutmann, J. *Hebrew Manuscript Painting*. London: Chatto and Windus, 1979.

Harbison, C. *The Mirror of the Artist: Northern Renaissance Art in its Historical Context*. Prentice-Hall, 1995.

Hartt, F. *Italian Renaissance Art*. New Jersey: Prentice-Hall, 1974.

Hauser, A. *The Social History of Art: Renaissance, Mannerism, Baroque*. New York: Vintage Books, 1997.

Janson, H. and Kerman, J. *A History of Art and Music*. New York: Abrams, 1968.

Johnson, M. *The Borgias*. New York: Holt Rinehart and Winston, 1981.

Kitzinger, E. *Early Medieval Art*. Indiana University Press, 1964.

Kristeller, P. O. *Renaissance Thought and the Arts: Collected Essays*. Princeton University Press, 1980.

Manchester, W. *A World Lit Only by Fire: The Medieval Mind and the Renaissance—Portrait of an Age*. New York: Little, Brown, and Company, 1992.

Metropolitan Museum of Art. *Treasures of Early Irish Art 1500 BC–1500 AD*, New York: 1977.

Musée Condé, Chantilly. *The Très Riches Heures, of Jean, Duke of Berry*. New York: George Braziller, 1969.

Paoletti, J. T. and Radke, G. M. *Art in Renaissance Italy*. London: Calmann and King, 1997.

Petzold, A. *Romanesque Art*. New York: Prentice-Hall, 1995.

Rabb, T. *Renaissance Lives: Portraits of an Age*. New York: Pantheon, 1993.

Saslow, J. M. *Ganymede in the Renaissance: Homosexuality in Art and Society*. Yale University Press, New Haven, CT, 1986.

Sullivan, E. *Book of Kells*. New York: Crescent Books, 1986.

Tinagli, P. *Women in Italian Renaissance Art: Gender, Representation, Identity*. Manchester University Press, Manchester, England, 1997.

Tuchman, B. W. *A Distant Mirror: The Calamitous 14th Century*. New York: Knopf, 1978.

Wallace, W. E. *Michelangelo: The Complete Sculpture, Painting, Architecture*. New York: Beaux Arts Editions, 1998.

Whiting, R. *Leonardo: A Portrait of the Renaissance Man*. New Jersey: Wellfleet Press, 1992.

Zarnecki, G. *Art of the Medieval World*. New York: Prentice-Hall, 1975.

6

Art After the Renaissance

By the middle of the 16th century, the art of certain areas of Italy had moved into a style called Mannerism. The artistic lessons of the Renaissance had focused on how to create a believable three-dimensional world on a flat two-dimensional surface. The Mannerists, having achieved this goal, looked beyond it to the imagination, into the psychological, emotional, and spiritual landscape of the artist's own mind. Distortion, elongation, mystery, and spirituality inhabit these strange, yet compelling paintings and sculptures.

The 17th century is known as the Baroque era. Artistic styles are separated by political lines, as countries emerged, borders shifted, and unique cultural identities were formed by politics, religion, and economics. In Italy, the Baroque period is manifested in visually expansive, opulent, ornate, and emotionally expressive painting, sculpture, and architecture. In France, painting takes on the look of Classicism, concentrating on controlled, balanced, and idealized imagery. Architecture also embraces the Classical model but is more elaborate. In the newly formed Protestant country of Holland, the Baroque is characterized by paintings that would appeal to the rising and very wealthy merchant class, while in Belgium the Catholic Church was still the major patron of the arts.

The 18th century is called the Rococo period. It was the last age of the aristocracy in France. Revolutions in both America and France would radically change politics and the role of monarchies in England and France, and would open the door to the modern age of industrialism and technology that began in the 19th century. Rococo art is filled with contradictions, framed as opposites, and reflective of a society

at odds with itself and the vast differences between the privileged and the poor. There are images of incredible wealth and power as shown in the portraits of the aristocracy. They are depicted in a rarified atmosphere of privilege—a world perfumed and powdered and completely insulated from the harsh realities that the majority of their subjects were living. There are also depictions of the common folk, attending to their daily tasks with simplicity and piety, while the low and most vile aspects of humanity are also portrayed. In the end, revolution would prevail and the best and the worst of human capacities and capabilities would be realized in the ensuing upheavals.

Mannerism

Mannerism is a style used to designate the works produced in Florence and Rome from about 1525 until 1600 when the Baroque period began. In Venice, Mannerism began in the latter part of the 1500s. Artists of the Early and High Renaissance had used the studious and direct observation of the natural world to develop their styles, along with mathematical perspective to create believable evocations of a three-dimensional world on a two-dimensional surface. But by the time of Raphael's death in 1520, all the problems associated with the development of this "window" into the world of the canvas had been solved. The next generation of artists took their models from their own personal inner visions and subjective realities. The harmony and serenity seen in the works of the Renaissance gave way to the distortion, excess, and anxiety of Mannerist art.

Mannerism is characterized by figures that are placed in mysterious spaces and dreamlike settings. They are arbitrarily elongated and distorted, and twisted into impossible poses. Many times there is a cool detached eroticism that belies the emotion of the scene. At other times, the figures can exhibit tremendous emotion, yet the setting is so unhinged from reality it is difficult to identify the source of angst. Colors are often improbable, saturated, and jewel-like. Many of the works exhibit a slick surface of textures that appear solid, hard, and metallic.

Parmigianino's (1503–1540) *Madonna With the Long Neck*, 1535, is typical of the period. In this work we see many of the stylistic conventions of Mannerism: elongated proportions, jewel-like surfaces, mysterious settings, and cool eroticism. A much attenuated Virgin Mary sits on some sort of chair unseen by the viewer. With cool detachment, she looks at the sleeping infant Jesus, who is also abnormally elongated and poses on her lap as if dead. Mary glances dispassionately at her son with an exaggerated elegance. Her impossibly elongated neck and hand, tiny bejeweled head, and huge hips, thighs and calves, are the hallmarks of Mannerist abstraction.

The Mannerists produced portraiture that is sophisticated and elegant. The distortions of the religious works are toned down. For example, a sitter's elongated hands now portray a sense of gentility and dignity. The cool detachment creates a mood of sophistication and tasteful restraint. The interest in rich color and refined design is manifest in the details of the clothing. Fabrics and jewelry are displayed meticulously,

so that the focus is shared between the elaborate materials and the features of the sitter. In most Mannerist portraits, the distance between subject and viewer is emphasized. However, this is less so in the work of Sofonisba Anguissola (c. 1535–1625) whose portraits of her family and herself display a much more personalized approach. In Anguissola's work, the personality of the sitter is conveyed in more depth through her capturing of the subtle psychological cues that allow us entrance. The glance of the eye, the turn of the mouth, however slight, are astutely observed and recorded.

The situation for women hoping to become artists was difficult, and it is only in the 16th century that we begin to see a few women emerge onto the artistic scene. The reasons are clear. Women were excluded from having a career in the fine arts due to gender roles and stereotyped expectations, along with an inability to obtain a competitive education in the arts. The rare exceptions were usually women who showed early artistic talent and who were born into wealthy, liberal, and aristocratic families. This small handful of women were allowed to pursue their artistic talents, usually through the support of a male member of the family. Sofonisba came from just such a family. Her father recognized her talent and arranged for her to be educated in the arts, going so far as to help her establish a correspondence with Michelangelo. He critiqued her drawings and gave her invaluable advice and guidance.

In Venice, the two late 16th-century painters who dominated painting along with Titian were Jacopo Tintoretto (1518–1594) and Paolo Veronese (1528–1588). Art historians debate whether these two should be considered in the category of the Venetian Renaissance or Venetian Mannerism. Their work is firmly rooted in both camps. Their later paintings were influenced by Mannerism while simultaneously providing inspiration for artists working in the style. Perhaps one of the most well-known Mannerists is El Greco (Domenikos Theotocopoulos, 1541–1614). Born and raised on Crete, which was under Venetian rule at the time, he received his early artistic training there. In 1560 he went to Venice, learning from Titian, Tintoretto, and others. He then went to Rome and studied the work of the High Renaissance painters and the Mannerist painters in Central Italy. Finally, settling in the Spanish town of Toledo in about 1576, El Greco (Spanish for "The Greek") established himself as one of the premiere painters of the Counter-Reformation in Spain. His religious works, filled with the stylistically typical distortions of Mannerism, are uniquely emotional. Using cool colors within predominantly dark canvases, he adds surprising bits of warm reds, yellows, and oranges. Sweeping brushstrokes describe impassioned figures caught up in waves of devotional fervor.

Baroque Art—The 17th Century

The 17th century was a time of great expansionism in Europe. It was an age of intellectual and scientific growth, and an era of exploration, colonialism, and empire building. This explosion of activity was mirrored in the flamboyant qualities of Baroque art. Passionate, extravagant, and dynamic painting, sculpture, and architecture

seem to break out of the controlled and modulated elegance of the Renaissance and enthusiastically embrace the exuberance of the age. Generally, Baroque art is dynamic, colorful, spacious, passionate, sensual, opulent, and extravagant. Although we can apply these attributes to the art of the period, there were a variety of tendencies in the style specific to a number of geographic locations. Therefore, we tend to divide the discussion of Baroque art by country of origin. Scholars differ as to the dates of the Baroque period. Most agree that it covers the entire 17th century (the 1600s), but there is less agreement as to when it ends. Basically, there are two general opinions: One is that the Baroque period ends with the death of Louis IVX in 1715, the other is that 1750 marks the end of the Baroque. For the purposes of this discussion, we will consider 1715 to be the approximate date that Baroque ends and Rococo begins.

A central theme of the age was the conflict between reason and passion in art. The question was "how should one paint?" Should the focus be on draftmanship and line or brushstroke and color? Should the painting be a product of the intellect or the emotions? Is a good painting one that exhibits balance and organization or passionate sensuality? The age was obsessed with these questions. But they were not new. We saw this visually manifest in the Renaissance in the art of Florence and Rome juxtaposed with the art of Venice. Intellect versus emotion was played out in the 17th century in the calm and reasoned work of the French Baroque painter Nicolas Poussin, and the turbulent painterly work of the Flemish Baroque painter Peter Paul Rubens. It would continue in the 18th century between artists illustrating morality and virtue via genre painting, and artists depicting the luxurious frivolity of the aristocracy. In the 19th century the debate would continue with the styles of Neoclassism and Romanticism and remain an issue, to some degree, throughout the 19th century.

Rome was the artistic center of Europe in the first part of the 17th century, as it had been a century earlier during the High Renaissance. The popes set out to make Rome the "most beautiful city in the Christian world, for the greater glory of God and the Church." Although Catholicism had lost some European territory as a result of the Protestant Reformation, it was gaining ground again as it expanded over all parts of the world through its missionary work in the wake of European discovery, conquest, and land appropriation. Rome was home to some of the most admired and beloved master-pieces from the High Renaissance as well as revered pieces of artwork from antiquity. Furthermore, Italian royal courts were considered to be the apex of refined gentility and civilized society. This belief was particularly true in Northern Europe, where countries were just emerging from bitter and bloody religious wars of the Reformation. Rome attracted artists from all over Europe who came there to live, study, and work.

Italian Baroque

Italian Baroque art is most clearly defined by the sculptor Gianlorenzo Bernini (1598–1680). Bernini, a sculptor, architect, and painter, was considered to be the greatest sculptor since Michelangelo, and indeed his work characterizes the aesthetic

concerns of this period in Italy. Bernini's sculpture is alive with expressive energy that seems to burst forth and radiate outward from a central core. It is dynamic, moving away from containment and into the space of the viewer. Because of the expressive and expansive nature of Bernini's sculpture, the work tends to be assertive in actively engaging the viewer in a visual dialogue that requires some degree of participation. His *David*, dated 1623, is just such a piece. Unlike the earlier statues of David, which were self-contained figures depicting either the calm aftermath of action or the contemplative intensity of the action to come, Bernini's *David* is fully engaged in the action. He shows us the figure in the process of hurling the stone, and as such, implies an entire series of movements that we anticipate. David possesses physical, emotional, and psychological presence as his total being is focused on his opponent. The sculpture pulses with life as the implied movement of the figure animates it and electrifies the space around it.

Italian Baroque painting in the early 17th century is best characterized in the revolutionary work of Caravaggio (Michelangelo Merisi, 1571–1610). His paintings represent a new approach to religious themes, which arguably contain more truth and passion for the scriptures than much of what had been previously produced. Prior to Caravaggio, the holy stories were told in standard formats that idealized the images of the apostles, saints, and Christ to elevate their spirituality and separation from the realm of the temporal. As a reaction to this tradition, Caravaggio applied a passionate naturalism to his works, using common men and women as his models and imbuing familiar religious themes with a humble, unpretentious realism.

Along with the skillful use of chiaroscuro to model the figures, Caravaggio manipulates the lighting to create dramatic effects in a technique called tenebrism. Parts of the figures and the setting are submerged in deep shadow, while other areas are brightly illuminated with a concentrated beam of light. Light and shadow are abruptly juxtaposed without intermediate tonal gradations. Caravaggio used the tenebrist technique as a metaphor of revelation. The intense light of God cuts through the darkness of ignorance and disbelief to reveal truth and bring enlightenment. Caravaggio's style was adopted by many Italian Baroque artists, while tenebrism was used throughout the era in many countries by a wide range of artists.

One of the most successful of the Italian Baroque painters who employed the lighting techniques of Caravaggio was Artemisia Gentileschi (1563–1639). The role of women in the arts was seriously curtailed by societal expectations and stereotypes, artistic support, and lack of access to training. However, there were some women who were able to attain artistic success through their unique situations. Sofonisba Anguissola had done it in the 16th century and Artemisia Gentileschi was able to achieve a successful artistic career in 17th-century Italy. Her father, Orazio Gentileschi, was one of Caravaggio's leading followers. He supported Artemisia in her artistic endeavors, arranging for her education and introduction to important patrons. She became one of the leading artistic personalities of her day. Artemisia's personal life was turbulent, and her paintings, using the tenebrist lighting technique, exhibit strong psychological

underpinnings. They are filled with complex arrangements of light and shadow which create a great sense of mystery, tension, and elegance in her work.

Francesco Borromini (1599–1667) was Bernini's architectural rival in Rome. Bernini's expansive double-colonnaded plaza (1657) leading to *St. Peter's Basilica* is extravagant in its sweeping, all-encompassing grandeur while still employing the balance and symmetry of Classicism. Conversely, Borromini's structures are dramatically complex. He uses a new structural vocabulary of undulating curves and countercurves that give his buildings a sense of visual elasticity. The façade of *San Carlo alle Quattro Fontane* (1665–1667, Rome) displays the alternating interaction of concave and convex surfaces. Borromini's style of dynamic movement and surging sensual rhythms, associated with Baroque aesthetics, is masterfully exemplified here.

Spanish Baroque

Diego Velázquez (1599–1660) was the most influential Spanish painter of the 17th century. His early work was greatly inspired by Caravaggio's tenebrism and chiaroscuro modeling. Velázquez's themes in his early paintings are centered on genre and still life rather than religion, yet his works have a character and dignity that invests everyday scenes with spiritual intensity. After being appointed as court painter to Philip IV, Velázquez spent the rest of his career in Madrid mostly creating portraits of royalty and aristocrats. One of his most famous and influential works is *Las Meninas* or *The Maids of Honor*, from 1656. The young princess Margarita and her attendants are shown along with the artist himself. The king and queen of Spain, assumed to be standing in our space and viewing the scene from our vantage point, are merely reflections in a mirror on the back wall. Here we see his mature style in the rendering of light and shadow achieved with the combination of delicate glazes setting off the thick impasto of the highlights. Loose brushstrokes and tonal gradations, rather than strong outline and definitive edges, define the figures in a continuous flow of paint. They seem to be caught off-guard yet they are securely anchored in a moment frozen in time.

Flemish Baroque

A truce in the religious warfare that had plagued Northern Europe was signed in 1609. The result was that the Netherlands became two separate countries. The southern portion, called Flanders and roughly analogous to modern-day Belgium, remained under Spanish rule and was therefore Catholic. The northern area became a sovereign Protestant country corresponding to modern-day Holland. The main patrons of the arts in Flanders remained the Catholic Church and the Catholic aristocracy, whereas in Holland patrons were the newly rising middle class and civic guilds and organizations.

Undoubtedly the most important painter in 17th-century Flanders was Peter Paul Rubens (1577–1640). A man of tremendous energy and talent, he painted for royalty in every court in Europe and received numerous Church commissions. He was so busy

that his workshop employed dozens of assistants. Educated in the humanist tradition, Rubens spoke six languages, and often acted as diplomat and emissary between the European monarchies, where he garnered even more commissions. His work includes every type of subject: Portraits, genre scenes, allegory, religious pictures, mythology, and landscape were all within his realm of expertise.

Rubens's style strikingly manifests one pole of the Baroque debate between line and color, intellect and emotion. His expansive brushwork, sensuous use of paint, and dynamic compositions are the very essence of passion and excitement. The exuberant color and brushstrokes that give his work such energy can be seen in his painting from 1617 entitled *The Rape of the Daughters of Leucippus.*

The mythological twins Castor and Pollux (later to be known as the Gemini twins in the constellation) abduct and marry Phoebe and Hilaeira, daughters of Leucippus. Here we see the twins carrying off the two women in a painting that writhes with action emanating from a central core and spiraling outward. Like the sculpture of Bernini, Rubens's work gives us the sensation that the energy of the figures reaches

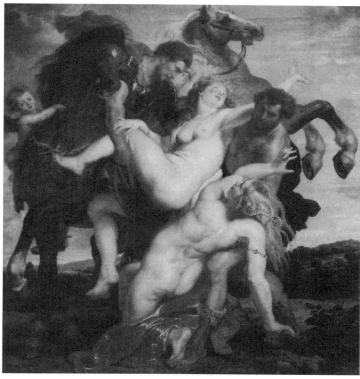

© World Films Enterprises/CORBIS

Peter Paul Rubens, *Rape of the Daughters of Leucippus,* 1617, oil on canvas, 7' × 7'.

beyond the space they inhabit and into that of the viewer. The female figures form two opposing curves with their torsos. Their gestures, along with the positioning of the male figures and horses, move the action into a massive swirling composition. Rubens's luxuriously fleshy and white-skinned females, a hallmark of his style, are then contrasted with the muscularity and dark tones of the male figures. Hair and drapery fly, horses rear up, and arms flail with centrifugal force that pulls the viewer into the heart of the action.

Anthony van Dyck, an assistant in Rubens's workshop, was the only other Flemish master in the 17th century to achieve a great degree of international stature. Painting mainly for the English aristocracy, van Dyck created a new style of portraiture that would have considerable influence in the 18th century. His figures, placed into idyllic landscapes or Classical settings, are more relaxed and less rigid than in the formal state portraits so popular at the time. Van Dyck's subjects are grandly conveyed and self-confident, yet more at ease in their surroundings. His formal portraits create an air of informality with the pose more momentary and the mood less stilted.

Dutch Baroque

In Flanders Rubens dominated the artistic scene and the patrons of the arts were the Catholic Church and the aristocracy. However, Holland (the Netherlands) was a constitutional republic and a Protestant country, having declared its independence from Catholic Spain in 1581. As the Protestant Church did not allow for religious paintings or the decoration of their churches, there was no religious patronage for the arts. Furthermore, as Holland was a republic, there was also no royal patronage. Dutch artists were dependant on the sale of their works to their wealthy countrymen. Holland was a nation of merchants, farmers, and seafarers. In the 17th century they gained vast colonial holdings in Asia, Africa, and the Americas. The Dutch East and West Indies Companies brought tremendous wealth into the Netherlands, and with that, the ability of the economically advantaged middle and upper classes to become powerful patrons of the arts dramatically increased.

Coming from Northern Renaissance artistic traditions, there was a tremendous interest in a very detailed observation of the natural world. Patrons wanted to see paintings that were a reflection of their own lives, of the people and the objects that surrounded them. The influence of the Northern Renaissance continued in the notion of disguised or secondary symbolism which imbued common objects with religious or moral meanings. Dutch artists maintained this tradition of double meanings thus creating a style of artwork that is unique to the Netherlands.

Dutch artists focused their energies on the types of paintings that would appeal to this new type of patron: portraits, still lifes, domestic scenes, genre scenes, and landscapes. Painters specialized and made their reputations by focusing on one particular type of painting that they became well known for. Merchants and farmers alike developed an insatiable desire for pictures. Paintings became a commodity and a symbol of

status. Art production followed the capitalist laws of supply and demand. Like the 17th-century phenomenon of Tulip Mania, Dutch citizens developed a kind of collector's mania that swept the country. One visitor to Holland wrote in 1641:

> . . . it is an ordinary thing to find a common farmer lay out two or three thousand pounds in this commodity [painting]. Their houses are full of pictures, and they vend them at their fairs to very great gain.

Although most Dutch painters did not go to Italy, Caravaggio's style came to Holland through the city of Utrecht, which maintained stronger ties with Catholic Flanders than did the rest of the country. Italian Baroque methods of representation were transmitted to Dutch artists who used their techniques in uniquely individualized ways. The most important portrait painter from the city of Haarlem was Frans Hals (c. 1580–1666). Characteristic of his style are the painterly brushstrokes that he uses to suggest that he is capturing his sitter in a quick, impromptu moment. This illusion of a split-second technique that arrests a single moment in time is enhanced by the positioning of the figures and objects, and by the expressions on their faces. They are often positioned in an off-center, diagonally oriented or obliquely positioned pose; their gestures and facial expressions are momentary and changeable. The implied spontaneity is belied by the strong modeling of the figure and the use of carefully considered and dramatic lighting. His work has the immediacy of a sketch combined with telling details that bring us into the emotional or psychological space of the subject.

Group portraits were popular in the Dutch Republic and were often commissioned by civic groups and guilds. The pictures were designed not only to show the individual members of the association, but also to depict the single unified personality of the group. These portraits give us significant information about the sociological and aesthetic aspects of Dutch life. Placed in important public buildings, they provided citizens with a reflection of their collective lives and the emphasis on social identity and civic leadership. Hals devised a looser style of group portraiture, breaking away from a simple horizontal row of figures placed in a stiff and stable setting. He created a more organic relationship between the sitters, showing them in different poses and often interacting with each other and with the viewer through gesture and glance.

Judith Leyster (1609–1660) became the first woman to join the Haarlem Painters' Guild. Leyster was considered to be an important painter in her day. However, her work was later overshadowed by Hals, in whose studio she trained for a time. Her paintings, often compared with Hals's, were considered to be derivative of his in later centuries. However, her choice of subject matter was more varied and her line and brushwork more precise. Leyster's understanding of Caravaggio's work led her to create paintings of great mood and atmosphere, and her intimate domestic scenes are said to have influenced the work of Vermeer.

Rembrandt (Rembrandt van Rijn, 1606–1669) is the most well-known of the Dutch painters and certainly one of the most famous painters in Western European art. His early work, done in the city of Leyden, expresses his familiarity with Caravaggio's

lighting techniques, which he, as well as other Dutch painters, had derived from the Utrecht School. In typical Baroque fashion, his figure groupings are filled with action and seem to burst forth from the containment of the canvas, implying action that extends into the viewer's space. This vigorous activity, detailed depiction, and strong contrasts of light and shadow secured his reputation as one of the leading painters in Holland.

After moving to Amsterdam in the 1630s, Rembrandt became the most sought-after portrait painter of the age, gaining great wealth and fame. His portraits of prominent citizens brilliantly portray the personal characteristics of his sitters with a casual nonchalance. Similarly, his history and Biblical paintings encompass more psychological, emotional, and intuitive aspects than his artistic contemporaries'. Perhaps his most telling paintings are his numerous self-portraits. We can read these as a pictorial autobiography. His portraits take us from a young man full of great promise and high hopes, to the height of his career, to the depths of despair. In the 1640s his fortunes and popularity waned and, at the same time, his wife and children died. His self-portraits are honest and pitiless in their portrayal of physical and emotional aging. Unafraid to show himself ravaged and careworn, we see the unflattering aspects of the aging process and the dissection of his own psychological journey.

In his religious pictures, Rembrandt develops the emotional interaction between the characters, humanizing them in ways that allow the viewer to enter into the psychic space of the participants and feel their spiritual pull. In *The Return of the Prodigal Son* (1665), painted just four years before his death, he creates a solemn ambiance filled with an atmosphere comprised of rich reds, golden tones, and the thick impasto application of paint. Without overdramatizing the scene, he captures the spiritual stillness of the moment when the son, kneeling before his father, is pardoned despite his many transgressions. Rembrandt makes this a deeply moving evocation of kinship and forgiveness. The other sons, placed on the right of the picture plane, emerge from the soft, shadowy background in varying degrees of clarity. The artist places the main figures of father and son to the left of the painting, thereby leaving the central area open and clear for the viewer to visually enter and share the moment.

Jan Vermeer (1632–1675) worked in the city of Delft during his short lifetime, dying at the age of 43 and leaving a wife and eleven children. Vermeer's style is the opposite of Rembrandt's. His approximately thirty-five known works are supremely dominated by a meticulously controlled technique that captures, with thrilling accuracy, the details of life set down in clear, timeless, and subtly persuasive precision. His interest in the way that light defines form, and his use of bright, pure, and glowing colors, is reminiscent of Jan van Eyck's paintings. Restricting himself mainly to domestic genre scenes, Vermeer paints in a direct manner, offering up a quiet, calm world where women engage in the mundane tasks of daily life, seemingly unaware that we, the viewer, are observing them. There is an internal magic to his paintings that is created by the defining aspects of beautifully lighted surfaces, rich colors, and refined draftsmanship. The delicacy of his brushstrokes and the details he depicts allow the

viewer to palpably comprehend the textures and designs of a rug, the shiny reflection of silver, or the gleam of a pearl earring. Like artists of the Northern Renaissance, Vermeer's painstaking exactitude envelopes even the simplest of scenes with a certain spirituality and reverence.

Often he constructs the canvas in such a way that we feel we are eavesdropping. In *The Letter* (1666) he constructs the canvas so that our point of view is outside the room where the main action takes place. We are allowed only the central third of the painting in which to view the two female figures. Brought into the perspective depth of the painting through the receding floor tiles, we see a maid delivering an unopened envelope to her mistress. This lady of the house is dressed in rich satin and furs, and is seated with a lute on her lap. A secret exchange of glances unites the maid and mistress as the letter exchanges hands. Vermeer fills the painting with symbolism. The lute signifies love or lovers who play each other's heart strings, while the picture of the ship on calm seas and the idyllic landscape above it denote the smooth relationship between lovers. Of course, the letter has not been opened, so its impact cannot yet be determined. Thus, a certain tension exists which is further enhanced by the secretive nature of the exchange. Perhaps this is a woman already married, who has just received a letter from her lover. Perhaps our point of view into the room is that of the husband's who will soon discover the deception. Although there are no definitive answers, Vermeer certainly presents some tantalizing questions.

Dutch still life paintings are miraculous renderings of remarkable detail. In lush floral arrangements and abundant displays of food, drink, and luxury items, paintings mirror the wealth and prestige of their owners. With extraordinary focus, the most minute details are exquisitely rendered. The metallic sheen of a silver plate becomes a mirror for the Oriental rug it sits upon. An ornate glass goblet prismatically reflects tiny multiple images of the items around it. A half-peeled orange oozes its sweet juice in luminous droplets onto a rich mahogany table. Overtly bountiful and lavish, these still lifes are vehicles for teaching moral lessons. Look closely at the flowers and notice a snail eating a leaf, falling petals, or a withered stem. Examine the food and see the overly ripe fruit or the half-eaten meal. These paintings deal with the theme of Vanitas (the vanity of earthly pleasures). As plentiful as the images are, they remind the viewer that earthly pleasures pass, that life is brief, and that vanity, greed, gluttony, sexuality, money, and material goods will all fade away. Vanitas go back to the disguised symbolism of the Northern Renaissance. To the 17th-century Dutch population, many of whom had become recently and fabulously wealthy through trade and speculation, Vanitas were a moral reminder of the impermanence of worldly goods and exotic luxuries.

French Baroque

Under Louis XIV (1638–1715) France became the most powerful country in Europe, and the cultural capital of the western world. People looked to France as the arbitrator of fashion, refinement, and taste. Louis XIV built the grand palace at Versailles as a

visual manifestation of his absolute and divine right to rule, and of the glorified place that the French aristocracy held in France and throughout the world. Nicknamed the "Sun King," as it seemed that the world revolved around him, he ruled France from 1660 to 1715. In 1648, the Académie Royale de Peinture et de Sculpture (the Royal French Academy of Art) was established. Under Louis XIV's rule, it became one of the most celebrated schools of art in Europe. A spot in its yearly juried exhibition, the Salon, was coveted by artists everywhere as a distinctive validation of their work and a key factor in acquiring important commissions. With the advent of the Royal French Academy, French art took a leadership role that would remain intact until the mid-20th century.

Louis was able to tap the best talents in France to create works of art that glorified himself and his reign in the grand manner that he approved of. His aesthetic sensibilities, which leaned decidedly toward Classicism, set the tone for the Academy. Under Charles Le Brun (1619–1690), royal painter to Louis XIV and director of the Academy, a rigid system of compulsory education was established. Students were rigorously trained in a program that was very difficult to enter and that was extremely competitive. A full knowledge of drawing techniques was mandatory and began with the copying of master etchings, then moved to plaster casts of Greek art, and finally to the live model. It was only after drawing was technically perfected that the student was allowed to pursue painting. Le Brun also established a hierarchy of subject matter. History painting was considered the highest and most noble form, followed by religious subjects. Mythology was also deemed suitable, particularly those themes based on Ovid's works such as the extremely popular *Metamorphoses*. Thus, Louis was assured that artists matriculating from the Academy would produce art in the manner, style, and subjects that he favored. The Academy would remain a dominant force in French art into the 20th century, articulating the conservative manner that avant-garde artists rebelled against.

The Classical aesthetic preferences of Louis XIV and Le Brun, and thus of the Academy, led French Baroque painting to be quite different than in other parts of Europe. Nicolas Poussin (1594–1665) was one of the most important French painters at the time and had been Le Brun's teacher. Poussin's work exhibits the balance, restraint, intellect, and reason that had defined Greek sculpture from the 5th century B.C.E. French Baroque painting, as typified in Poussin's work, represented noble and serious themes such as historical events, religious stories, mythological scenes, and famous battles. His work is based on the elevated visual language of Classicism, appealing to the mind rather than the senses, and suppressing color while stressing form and composition. His compact and balanced figure groupings, reserved mood, and mathematically precise pictorial space provide the counterbalance to Rubens's colorful and emotionally turbulent paintings which were considered by the Academy to be a very low form of artistic expression.

Poussin's figures are idealized and placed in landscapes that are orderly and rational or into carefully constructed battle scenes. This is not how nature really

Nicolas Poussin, *The Adoration of the Golden Calf,* 1633–1634,
60" × 83".

looks. It is how nature would look if arranged by Poussin. It is not how war really looks, but rather how it would look if directed by Poussin. The intellectualized, balanced, and modulated style of French Baroque painting exerted a tremendous influence on Academic painting for generations to come.

While Poussin set his classically idealized figures into landscapes that were designed to call to mind strength, virtue, and morality, Claude Lorraine (1600–1682) developed the idealized idyllic landscape. Figures were incidental to Claude's work and were placed there to impart a sense of scale. The real subject of his paintings was the landscape itself. An interest in soft lighting effects bathed his land and seascapes with luminosity. Nature, in its perfectly tamed form, was constructed of feathery trees, gently rounded hills, and sparkling sun-drenched harbors. His nostalgic moods, created with light and color, set the tone for much of 18th-century Academic landscape painting. Additionally, for 19th-century Romantic landscape painters, Claude's work paved the way for a renewed interest in nature as a way to express emotion and mood.

French Baroque architecture is based on classical motifs and strict formal organization. The royal hunting lodge at Versailles was transformed into a resplendent palace that reflected Louis's grandeur and power as an absolute monarch. Versailles brought together the finest architects, designers, and painters of the day. The sumptuous interior spaces and magnificent gardens are exquisitely crafted with controlled symmetry. Its magnificence became a model for other European monarchs as the representation of political power and prestige. Designed by Louis Le Vau (1612–1670) and Jules Hardouin-Mansart (1646–1708) and decorated by Charles Le Brun, the exterior of

Versailles is classically elegant, while the interior is encrusted with elaborate surfaces and glittering decoration. Le Brun, the king's favorite painter and a follower of Poussin, set his refined classicism aside to create an interior of luxury and ostentation. The space encapsulated all the pomp, ambition, and opulence of the Sun King.

Rococo Art—The 18th Century

The 18th century gave rise to a number of changes that would eventually end the world born of the Renaissance and begin the modern age. With the death of Louis XIV in 1715, the aristocracy that had surrounded him at Versailles felt a sense of freedom not previously possible under the domineering monarch. Many of them moved away from the palace and took up residence in Paris, decorating their townhouses in the most ornate and sumptuous manner possible. Similarly, the stranglehold that the king and Le Brun had on the Academy began to loosen. Not surprisingly, two distinct artistic factions arose: the Poussinistes (those that considered themselves followers of Poussin), and the Rubénistes (those who considered themselves followers of Rubens). The Poussinistes maintained a conservative approach to art based on French Baroque models of Classicism as exemplified in Poussin's paintings. They asserted that strong draftsmanship, as displayed in precise drawing, appealed to the intellect and was therefore a more valid form of expression. The Rubénistes insisted that color had far more value in painting as it appealed to the emotions which everyone could understand, whereas drawing only appealed to the intellectual few. In the 18th century, it was the Rubénistes who dominated the Academy. The debate that had formulated with the establishment of the Royal French Academy began to grow and would continue to manifest throughout the 18th and 19th centuries.

This was an era that began with subtle changes and ended with monumental upheavals that altered the entire political landscape of Europe and America. These were preceded by a philosophical transformation in the way that people viewed the world. Early in the century great thinkers in England, France, Germany, and the American colonies like Voltaire, Rousseau, Hume, Diderot, Franklin, and Kant formulated The Enlightenment. These writers, responding to traditional European politics and a class system established in the Middle Ages, pushed for reforms and limits on the monarchy and the privileges afforded the Church. They believed that reason and common sense were the cures for social ills and aristocratic and ecclesiastic excesses. The forces of change were gathering, and while old patterns of society were maintained in the first half of the century, the second half would prove to be explosive. The nobility in France were becoming obsolete, and although they did not realize it, this was to be their last few decades of superiority and dominance.

Eighteenth-century painting is fascinating in that it encompasses the many aspects of the period in a variety of styles that express the tremendous divergences that occurred. For the aristocracy, life was extravagant, luxurious, and frivolous. They

lived life in the pursuit of pleasure, devising elaborate theatrical entertainments, clever games, and intricate intrigues. They built an insulated world of sensual pleasures that shielded them from the harsh realities of poverty and the political and social unrest that was beginning to foment outside the rarified world they had created for themselves. French painters of the court of Louis XV give us an intimate look at this grandiose lifestyle.

The work of Antoine Watteau (1684–1721) introduces the age with canvases filled with representations of fête galantes (elegant entertainments) and acts of seduction. Young and beautiful nobles dressed in satin and lace flirt and frolic in idyllic, dreamlike landscapes. Feathery brushstrokes loaded with color define the graceful and elegantly clad figures. François Boucher (1703–1770) succeeded Watteau as the favorite painter at the court of Louis XV. His patron Madame de Pompadour, the mistress of the king, promoted his career in the royal court. Boucher concerned himself with love, eroticism, and sensuality. As the Director of the Royal French Academy, he was considered to be the most important painter of his day, and was much celebrated for his depictions of goddesses and nymphs cavorting with erotic frivolity in fantasy landscapes. His light palette, pink and pearly flesh tones, and juicy painterly style create an atmosphere of perfume and powder that mirrors the amazingly decadent and trivial concerns of the landed gentry. Boucher's favorite pupil, and the artist who inherited his place at court after his death, was Jean-Honoré Fragonard (1732–1806). Fragonard was, first and foremost, a colorist of tremendous talent. His glowing pastels and fluid spontaneous brushstrokes create images of lighthearted and graceful superficiality set in pastoral settings filled with pink and golden light. Oftentimes, his landscapes are overtly sensual as a reflection of the action taking place. Prior to the Revolution, Fragonard was hailed as a genius of the art world. In its aftermath he died alone, penniless and forgotten.

Rococo art as practiced by these three court painters, as well as others, is a fascinating documentary on the lavish and licentious nature of the French court in the 18th century. However, this style of painting was not the only one open to artists at the time.

As the power of the middle class rose, they too were able to become patrons and their taste leaned more toward genre scenes and still lifes. One of the most important painters in this vein was Jean-Bapiste Chardin (1699–1779). Chardin was a master of the subtle nuanced beauty to be found in the commonplace. In the tradition of the great Dutch Baroque painters, his subject matter was domestic simplicity. His specialty was interior scenes that appear to give an honest insight into the character and nature of his subjects, imbuing them with a solidity and reverence. Chardin's main subjects are servants in wealthy households. They are illustrated as solid, humble folk who possess an innate goodness and morality that is, perhaps, in contrast to their employers. Every aspect of Chardin's work evokes the substance of reality, yet it is quite different from the hyper-realism of Dutch genre scenes.

This new naturalism in French Rococo painting corresponds to Enlightenment writing of the era. Diderot wrote of Chardin:

> O Chardin! It is not red, white, and black you mix on your palette: it is the very substance of objects, it is the air and the light you take with the tip of your brush and fix on the canvas.

Interestingly, the patrons of Chardin's work were not just the rising middle classes, but the aristocracy as well. His work was collected by the King of Sweden, Madame du Pompadour, and Catherine the Great of Russia. Perhaps it was the reassuring contrast between the social classes that they found attractive. Or, maybe in their world so consumed with artifice and artificiality, it was the unattainable comfort of reliable and predictable domesticity that engaged them.

The move toward greater naturalism, even within the royal court in the latter part of the century, can be seen in the work of Élisabeth-Louise Vigée-LeBrun (1755–1842). Her father, Louis Vigée, was a well-known pastel portrait painter and saw to it that her remarkable innate talent was supported through training from many sources. At the age of 15, she already had a clientele for her oil portraits. After her marriage to the artist and art dealer Jean-Baptiste Le Brun, the great-nephew of Charles Le Brun, she continued to paint and exhibit her work. Her portraits gained her an international reputation that brought her into the court of Marie-Antoinette, Queen of France, where she became the personal painter to the Queen, painting over thirty portraits of her. When the royal family was imprisoned, Vigée-LeBrun left France with her daughter and traveled throughout Europe for twelve years. Supporting herself with portraits commissioned by European royalty, she was finally able to return to France in 1805. Although she continued to paint, she never reached the heights of fame and fortune that she had in pre-revolutionary days.

Vigée-LeBrun's work moves away from the stilted artificiality of royal portraiture, and infuses the genre with a refreshing naturalism. Her subjects are portrayed as open and accessible, often placed right in the foreground and making direct eye contact with the viewer. Instead of the Rococo frills and perfumed cosmetic atmosphere, they appear in far less pretentious clothing, and without the ostentatious backdrops. Instead, they are placed against a neutral background and directly against the picture plane. The lower half of the body is cropped so that they seem almost to be in our space. Rather than appearing stiff or mannered, her sitters exhibit a relaxed positioning, direct gaze, and spontaneous air. She captures warmth and personality in her sitters. This type of portrait painting is innovative and in tune with the changing attitudes of the times. The Enlightenment called for natural feeling and emotion as a departure from the affected pretentions of wealth and privilege. Although Vigée-LeBrun remained a loyal royalist her entire life, her work heralds artistic changes that are reflective of the altering political landscape of the late 18th century.

The two most prominent English Rococo painters were Thomas Gainsborough (1727–1788) and Sir Joshua Reynolds (1723–1792). The artists were rivals; their differing philosophical stances on the proper nature of painting typified their artistic output. Both were portrait painters, as that was the most lucrative type of art for English painters. Gainsborough preferred landscape painting, but as the market was not sufficient, he contented himself with portraits for which he was in great demand by British society. Gainsborough's style could convey the cool elegance of a wealthy sitter with all the Rococo flamboyance of rich textures and flowing drapery. On the other hand, he, like Vigée-LeBrun in France, was moving toward a more natural style, and some of his later portraits are exquisite in this respect. Often placing his female subjects in a softly constructed and harmoniously idealized landscape, he rendered them in simple unadorned drapery, matching the natural beauty of nature with their own innate loveliness.

Sir Joshua Reynolds took a more academic view of art and insisted that painting should be in the grand manner of Charles Le Brun and Nicolas Poussin. He was the president of the English Royal Academy of Art, founded in 1768, and he insisted on a much more formalized and rigorous approach. Reynolds would often clothe his sitters in costume and place them in elaborate settings to elevate them to the status of history or mythology painting. However, Reynolds too moved toward a more naturalistic approach as the century wore on. Many of his later portraits exhibit an uncompromising realism that is intent on capturing the personality of the sitter without idealization.

In Italy, one of the great Rococo painters was Giovanni Antonio Canaletto (1697–1768). Canaletto was a landscape painter from Venice who studied in Rome and then returned to his native city to paint typical Venetian scenes. His carefully constructed pictures of the famous Venetian canals, city life, and festivals were appealing to travelers, particularly from England. Wanting to take the warmth of Southern Europe back to the colder climates, Canaletto's paintings were like picture postcards. His clearly defined and precisely detailed depictions are clever arrangements that recreate the mood of the city. Reflections from the canals bathe the buildings in light and color. Meticulous perspective gives the viewer a vast panorama of the bustle of daily life and the romance of this unique city on the water.

The tides of change picked up tremendous speed in the late 18th century. In the American Colonies, the battle for Independence from England had begun, and in France the wonton lavishness of the French Rococo Court heralded their impending downfall. There was a new sensibility and a spirit of criticism toward the old regimes. There was a move toward rebellion against the perceived false, calculating, and artificial Rococo era. Natural feelings, true thoughts, and sincere emotions coupled with heroism, civic duty, and revolutionary passions dominated society and politics. Out of the turmoil the modern world would be born.

DISCUSSION QUESTIONS

1. Consider one of Raphael's madonna paintings and compare it with Parmagianino's *Madonna with the Long Neck*. What has changed between the High Renaissance and Mannerist styles? Describe the composition and organization of forms and the aesthetic considerations in depicting the figures.

2. Using Bernini's *David* and Michelangelo's *David*, discuss each artist's interpretation of the theme. Discuss the physical form, emotional content, and the relationship of the figure to the space around it. How does each work fit into the artistic period and historical context in which it was created?

3. Poussin and Rubens are considered to be the two poles in the Baroque debate between the forces of reason and passion. What characteristics in the work of each artist reflect their attitudes? Discuss the history of the debate going back to the artistic concerns in the High Renaissance between the work produced in Florence and Rome with that of Venice.

4. Discuss the differences in Baroque art between Flanders and Holland. Use specific examples of work from each area to discuss the political, social, and religious differences that impact both the iconography and the formal elements.

5. Discuss the use of light in a Caravaggio painting as compared to a painting by Boucher. How does light affect color? How does light help create mood?

6. Compare and contrast a painting by Vermeer with a work by Chardin. How does each artist model the objects via color, brushstroke, light, shadow, and dimension? What is the same and what is different? What mood is the same in each painting and how does the artist achieve it through the formal elements?

7. How does Watteau's work reflect Rococo art? How does the work of Vigée-LeBrun differ from Watteau's yet remain representative of Rococo art?

8. What do you see as the differences between the paintings of Gainsborough and Reynolds? Give examples to support your statements.

9. Pick a self-portrait by Rembrandt and compare it to van Eyck's *Man with the Red Turban*. What do you see as the similarities and the differences? Explain your answers using examples from each painting.

10. Using the façade of *San Carlo alle Quattro Fontane* and the façade of *Versailles*, discuss the differences between Italian and French Baroque architecture.

BIBLIOGRAPHY

Bazin, G. *Baroque and Rococo Art*. New York: Praeger, 1969.

Berti, L. *The Uffizi*. Florence, Italy: Becocci/Scala, 2000.

Broude, N. and Garrard, M. (eds.). *Feminism and Art History: Questioning the Litany*. New York: Harper and Row, 1982.

Burroughs, B. *Vasari's Lives of the Artists*. New York: Simon and Schuster, 1946.

Chadwick, W. *Women, Art, and Society*. London: Thames and Hudson, 1990.

Franits, W. *Dutch Seventeenth-Century Genre Painting: Its Stylistic and Thematic Evolution*. New Haven, CT: Yale University Press, 2004.

Garrard, M. *Artemisia Gentileschi*. New Jersey: Princeton University Press, 1989.

Gaunt, W. *Flemish Cities: Their History and Art*. London: Elck, 1969.

Harris, A. S. and Nochlin, L. *Women Artists: 1550–1950*. New York: Knopf, 1976.

Hauser, A. *The Social History of Art: Renaissance, Mannerism, Baroque*. New York: Vintage Books, 1997.

Holt, E. (ed.). *A Documentary History of Art: Michelangelo and the Mannerists: The Baroque and the Eighteenth Century*. New York: Doubleday, 1958.

Jaffe, D. and McGrath, E. *Rubens: A Master in the Making*. New Haven, CT: Yale University Press, 2005.

Liedtke, W., Plomp, M., and Ruger, A. *Vermeer and the Delft School*. New York: Metropolitan Museum of Art, 2001.

Nochlin, L. *Women, Art, and Power and Other Essays*. New York: Harper and Row, 1988.

Perlingieri, I. S. *Sofonisba Anguissola: The First Great Woman Artist of the Renaissance*. New York: Rizzoli, 1992.

Prater, A. and Bauer, H. *Painting of the Baroque*. Germany: Taschen, 1997.

Slatkin, W. *Women Artists in History: From Antiquity to the 20th Century*. New Jersey: Prentice-Hall, 1985.

Starcky, E. *Rembrandt: The Masterworks*. New York: Portland House, 1990.

Taylor, J. *19th Century Themes of Art*. Berkeley: University of California Press, 1987.

Wallace, R. *The World of Rembrandt: 1609–1669*. New York: Time-Life Books, 1968.

Westermann, M. *A Worldly Art: The Dutch Republic 1585–1718*. New York: Abrams, 1996.

Wheelock, A. and Broos, B. *Johannes Vermeer*. New Haven, CT: Yale University Press, 1995.

Wright, C. *The French Painters of the Seventeenth Century*. Boston: Little, Brown, 1985.

Zuffi, S. *Baroque Painting: Two Centuries of Masterpieces from the Era Preceding the Dawn of Modern Art*. New York: Barron's, 1999.

7

The Modern World

There is no specific date that we can pinpoint for the beginnings of modern art. Art, like life, is fluid and responds to the ebb and flow of many factors. While some artists continued to hold onto traditional formats and subject matter, others moved toward experimentation in both form and content. Generally speaking, scholars tend to say that the beginning of the modern period coincides with the great political revolutions of the late 18th century: the American Revolution, beginning in 1776 with the Declaration of Independence, and the French Revolution beginning with the calling of the Estates-General in 1789.

Similarly, the distinction between the modern period and what is considered contemporary art is nebulous. Certainly, contemporary life is what we are currently living and contemporary art is what is currently being produced. But when does *modern* end and *contemporary* begin? Some scholars think of contemporary art as what has been produced within the last thirty years. Others believe that modern art ends in the mid-1970s with the advent of *post-modern* developments in art and architecture that directly break the linear progression of Clement Greenberg's formalist theories as described in Chapter 3. For the purposes of this chapter, we will take the latter definition of Modern Art.

Perhaps there is no other period in history that covers so many monumental events or has had such far-reaching consequences. The two revolutions that began the era ushered in a tremendous change. England lost its hold in North America while the original thirteen colonies became the United States of America and began the great democratic experiment. Subsequently, the governmental structure in France disintegrated, bringing

an end to aristocratic rule and monarchy in France. Additionally, the Industrial Revolution changed the face of Europe and America in the 19th and early 20th centuries. The repercussions were felt and continue to be felt in all walks of life: art, technology, social structure, politics, city planning, environment, and health to name just a few areas of influence. Meanwhile, the 20th century experienced the end of European colonialism, two world wars, and countless other conflicts. The end of slavery in the United States, the end of Apartheid in South Africa, the Cold War, the Civil Rights movement, and numerous social revolutions and social problems have arisen in the 19th and 20th centuries. It has been a time of vast changes, alternate periods of stability and uncertainty, great good, and massive destruction. We have inherited this world, and are products of it. Modern art is the visual manifestation of all of this.

Neoclassicism

Two art movements begin the modern era: Neoclassicism and Romanticism. The Neoclassic style arose in the late 18th and early 19th centuries in response to the changing politics in Europe and North America. Neoclassicism was first developed theoretically through the writings of Johann Winckelmann. Artists and intellectuals working with Winckelmann saw the importance of Neoclassicism as a vehicle to express their reaction against the current excesses of the French aristocracy as displayed in Rococo art.

Inspired by the discoveries at Pompeii and Herculaneum and the Greek marbles brought to England from the Parthenon by Lord Elgin, Winckelmann spoke of Greek and Roman art and culture as being the high point of civilization. European artists like Swiss-born Angelica Kauffmann, Frenchman Jacques-Louis David, and American artist Benjamin West used the new style to evoke a sense of rationality and give visual expression to the "Age of Reason."

Neoclassicism was the artistic counterpoint to the perceived dishonesty, self-centered distraction, frivolity, and extravagance of the French Rococo court and its expression in the arts. Artists adopted Winckelmann's idea of the "noble simplicity and quiet grandeur" of classical art which was thought to embody higher and nobler ideas and forms. Artists emphasized civic idealism, heroism, and the heroic emotions of the revolutionary age in images that extolled simple, earnest moral virtues and values. Calm rationality was emphasized using organized and balanced compositions, subtle sophisticated colors, and idealized figures. Also taking inspiration from the French Baroque artist Nicolas Poussin, Neoclassic painters embraced an intellectual approach to art that relied on strong draftsmanship and images clearly defined first by line, then filled in with color.

In Neoclassic paintings, the figures are arranged parallel to the picture plane and within shallow stage-like settings that draw reference to classical architecture. They appear as solid, immobile, and idealized images that are defined by line and drawing techniques as well as strong light and shadow. Grand ideas and stories of a didactic nature are told in the elevated images of classicism to inspire correct behavior, moral

uprightness, and patriotic duty. A simple and balanced organizational structure allows the message of the work to be conveyed through the gestures, glances, and figure arrangement within the composition.

In the early 19th century Neoclassicism became the dominant style of the Royal French Academy of Art. Jean-Auguste Ingres, a student of David's and the Director of the Academy, was the primary proponent of the style which continued in a variety of forms well into the century. Its emphasis on draftsmanship and line provided the conservative antithesis to the emotional color and vivid brushstroke of Romanticism.

Romanticism

Romanticism arose in the early 19th century as a literary and artistic movement designed in opposition to the French Rococo court and the perceived detachment, insincerity, cold calculation, and lack of emotion of the ruling classes and their art. Like the Neoclassicists, Romantic artists sought to stimulate a true, sincere, and strong emotional response in the viewer. However, unlike Neoclassicism, this style was aimed at asserting the validity of the subjective experience as characterized by intense emotional excitement, powerful forces in nature, exotic lifestyles, danger, suffering, nostalgia, spontaneity, intuition, and emotion.

Romantic artists were inspired by the passionate brushstrokes, swirling compositions, and vivid colors of the Northern Baroque artist Peter Paul Rubens, rather than the sustained, balanced intellectualism of Nicolas Poussin. They often took their subject matter from literary sources that dealt with strongly erotic or exotic themes and locations. The cultures of the Middle East and North Africa provided an endless source of inspiration, particularly the idea of the harem and the odalisque. Intense color and richly textured brushstroke combine with dynamic compositions that recede into pictorial depth. Emotion, pleasure, and sensuality are stressed with subject matter that explores the subjective and individual human experience.

Romantic artists sought moments of great drama whether real or imaginary. In *Raft of the Medusa*, Gericault picked the highly charged moment where the few remaining crew members of the sunken ship realize that they will be rescued after being lost at sea in a open raft for weeks. Gericault portrayed not only the living, but the dead bodies as well. These are the bodies that the survivors had been forced to eat in order to survive. The horrific means of survival and the dramatic rescue are encompassed within the painting.

Eugene Delacroix was the great Romantic artist of the age. Emphasizing color and brushstroke over line, his passionate and painterly oils were often ridiculed by the establishment as being merely sketches. He was accused of attempting to pass off his sketches as finished paintings. Yet, Delacroix's notoriously "sketchy" and "unfinished" style was the avant-garde answer to academic conservatism. His unique work paved the way for a more spontaneous style that would influence the Impressionists later in the century.

Realism

The Industrial Revolution began in the late 18th and early 19th centuries with the mechanization of the textile industry in England. This trend toward greatly improved productivity through the development of machines spread throughout Europe and America. It continued and was enhanced by the development of faster means of transportation—the invention of the steam engine and its eventual use in the coal-powered locomotive engine in the 1850s. The effect on the European economy was profound, changing it from agrarian to urban, and moving workers from farm to factory.

Artists responded to these changes in several ways in the mid-19th century. The Pre-Raphaelite Brotherhood retreated into the world of fantasy or to images inspired by the Medieval and Renaissance past. Others remained firmly rooted in the traditional techniques and subject matter of the Academy. There was, however, a generation of painters willing to directly tackle the gritty realities and issues of the day—the Realists.

The shift occurred as artists began to critically evaluate the aims of academic painting which were steeped in Neoclassicism and Romanticism. Both, they felt, were turning away from the vast sociological, cultural, and technological changes brought about by the Industrial Revolution. In spite of the tumultuous world around them, Academic painters continued to retreat into the world of grand classical themes, poetic literary fantasies, and romanticized genre scenes.

Beginning in the 1830s and continuing into the 1870s, a group of painters left Paris and settled in and around the small town of Barbizon in the Fontainebleau Forest. These painters wished to leave behind the rigid expectations and methods of academic painting. They advocated landscape and genre painting that was truthful, without contrived constructions or romanticized fantasies. Moving away from false studio lighting, painting out-of-doors was made easier in the 1840s with the invention of tube paints and synthetic colors. These painters were known as the Barbizon School.

The Barbizon painters encouraged a more realistic and truthful visual rendition of the world. In doing so, they would influence the Realist movement of the mid-19th century by advocating the depiction of real people within the context of their real existence. Later, the Impressionists would be influenced by the Barbizon painters' practice of working outdoors in the natural light, depicting nature as it is, and without the organized and constructed compositions of previous generations of painters.

Jean-Francois Millet was an influential Barbizon painter who created images of the rural peasant that were far from the idealized versions from the past. Millet monumentalized the rural poor and their plight in the social caste system of 19th-century France. His counterpart in Paris, who championed the plight of the urban poor, was Honore Daumier. Through his political and social cartoons as well as prints and paintings, Daumier pointed out the injustices and inequities of the lower socioeconomic classes as well as the changing inner-city landscape of the Industrial Revolution.

The Realist movement began about the middle of the 19th century as a reaction to Romanticism and Neoclassicism. The Realists, particularly as seen in the work of

Gustave Courbet, were concerned with an art that represented the "things of our times," and as his friend and writer Charles Baudalaire said, the "heroism of modern life." Courbet felt that only those things that are real and tangible were fit subject matter for the painter. The famous Courbet quote sums it up: "Show me an angel and I'll paint one." Thus, we begin to see paintings of everyday life that deal with common people within the context of their actual lives and the common experiences of the times.

The other aspect of painting that interested the Realists and would have far-reaching consequences for modern art was the question of the "true nature of painting." Edouard Manet, one of the most influential painters of the 19th century, posed the question: "What is the reality of the painted surface?" He answered the question by stating that he believed the true nature of painting was "color patches on a flat surface," thus reducing painting to its two essential elements: pigment (paint) applied to a flat surface (canvas). The canvas possesses only two dimensions: height and width. The third dimension (depth) is an illusion created with perspective techniques (such as overlapping and diminutive perspective) and linear perspective discovered in the Renaissance. Using these techniques, the artist could create a believable third dimension on the canvas.

This creation of depth on a two-dimensional surface was an illusion, and for ardent Realists, it was a "lie." Manet and others experimented with paintings that

© Image courtesy of Corel

Edouard Manet, *The Fifer,* 1866, oil on canvas (60" × 38").

emphasized the flat surface of the canvas. Manet's *The Fifer* asserts the "primacy of the canvas" using broad, flat areas of color with little shading and shadow. In addition, dark outline around the face and hands and in the stripe at the side of the red pants further flattens the figure. The background is a visually impenetrable flat dense gray. The space is compressed, so that the traditional foreground, middle ground, and background are lost. The main reference to the illusion of a third dimension is the shadow cast by the foreshortened feet. Both Courbet and Manet, in many of their paintings, alternated three-dimensional illusionism with flat areas of color, thus leading the viewer into pictorial depth while reminding them of the realities of the painted surface.

The influence of Japanese woodblock prints was greatly influential to the French Realists of the 1860s. As Europeans traded with Japan, increasing numbers of Japanese goods arrived in France. Many were wrapped in paper printed with traditional woodblock prints that displayed flat picture space, strong dark/light contrasted areas of color, and strong outline. Japanese aesthetics as seen by artists in the 1860s had a great influence not only on the Realists, but subsequent artistic movements in the 19th century.

American Realists like Winslow Homer emphasized the harsh realities of nature. Themes such as man versus nature are common in Homer's later work and coincide with the writings of Jack London. Thomas Eakins, Director of the Pennsylvania Academy of Arts, advocated that his students work from live models rather than plaster casts so common at the European academies at the time. He also dealt with subject matter such as current medical practices which were considered shocking and unsuitable at the time. One of his students, Henry O. Tanner, was the first African-American to gain widespread prominence, painting the reality of the lives of African-Americans in rural farming communities.

Impressionism

The Impressionists were the next generation of avant-garde artists to follow the Realists. They believed that painting should represent objective visual truth, the truth of perceptual experience—nature just as it is—nothing more and nothing less. In their pursuit of the natural world they felt that the Realists had not gone far enough. For the Impressionists, the ultimate refinement of Realism was to capture the elusive qualities of light and atmosphere as well as the objects of the physical world on the canvas. The ever-changing conditions of light and shadow and the diaphanous qualities of atmosphere were important aspects in capturing the reality of the natural world.

Unlike the Realists, the Impressionists were rarely interested in making political statements or choosing difficult or controversial subject matter. Impressionist painters most often focused their attention on the middle and upper classes. Sunny days, people enjoying themselves in pleasant surroundings, the opera and ballet in Paris, the seaside, and quiet scenes of domestic tranquility were some of the staple subjects of much Impressionist work.

Using short, quick, comma-like brushstrokes and a wide range of colors, they were able to depict the flickering sensation of changing light and color, momentary scenes passing by their line of vision, spontaneous movement, and layers of atmosphere. Influenced by the Barbizon painters, many Impressionists worked out-of-doors, on-the-spot, and away from the somber tones of studio painting into the light and colors of nature. Theories about color and the way that our eyes receive color were being developed at the time, and the Impressionists made full use of them. Visual intensity was created by juxtaposing primary colors and complementary colors, and through the use of optical mixes to heighten and brighten the depiction of sunlight and its transformation of objects and colors.

The development of photography and the way that it could spontaneously capture moments in time was intriguing to the Impressionists. Many of them worked with photography to develop interesting arrangements and exciting angles and points of view. Transitory atmospheric effects, the movement of clouds across the sky, and momentary changes in light and shadow could be caught on film and used later for study and composition construction.

The asymmetrical compositions, flattened picture space, and strong patterning of Japanese prints were also influential to the Impressionists. So too were the English Romantic landscape painters of the early 19th century. The work of William Turner, who created emotionally evocative atmospheric qualities on his canvases by pushing the liquidity of his oil paints, was of particular influence.

Manet was experimenting with movement, focus, and depth of field early in the 1860s. In works like *Concert at the Tuileries* his typical light/dark contrasts and fields of flat color are combined with a focused foreground where the images are cropped in such a way as to imply activity outside the picture space. In the background, the figures are depicted by quick sketch-like dabs of color so that the overall effect is a cacophony of movement in time and space. Works such as this would be powerful inspirations for the Impressionists.

This tightly knit group of artists exhibited their work together in eight exhibitions organized by Edgar Degas between 1874 and 1886. Although Impressionist work displays similar formal concerns, the work of each artist is uniquely distinguishable from the others. Each artist had his/her own personal style while adhering to the overall aesthetic concerns of the group as a whole. For example, Degas and Cassatt were mostly interested in the effects of interior lighting, whereas Monet was mainly a painter of outdoor scenes. While most of the group painted idyllic spring and summer scenes, Pissarro would often paint the more solemn landscapes of winter.

The Impressionists were considered a radical avant-garde group of artists in the early 1870s. But by the mid-1880s, many of them were already beginning to experience some degree of financial security from the sale of their paintings, and the public was beginning to embrace the style. By this time, a new group of artists was beginning to emerge that would lead to many of the divergent styles of the early 20th century.

Post-Impressionism

Post-Impressionism is a term used to describe a divergence of artistic styles in painting that arose in the early 1880s as artists broke away from Impressionism and began to experiment with method, style, and content. Many artists continued to work in the Impressionist format, and by the mid-1880s Impressionism had been accepted by the public and continued to grow in popularity. At this point, there were several artists who had tired of Impressionism and found that it was limited in its expressive possibilities. These artists had worked in the Impressionist style and had exhibited with them. Yet, they felt that the style lacked certain essential elements. Namely, Impressionism failed to impose a strong discipline of design onto the canvas, and in the pursuit of light and atmosphere, structure and strong composition had been neglected. Another critique of the style was that it failed to allow for the representation of the many emotional and psychological aspects of the human condition. The insistence on representing only pleasant and transitory scenes that emphasized little emotional involvement from the artist created a distanced approach to the act of painting.

There are several artists of the period whose work provides a link between the late 19th century and the early 20th. Each paved the way for the variety of art movements that sprang up in the first decades of the new century. These artists set about reexamining properties of three-dimensional space and the expressive and symbolic qualities of line, pattern, and color. They were Georges Seurat, Paul Cezanne, Vincent Van Gogh, and Paul Gauguin.

Georges Seurat combined the theories and principles of traditional Renaissance pictorial space with Impressionist subject matter. He considered himself an artist and a scientist, working with color theory, optical afterimage, and a scientific understanding of the anatomy and functioning of the eye. Along with another artist, Paul Signac, he developed a pointillist technique where tiny dots of pure color were placed side-by-side to create shimmering tonal gradations and striking optical mixes. The artists surrounding Seurat and employing his technique are known as Neo-Impressionists.

The pinpoint application of color is a painstaking process. Several of Seurat's larger works took two years or more to complete. Subject matter, setting, and color are derived from Impressionism, but because of the way the paint is applied, the effect produces very structured images. Seurat further emphasized this in the way he minimized the details of both figures and landscape. His figures are flat and geometricized, and are placed within a carefully constructed recessional depth. Whether they are alone or in groups, they seem not to relate to one another, and each stays within his or her private emotional and psychological space. The effect is one of eerie disconnect among the figures. Yet, there is something vaguely familiar and modern in the "alone in a crowd" sensation that is created.

Additionally, toward the end of the 1880s (he died in 1891) both the figures and background become increasingly flattened, simplified, and geometric, moving toward

greater degrees of abstraction. Late paintings can almost be read as abstract geometric patterns of color. We can only guess at where he might have taken this had he lived longer. However, his experiments in this area will lead to some of the geometric abstractions in the early 20th century.

Paul Cezanne felt that Impressionism ignored the essential structure of nature. He believed that the truth in nature was not the intangibles of light and atmosphere, but rather the solid underlying geometric structure that all objects possess. For Cezanne, the true nature of painting was to define the most basic elemental forms that shape our world. In his work, color and brushstroke emphasize solid layers of geometric form that are the truth of nature. Further, perceptual truth is depicted through the changing viewpoints presented in his work. Unlike traditional perspective techniques, Cezanne suggested that we perceive the world in a series of glimpses—shifting points of view—as we move through space and time, and that the reality of perception is not captured in a single immobile point of view, but rather through a series of shifting movements around the objects.

Because the objects in a Cezanne painting are simplified to their essential shapes, and color and brushstroke are repeated throughout, textural variety is diminished and the elements seem to be of equal weight and solidity. Whether depicting a still life, landscape, or figure, Cezanne captures the essential core of the object, peeling away the layers of detail to find the solid structure beneath. This tends to flatten the picture space, develop an interdependency among the various elements, and create a strong architectonic structure. The diaphanous landscapes of the Impressionists have become solidified and structured, and yet abstracted in their simplicity, so that they read as color and shape as much as objects.

© Image courtesy of Corel

Paul Cezanne, *Still Life with Basket of Apples,* 1890–1894, oil on canvas, (24" × 31").

Shifting perspectives in Cezanne paintings are utilized to give the viewer a new sense of three-dimensional space. The objects in a still life, for example, are displayed on a table in such a way that we are able to see many aspects of them simultaneously. The top of the table is seen as if we were standing above it, while the side of the table is visible at the same time. A pitcher is viewed from the side and the top. Fruit is pared down to simple circles and appears to be rolling off the table if we view it from one angle, yet is stable and fixed when viewed from another. Cezanne presents the world from many angles, suggesting that this is the way we truly comprehend it—not from a single fixed perspective, but from many as we move around an object and take it in from many points of view. In the early 20th century, Cezanne's experiments with space, geometric structure, and multiple viewpoints would be profoundly influential on the development of Cubism.

Vincent Van Gogh and Paul Gauguin introduced psychological content into painting, and are considered to be the pioneers of a number of modern movements such as Symbolism, Fauvism, and Expressionism. Both artists used color to convey mood and the internal world of the artist, apart from the natural appearance of things. Expressive brushstroke, simplified drawing, the flattening of the picture space, and the arbitrary use of color are some of the stylistic traits that distinguish the work of these two artists. Both artists would become mythologized in the 20th century as icons of the artistic soul and temperament.

Van Gogh was born in Holland and began his career as a painter after leaving his post as a missionary in Belgium. The majority of his paintings were produced in a whirlwind of activity between 1885 and 1890 when he committed suicide at the age of 38. His early paintings were influenced by the Realist movement and particularly the work of Millet and Daumier. During his lifetime he could barely give his paintings away and sold only one. In 1990 a single Van Gogh painting sold at auction for over 80 million dollars. He maintained an avid correspondence with his younger brother Theo, and much of what we know about his thinking on his life and art comes from these letters compiled into a book entitled *Dear Theo*.

A largely self-taught painter, Van Gogh's intensely passionate style is conveyed in strong colors and expressive brushstrokes. For Van Gogh, color was not used to describe the natural world, but rather to convey psychological content, mood, and feeling. Color is removed from its descriptive function of the natural world and is applied at the will of the artist to communicate a deeper meaning. Similarly, brushstrokes are vivid and intense, conveying the passion of the artist in the midst of creating. In doing so, Van Gogh opened up the world of painting to convey the inner world and being of the artist. Acceptable subject matter was now not only a depiction of the external world, but the subjective inner world of the artist was now also fair subject matter.

Van Gogh's troubled life became the stuff of myth propagating the romantic cliché that an artist must suffer for his art, and that genius and insanity are closely related. Paul Gauguin's life also came to be mythologized in the 20th century, as the artistic soul seeking the solace of distant places far removed from western civilization

and society. Gauguin left his wife and family to pursue his art, lived with Van Gogh for a short time, and finally left for the South Pacific, settling first in Tahiti and later in the Marquesas Islands.

Europeans had been fascinated by the idea of the "noble savage," referring to native peoples in Africa, the Americas, and the Pacific Islands. As colonialism grew, so too did the fascination that although uncivilized, they possessed a kind of innocence and a connection with the natural rhythms of the earth. Disenchanted with western civilization, Gauguin moved first to remote areas of France and then to remote areas of the world.

He used color in a similar emotional and psychological way as did Van Gogh. Gauguin's work is filled with intense color, smooth brushstroke, serpentine lines, strong outlines, and simplified drawing. His fascination and depiction of native cultures did much to influence other European painters as his canvases were brought back to France and displayed after his death.

Symbolism

Many artists at the end of the 19th century were involved in a search for new forms and content in art. Symbolism was an approach to art designed to transcend the literal and physical experience and achieve a reality filtered through intuitive experience. Artists believed that a work of art is ultimately a consequence of the emotions of the inner spirit of the artist rather than of observed nature. (This attitude toward art will recur continually in the 20th century in the work of the Expressionists, Dadaists, Surrealists, and others.)

With Symbolism, the subjectivity of Romanticism became radical. The artist's task was not to "see" things, but to "see through" them, in order to come to a significance and reality far deeper than what is given in the appearance of a thing. The Symbolists cultivated the idea that art is created to satisfy or to explore the inner person of the artist and need not convey a universal meaning or speak to the masses. Symbolist subject matter is often characterized by a worshipful attitude toward art, exaggerated esthetic sensations, and a certain lushness and overabundance on the canvas. Subjects became increasingly esoteric, exotic, visionary, dreamlike, mysterious, and fantastic, while at the same time being intensely personal and symbolic of the inner state of the artist.

The Symbolists replaced traditional subject matter with images that were visual "symbols" expressing ideas beyond the literal world or the objects being depicted. Influenced by new ideas in the field of psychology, the inner workings of the mind, the symbolic significance of dreams, subjective experience, and emotional angst were explored. The work of Paul Gauguin with its strong colors, exotic dreamlike images, flat pictorial space, and elegant serpentine lines were especially influential. The ability of Van Gogh to use color for expressive purposes and his unflagging emotional honesty were also powerful influences on the Symbolist movement.

Into the 20th Century

The Industrial Revolution had profound effects in changing the socioeconomic struc-
ture of Europe. People moved from rural areas to the cities hoping to find a better life
in the inner-city factories. For many, what they found was another kind of poverty,
living in crowded slums, working fourteen- to sixteen-hour days, and barely scraping
together enough to feed their families. The machine-age had made the upper classes
wealthy, but it had exacerbated an already bad situation for many. Toward the end of
the 19th century, many artists and intellectuals wondered what effect the mechaniza-
tion of Europe was having on the individual. People worried that machines were rob-
bing us of our humanity, that we were becoming repetitive and mindless drones,
small cogs in a gigantic machine that was gaining a life of its own. Others wondered
what the ultimate effect of mechanization would be. Certainly productivity was high,
and economies were growing, but the benefits of rapidly growing technology also
brought about fears that this same technology could be employed for more sinister
uses.

Of course, these fears came to pass with World War I beginning in 1914. The
fears of dehumanization through mechanization would continue to be a theme mani-
fested in a number of ways throughout the century. However, in the last decade of the
19th century and the first decade of the 20th century, there was great hope for the
future as well as great worry. Artists like Henri de Toulouse-Lautrec, among others,
summed up in his work the phenomena of *fin de siecle*. This is a common feeling of
melancholy and fearfulness at the end of a century—a worry that the world is going in
the wrong direction and that dire consequences will result. Many people experienced
fin de siecle at the turn of the 20th to the 21st century and this was further increased
by the change to a new millennium. The Y2K fear was just one of many manifesta-
tions of the phenomenon that we recently experienced.

In Toulouse-Lautrec's work, the lively nightlife, so enthusiastically embraced in
Impressionist scenes from the 1870s, takes on a sinister tone in the 1890s. The beauti-
ful people have turned frightening. Now, instead of the pearlescent skin tones of
Degas's ballerinas, the gas lights make these faces appear debauched and mask-like.
The young performers of the Impressionist era have turned old and disillusioned. In
the world of his paintings, youth has turned to age, joy to melancholy, and hope to
despair.

The first twenty years of the 20th century saw tremendous changes in every
sphere of life. Art was no exception. New styles sprang up simultaneously as the pace
of experimentation and cross-cultural influences increased as rapidly as the technol-
ogy of the times. Within these first two decades the Fauves, the German Expression-
ists, the Cubists, the Futurists, the Abstract/Non-Objective artists, the Russian Con-
structivists, the Supremacists, the Bauhaus, and the Dada movement all took place. In
about 1924 Surrealism was developed, while German Expressionism, Cubism, Con-
structivism, Bauhaus ideas, and Abstraction continued.

In the late 1930s, as Hitler and the Nazi Regime came into power, there was a gradual shift from Europe as the center of the arts (particularly France and Germany), to New York City. The United States in the late 1930s and 1940s became the refuge for European artists who were forced to flee Europe and the persecution by the Nazis of all artists and intellectuals. As Europe was embroiled in war, a new generation of artists in the United States took the lessons of Surrealism and Abstraction and developed Abstract Expressionism.

Post–World War II artists continued to develop and expand on the ideas of the early 20th century art movements in such styles as Pop, Post-Painterly Abstraction, Conceptual, and Performance art. The rise of the Feminist movement in the '60s and '70s led to a redefining of art both in method and media, with the subsequent emergence of Pluralism involving pattern painting and decorative aesthetics based on nontraditional and nonwestern forms of art. Post-Modernism emerged in the '70s and '80s and embraced a much wider definition of art, combining styles from all periods of time and from western and non-western traditions in the arts.

Fauvism

The term *Fauve* was first coined by an art critic on the occasion of the Salon d'Automne in 1905. The Salon d'Automne was an art exhibition held in the autumn of the year so as not to conflict with the official Salon exhibition in the spring. By 1903 it was clear that there were so many divergences from Academic art that this alternative exhibition venue was established. At the Salon d'Automne of 1905 a group of brash young artists exhibited their explosively colorful canvases, filled with wildly passionate brushstrokes and simplified drawing. In the center of the room was a small conservative-looking sculpture. The critic stated that this sculpture looked like a "Donatello in a room filled with wild beasts." This assessment pleased the young painters who were looking to create a sensation, and they adopted the name for themselves.

The Fauve movement took place in France between about 1905 and 1910 and was headed by Henri Matisse. The Fauves stressed the use of strong vigorous brushwork and colors used in arbitrary ways to express a "feeling" toward or about the subject, or to create a mood. Unlike the Expressionist groups that formed about the same time in Germany, the Fauves investigated the expressive and constructive properties of color and strong brushstroke, rather than using those formal elements for political or social purposes. Adopting a benign subject matter of portraits and landscapes, similar to that of the Impressionists, the Fauves were interested in the pure joy of painting and the wild abandon with which color and brushwork could be used to create visual explosions of imagery, texture, and pure sensation. Sometimes squeezing pure color directly from the tube, paint was applied with spontaneous rough strokes to create bold surface designs. Simplified drawing, strong dark outlines, and broadly applied planes of color emphasized the primacy of the canvas.

Several of the Fauve painters had met in the studio of the Symbolist painter Gustave Moreau, who encouraged his students to strive for originality and a personal style while breaking away from the pictorial traditions of Western-European painting that had been in place since the Renaissance. Two major retrospectives took place early in the century: the Van Gogh exhibit in 1901 and the Gauguin retrospective in 1903, the year of his death. In both cases these young artists were exposed to the full intensity of color, brushstroke, and emotional content in rooms filled with the works of these two artists. It was the first time that anyone had been given the opportunity to see paintings by these artists en masse, and it had a powerful effect. Maurice de Vlaminck said on the occasion of the Van Gogh retrospective, "Upon seeing Van Gogh's work I wanted to weep. On that day I loved Van Gogh more than my own father."

The Fauves never had a tightly knit group united by cause or philosophical stance. By 1910 the group had dissolved, with artists going their separate ways. For Henri Matisse, the Fauve style helped develop his later works with an emphasis on line, simplified drawing, and luxurious color remaining consistent. However, he too abandoned the wild intensity that had characterized his Fauve period, saying, "There was once a time when I had to turn my paintings to the wall, as they reminded me of moments of great agitation." Matisse went on to become one of the most influential artists of the 20th century, experimenting with a variety of media while maintaining a consistent clarity of line, color, and form that helped to shape 20th-century art.

German Expressionism

Expressionism was a style that originated in Germany, and was at its height between 1905 and 1940. The term "expressionist" or "expressionistic" can be used to describe works that are passionately energized with the emotions and psychology of the artist. The influence of Expressionism on later generations of artists helped produce the Abstract Expressionist movement of the 1940s and '50s, and the Neo-Expressionist movement of the late 1970s. Therefore, many texts refer to the original Expressionists as German Expressionists, thus denoting the time and location of the origins of the movement.

German Expressionists began about the same time as the Fauves were working in France. In fact, their first group exhibition was held only one year after the first Fauve exhibition. Expressionism, unlike Fauvism, was rooted in strong theoretical and philosophical ideologies with tightly knit groups of artists who developed clear constructs on the nature of art, the relationship of the artist to the artwork, and that of the viewer to the work of art. The work of the Post-Impressionists, Van Gogh and Gauguin, as well as that of the Symbolists Edvard Munch and James Ensor, was particularly inspirational to the German Expressionists.

Van Gogh's bold use of line and color, the great gestural quality of his brushstrokes, and the use of color for its expressive psychological meaning rather than for its description of the natural world were profoundly influential on the Expressionists. Gau-

guin's decorative and symbolic use of color, his flat patterning, and simplified and strongly outlined forms were also inspirational to them. Munch's images of emotional angst and psychological vulnerability were conveyed in physical distortions, rough brushwork, and intense colors, while Ensor's investigations of the human psyche through the symbol of the mask also had great influence on the German Expressionists.

The greater accessibility of nonwestern art to European artists in the early 20th century, particularly from Africa and Oceania, was a significant force in shaping much of early modernism. For the Expressionists, the raw emotive power inherent in the abstraction of the human form proved a strong force in the development of the style. This ongoing fascination with the "primitive" was also now focused on the native German population as well. The German peasant, linked to the land and therefore closer to nature, was a source of inspiration, as were traditional German woodblock prints.

Early 20th-century philosophies about the nature of artistic expression were also instrumental in developing the style. The idea of "inner necessity" dictated that the artist create according to his or her inner need rather than by some academically prescribed formula. Thus, whatever forms a work of art took, it would be acceptable as the result of the outward manifestation of the inner need of the artist. Another theory, "abstraction and empathy," postulated that colors and shapes possess emotive qualities, and that the viewer could be moved toward a variety of feelings that specific colors and shapes would elicit. This idea would later develop into Non-Objective painting where the canvas was completely devoid of subject matter or content, except insomuch as lines, shapes, and colors were the subject.

Prior to World War I two groups of German Expressionists emerged: Der Blaue Reiter (The Blue Riders), and Die Brucke (The Bridge). Der Blaue Reiter artists were more interested in abstraction with an emphasis on the spiritual nature of art. Die Brucke artists sought to "bridge" all the new artistic tendencies and worked in a more representational imagery that focused on the anxiety and distortion inherent in the modern world. Between the two world wars the German Expressionists were intent on exploring the inner nature of the artist and the corrupt and chaotic world around them with strong emotionally charged imagery. They became increasingly concerned with the political and emotional ramifications of World War I, the decay of the Weimar Republic, and the rise of Fascism in Germany under Hitler and the Nazis.

Expressionism, as well as other forms of modern art in Europe, came under attack from the National Socialist Party when they took office in the early 1930s. Seeking to control every aspect of culture, they sent out a constant stream of brainwashing propaganda. All forms of modern music, books, film, and artwork were called "degenerate." The idea was that culture could be infected with decay, decadence, and decline if not carefully controlled by strong governmental intervention. The Nazi Ministry of Culture declared that only works of art adhering to Classical aesthetics and strict representational images would be acceptable. They confiscated works from museums, private collections, and the artists themselves, and hung them in an exhibition entitled *Entartete Kunst*, or Degenerate Art, in July 1937. Many

works of modern art were auctioned off in Switzerland to feed the Nazi coffers and fund the escalating war. Many artists were forced to "retire." Some were sent to concentration camps; others committed suicide. Some, who were fortunate enough to flee Germany, found refuge in the United States. These would influence a young generation of American painters who would become the Abstract Expressionists.

Cubism

Cubism was developed by Pablo Picasso and Georges Braque in the first decade of the 20th century. Both artists had been working independently on projects that were inspired by Cezanne's simplification of forms, elemental geometric structures, and the simultaneous presentation of multiple views. Similarly, they as well as other early modernists, were fascinated by the emotive power and visual abstractions and distortions of African art. Once Picasso and Braque met, they realized their artistic experiments were heading along similar paths, and they set about working together to develop a style based on the geometric reconstruction of the subject in a flattened, ambiguous pictorial space.

Picasso and Braque met at the home of sister and brother Gertrude and Leo Stein. The Stein family was a major collector of modern art in the first decades of the 20th century. Gertrude and Leo shared a fashionable apartment in Paris and held evening soirees to which modern artists, writers, and musicians were invited. Picasso's friend and lover Fernande writes about the Steins:

> Too intelligent to care about ridicule, too sure of themselves to bother about what other people thought. . . . They soon provided the informal focal point of contemporary art. They inspired, catalyzed and cross-fertilized, and even more important at this stage of Picasso's precarious existence, they bought.

It was at one of the Stein's soirees, in 1907, that Picasso unveiled his pivotal pre-Cubist piece *Les Demoiselles d'Avignon*. Here, Picasso combines his experiments with fractured and fragmented geometric elements combined with the powerful evocations derived from African art. Fernande writes of the event:

> Appollinaire murmured revolution. Leo Stein burst into embarrassed uncomprehending laughter. Gertrude Stein lapsed into unaccustomed silence. Matisse swore revenge on this barbaric mockery of modern painting, and Andre Derain said that one day Picasso would be found hanging behind his big picture.

Georges Braque, who had just met Picasso when he saw *Les Demoiselles d'Avignon*, realized that it was revolutionary and said, "It made me feel as if someone was drinking gasoline and spitting fire." Later he wrote about their collaboration in developing Cubism: "The things Picasso and I said to each other during these years will

never be said again, and even if they were, no one would understand them anymore. It was like being two mountaineers roped together."

Analytical Cubism was developed between 1907 and 1911. In this style of Cubism the program was to replace the traditional Renaissance perceptual-based system of painting with a systematic conceptual program of painting. The history of western art, up to the late 19th century, was about how we perceive the real world and then how to re-create that visual perception on the canvas. With Analytical Cubism, the emphasis was not on how we perceive the world, but how the artist conceptualizes the world within the given parameters of the rules of the Analytical Cubist format. The figure or subject was broken down into its most elemental components, analyzed into basic geometric forms, and rearranged in a variety of faceted planes intermingled with the geometric planes of the background. Monochromatic colors give dominance to the shape and form of the reconstructed object so that the eye is not distracted by color. Thus the canvas becomes an interwoven surface of "faceted" shifting planes.

The second phase of Cubism, *Synthetic Cubism*, was developed between 1911 and 1912. Picasso and Braque sought to synthesize or utilize and combine a number of elements that Analytical Cubism had dismissed. Synthetic Cubism reintroduced color into Cubist paintings as well as collage, and trompe l'oeil. The tiny and numerous planes of Analytical Cubism were given up for flatter, broader areas of overlapping planes of color, applied materials, and trompe l'oeil elements.

Cubism quickly became an international avant-garde style and influenced the development of other types of abstraction as well as many offshoots of the original style. While Picasso and Braque moved into other phases of art after World War I, much of their subsequent work could be traced to the early geometric abstractions of both Analytic and Synthetic Cubism.

Futurism

Originating in Italy in 1909, Futurism began as a literary movement of young Italian intellectuals who published manifestos rallying against the current culturally vapid state into which they perceived Italians had sunk. Basically an anarchistic movement, the Futurists advocated rebellion against the cultural disarray into which they perceived Italy had deteriorated during the 19th century. Comparing 19th-century Italian culture with that of the High Renaissance, their manifestos expounded a complete revamping of politics and culture. They were intent on destroying the old and rebuilding Italy in a thoroughly new way that embraced technological advances and the age of the machine. Their manifestos rallied against old art and old institutions and advocated their complete destruction in order to create a new Italy.

They embraced and celebrated the machine. A famous Futurist saying is: "A roaring motorcar that looks as if it is running on shrapnel is more beautiful than the *Nike of Samothrace*." Natural and mechanical motion and speed were glorified and

modernism was worshipped. Revolution and war were seen as the cleansing elements of society.

Artistically, Futurism grew out of Cubism. To the geometric forms and faceted planes of Analytical Cubism, the Futurists added implied motion to the shifting planes and multiple observation points. Simultaneous points of view, "Simultaneity," was combined with dynamic motion, "Dynamism," to create images that were designed to bring the viewer into the center of the action, with the enhanced sensation of speed, progression, and evolution through space and time.

Abstract/Non-Objective Art

Abstract art uses imagery that departs significantly from natural appearances. Forms are modified or changed to varying degrees in order to emphasize certain qualities or content. Recognizable references to the original appearance may be very slight.

Non-Objective art is abstracted to the point that images of the natural world are not recognizable. In painting and sculpture, forms are created without an actual recognizable object or reference to the visible world.

Abstract art and Non-Objective art are large categories that cover a lot of territory in the early 20th century. The idea of abstraction was not new. In the 1870s James McNeil Whistler had experimented with it in paintings such as *Nocturne in Black and Gold: Falling Rocket*. In this painting of fireworks at night, the artist uses dark blue, gold, and silver to create the visual sensation of explosions of sparks in the night sky drifting toward earth in a glittering spray. Because of the darkness of the painting, land and lake fade into the night, and the most dominant elements are the fireworks which appear as abstract marks of gold and silver on a dark background. Whistler's title "Nocturne" is a reference to music, which is a kind of abstract language that moves the listener emotionally without any tangibly recognizable element.

The Der Blaue Reiter artists, with their emphasis on "abstraction and empathy," took the idea further. In fact, the leader of that movement, the Russian-born artist Vassily Kandinsky, went on to develop the concepts of Non-Objective painting in his pivotal work from 1910, a book entitled *Concerning the Spiritual in Art*. Here, Kandinsky elevates Non-Objective art, which is art without any apparently recognizable object, to the supreme form of spiritual communication between the artist and the viewer. By not suggesting what the viewer should be seeing or feeling, Kandinsky felt that he could more purely and directly communicate with the viewer.

Again, the idea of music is used to illustrate the power of pure abstraction. As he moved to an art that was entirely without subject matter, except insofar as color and lines and their relationships constituted a subject, he wrote, "The harmony of color and form must be based solely upon the principle of the proper contact with the human soul." Like music, Kandinsky felt that art was based on an abstract language that could evoke emotional feelings without describing objects. Even his titles evoke

the idea of music. Many of his works are numbered preceded simply by the word *Composition*. The work of many artists of the 20th century falls within the category of abstract or Non-Objective art. However, the early modernists like Kandinsky, Mondrian, Malevich, Tatlin, Calder, Brancusi, Hepworth, Moore, O'Keeffe, and others set the stage for the generations that followed.

Piet Mondrian, Theo Van Doesburg, and the "De Stijl" (Dutch for "the style") artists sought to simplify forms into a purist format that would affect all the arts and crafts. They sought to strip objects down to their essential forms and to find their pure essences. Working toward greater and greater simplification, Mondrian finally reduced his colors and lines down to their most essential nature: primary colors plus black and white, and vertical and horizontal lines. *Neoplasticism* refers to this style of Non-Objective painting.

The Bauhaus was a school of architecture, art, and design begun in Germany in the 1920s under the leadership of Walter Gropius. Coming out of World War I, Gropius believed that the machine age could be used for the betterment of mankind, and could create a type of cooperative utopia. He gathered artists in all the disciplines, along with architects and urban planners, to work together and develop designs that created solutions to contemporary problems in housing, urban planning, and high-quality utilitarian mass production of household goods of all sorts. Beauty via simplicity of form and modern materials merged with functional appropriateness, clarity, and precision. The Bauhaus motto was "Form Follows Function," meaning that the form an object is given is determined by its functional usage.

Constructivism, when used to refer to the movement in the first quarter of the 20th century, is synonymous with "Russian Constructivism." This movement began directly after the Russian Revolution of 1917. Sculpture, painting, and architecture focused on modern rationality, simplicity, and straightforward representations. Technology was embraced in clear, crisp, strongly abstract images of the Machine Age.

The theoretical basis for the Suprematist (also called Abstract Formalism) movement was the belief that the supreme and ultimate reality is pure feeling. Pure feeling cannot be attached to a literal object or representation of an object. Thus, the Suprematists used non-objective forms—shapes not related to objects in the visible world.

Dada

The official Dada movement was founded in Switzerland in 1916 by a group of writers and artists who had fled the madness of World War I by seeking asylum in Switzerland. Hugo Ball, a poet and playwright, and his partner Emmy Hennings, an artist and performer, established the Cabaret Voltaire in Zurich in 1916. The Cabaret Voltaire became the meeting place for a variety of artists, writers, and performers, such as Han Richter, Richard Huelsenbeck, Hans Arp, Sophie Tauber-Art, and Tristan Tzara, who had also fled the massive horror and destruction of World War I.

Dada artists felt that the rationalism and industrialism of the 19th century had led to the chaos of World War I. They set out to revolt against bourgeois society with an anarchistic attitude that ridiculed contemporary culture and conventional art. Rejecting the accepted canons of morality and good taste, they defied logic, authority, and rationality, reasoning that those bourgeois values had been exactly what had led the world down the disastrous path of war. The Industrial Revolution had produced machines that made a few rich, kept the poor in a continued state of poverty, and had developed the technology to create war machines that brought about brutality and destruction on a scale that no one had imagined possible.

Dada artists went to extremes to shock and disrupt public complacency by staging events at the Cabaret Voltaire that included noise concerts, nonsense poetry readings, and wildly bizarre performances with incomprehensible costumes, stage sets, and scripts. Artists felt that if rationality had failed, then the antidote to that was the irrational, the intuitive, and the spontaneous. In the visual arts Academic values were completely dismissed. This included the notion of art as a learned discipline and inspired act of creativity as well as the Renaissance-based tradition of the artist as "genius." The concepts that certain mediums such as oil painting or bronze sculpture were more worthy of being designated as "high art," or that museums housed the finest artistic creations, were also challenged.

Dada centers of activity sprang up in New York City with the work of Marcel Duchamp, Frances Picabia, and Man Ray, and in Berlin, Hanover, and Paris. Although the artistic output in these centers differed, the overarching theme of all the Dada artists was to shock and disrupt the traditional ideas and expectations about art, and to create works that were anarchistic and provocative and the antithesis of "high art" values.

Seeking to dissolve the separation between art and life, and between the common person and the artist, Dada artists used the objects of everyday life to create works of art. Kurt Schwitters, in Hanover, Germany, collected trash and garbage to create lyrical collages. Marcel Duchamp developed the idea of the "Readymade"— works of art that are simply objects found by the artist and declared to be art. He went further by expanding this notion to the "Readymades Assisted," taking two "Readymades" and combining or assisting them to become one work of art, again simply by declaring it to be so.

One of the most eloquent evocations of the Dada program to combine art and life was the incorporation into their art of the laws of chance. The random fates that can befall us, our ability to control only a small portion of our world, and the necessity of ultimately accepting the chance happenings, encounters, and outcomes in our lives, is intrinsic to the Dada program. Of course, World War I was the impetus, stimulating artists to consider the randomness of luck, and the cruel inequities inherent in the larger universal setting. There was no rhyme or reason to why an exploding bomb could kill ten men and leave the eleventh with only minor injuries. There was nothing but chance that allowed one to survive and the others to die.

This idea of chance was incorporated into the name given to the movement. The story was that a dictionary was opened randomly and a finger was pointed to the page. The result was "Dada," a word meaning a child's rocking horse, but in the context of an art movement, simply a nonsense word acquired by chance. Hans Arp's collages were said to be arranged according to the laws of chance—simply cut or torn shapes shaken in a bag, and randomly left to drift onto the paper where they were then affixed. Alexander Calder, creating the first mobiles (a word coined by Duchamp), sought to give motion to his sculptures by the random and uncontrolled shifting of currents of air.

The artistic experiments and challenges the Dada artists posed in the early 20th century can be directly linked to mid- and late-century movements such as Pop Art, Conceptual Art, Performance Art, and Installation art, mixed media art, and ultimately the blurring/dissolution of the traditional separation between fine arts and crafts, artists and artisans.

Surrealism

Surrealism began in Paris in 1924 as a literary movement developed by poet and writer André Breton. Breton had been part of the Paris Dada movement, but by 1924 he and others realized that a movement based on such strong anarchistic and anti-art tendencies could not sustain itself. He felt that Dada needed a more positive program and that the avant-garde must reconnect with art and history. While maintaining the iconoclastic flair and vigor of the Dada movement, Breton was also responding to the carnage of World War I. However, now instead of rejecting and turning away from the history of ideas and culture, he advocated embracing it in order to create a better society—one that understood itself and could be liberated from old, outdated ways of thinking that had caused the war.

Breton turned to two important figures: Karl Marx and Sigmund Freud. He believed that Marx's communist ideology could liberate the political realm from the old capitalist systems that had contributed to the oppression of the masses in the factories of the 19th and early 20th centuries. Additionally, he felt that governments and greed had sponsored and propagated the war, and that the real losers were the masses of troops who, under the guise of patriotism, had fallen in the battle trenches.

Just as communism could liberate the political system, Breton saw Freud as the liberator of the human psyche. In 1899 Freud had published his pivotal book *The Interpretation of Dreams*. Here, Freud postulated that dreams are a window into the unconscious mind, and that when we dream, we dream in symbols. By understanding the symbols, we can unlock the unconscious and bring it into the realm of the conscious, thereby understanding ourselves and our motivations more completely. Freud gave people a common language by which they could attempt to scientifically discuss the common experiences we all have when we dream. He talked about the illogical juxtaposition of objects, condensation of space and time, primal needs, hopes and

fears, repressed desires, obsessions, and the intensity of dreams, among other things. His theories seemed, at the time, to explain so much about human psychology.

Thus, Breton saw Freud as a liberator of the mind, and Marx as a liberator of politics. Together, they could change the world and perhaps make it a place where another war of such scale would never happen. Surrealism was to be the visual manifestation of this liberation. And, as such, we can view the movement as almost utopian in its intent. In 1924 Breton published the *Manifeste du surréalisme* which outlined the ideas and the movement he, along with other poets, writers, and artists, envisioned. Many of the artists who had been part of the Dada movement joined in the development of Surrealism, creating a variety of methods to get to the material locked in the unconscious mind.

Like the Symbolists of an earlier generation, the Surrealists sought ways to bypass the logical mind and liberate the creative and intuitive part of the brain. They sought a heightened awareness and a dislocation of the rational. Salvador Dali developed his own method, the "paranoid-critical" technique whereby he would simulate a state of paranoia, recording multiple images of paranoic fantasy on the canvas. These were controlled by his "logical" or "critical" mind, which he continued to employ to organize the images. The idea of controlled or rational derangement was tied into Surrealist thoughts on the mentally ill. It was felt that a state of mental illness automatically allowed the patient to be freed of the rational and therefore be more in tune with the intuitive and unconscious parts of the mind.

Breton connected the irrational and the intuitive with the idea of the female and femininity. Supported by Freud's concepts of repressed sexuality, Breton saw the idea of sexual freedom as a way to tap into the unconscious. The social stereotypes about women that were prevalent at the time (women are irrational, changeable, child-like, and emotional) helped Breton to justify the formulation of his theories. Women became the "muses" or inspirations to the male Surrealists. Sexual activity was seen as a liberating factor for the unconscious, and women, who were deemed to be naturally so much closer to their unconscious selves, became the objects of desire and the vehicle to unleashing the mind. This, of course, led women Surrealists to have a difficult time finding equal footing in the movement, and by the early 1930s many of them had left Breton's group of "official" Surrealists to strike out on their own.

Artists developed dream imagery in which they attempted to re-create the feelings that we have when we dream through a series of bizarre juxtapositions of images similar to what we might experience in a dream. The visual language of the strange and inexplicable had already been established in the paintings of the Italian Metaphysical painter Georgio DeChirico. Surrealist artists, inspired by DeChirico and Freud's book, created paintings and sculpture that mimicked the world of the dream. Artists also explored automatism or automatic drawing as a method to unlock the unconscious. This produced a more abstract style of painting whereby the artist, after clearing the mind of any conscious thought through meditation, would allow the hand to move across the page creating a random series of trance-like markings. The artist

would then go back in and add paint, or allow the markings to suggest images to be developed.

The Surrealist movement was disrupted by the outbreak of World War II. Artists fled Europe and came to the United States in the late 1930s and early 1940s. The influx of the Surrealists into New York City became one of the pivotal influences on the development of the Abstract Expressionist movement. At this point, as Europe was embroiled in war, the United States, and particularly New York City, became the center of the art world and Americans would take the lead of the avant-garde.

Abstract Expressionism

When the Surrealists and other avant-garde artists were forced to leave Europe in the 1930s and 1940s, many of them came to the United States. This was particularly influential on a young generation of American artists who had been working during the decade of the '30s in the Works Projects Administration (WPA). The WPA had been formulated by President Franklin Roosevelt during the Great Depression to put Americans back to work. One section of the WPA, the Federal Arts Project, was created to give artists jobs doing public art projects. The Federal Arts Project kept over 5,000 artists employed during the Depression. Additionally, this project hired art historians, historians, anthropologists, musicologists, and photographers to document the American experience. Interviews were conducted with former slaves, recordings were made of early bluegrass and jazz, traditional quilts were collected and patterns documented, and photographs captured rural America and the great migration of the Dust Bowl era.

American painters, supported by WPA monies, had been working in the Social Realist and Regionalist styles. Artists in both styles consciously rejected the European influences of abstract art as elitist and focused on clearly defined images that were easily understood. Social Realism investigated the social ills of the times, while Regionalist artists created depictions of American life typical of various regions of the United States, emphasizing the positive aspects of life in those regions, as a counterpoint to the massive problems facing the country during this period.

As European artists immigrated to the United States to escape war and persecution, it was the Surrealists, in particular, that brought with them the possibility of spontaneity and freedom of imagination. This was a liberating factor to this young group of American painters who had been working for a decade in the styles of Social Realism and Regionalism. Additionally, for the first time in modern history, there was no European model that could show the way ahead. American artists were free to develop a style and a way of working in which they could became the innovators rather than following the lead of the European avant-garde. Gathering in New York, and sometimes called the "New York School," this group of young artists developed the uniquely American style called Abstract Expressionism.

Abstract Expressionism was influenced by the emotive power of Non-Objective painting, the raw power of German Expressionism, and particularly by the group of

Surrealist painters involved with automatism. The window into the unconscious that was offered by Surrealism, and the meditative qualities of automatic drawing that allowed for the abstract landscape of the unconscious to be made visible, was especially appealing to Jackson Pollock. He developed a method of painting, a type of Abstract Expressionism, that the American art critic Harold Rosenberg dubbed "Action Painting." In a 1952 article Rosenberg wrote: "At a certain moment the canvas began to appear to one American painter after another as an arena in which to act—rather than as a space in which to reproduce, re-design, analyze or express an object, actual or imagined. What was to go on the canvas was not a picture but an event." ("The American Action Painters," *Art News*, December 1952: 25.)

Action Painting combined physical movement with large gestural techniques. Paint was dripped, splattered, thrown, heaved, and poured onto the canvas. In Pollock's technique, the canvas was placed on the studio floor and the artist moved around it in a trance-like state of mind based on Surrealist automatism. Action Painting, however, was not a passive meditation, but an active "event." Pollock's childhood, growing up in the western United States, contributed to the development of the method. The repetitive movement and trance-like quality of Native American dance rituals coupled with the sacred ceremonies of sandpainting, where the canvas is the ground and the artist moves around it, were important influences on Pollock's

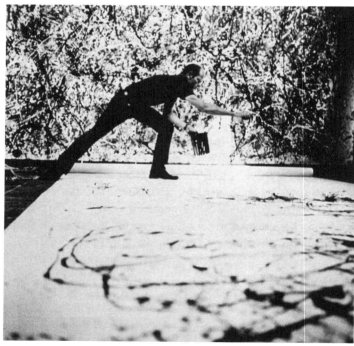

© Lefrank David/CORBIS

Jackson Pollock painting.

methods. Pollock's brand of Action Painting is characterized by spontaneous emotion, bold colors, and strong and evocative non-objective shape and line.

Another branch of the Abstract Expressionist movement was "Color Field" painting. Developed by Mark Rothko, Color Field painters concentrated on creating huge stained or painted "fields" of color on the canvas. Rothko's vibrantly colored rectangles are stacked vertically on the canvas, their softly blurred edges melding into the layers of background colors. These large paintings evoke expressive and emotional responses as the viewer becomes enveloped in the floating fields of diaphanous, ethereal, and translucent colors. The intrinsically "quiet" mood of his paintings produces a soothing meditative aspect to his works. As the canvas is simply about the interaction of color and shape, the viewer is not guided by the artist, but rather is invited to journey, through the painting, into his/her own thoughts and inner consciousness.

In both cases, the "primacy of the canvas" and "truth to materials" seen 100 years earlier in the Realist movement, become more fully realized. The logical extension of this idea would materialize in the 1960s with Post-Painterly Abstraction and Minimal Art.

Pop Art

The term "Pop" is used to apply to art in the 1950s and 1960s that adopted the look and/or the techniques of advertising, industrial design, movies, pulp literature, and everything that we now associate with a consumer society and popular culture. Pop began in London in the mid-50s with a group of artists known as the Independent Group. They were fascinated by the impact on British life of American mass media and the consumer culture that had been flooding into England since the end of World War II. Richard Hamilton, a member of the group, created one of the first Pop Art statements in his collage from 1956 entitled *Just What Is It That Makes Today's Homes So Different, So Appealing*. The puns on '50's stereotypes and culture capture the mood of the times. Hamilton wrote that Pop Art should be: "Popular (designed for a mass audience), Transient (short-term solution), Expendable (easily forgotten), Low-cost, Mass-produced, Young (aimed at youth), Witty, Sexy, Gimmicky, Glamorous, Big Business." These, of course, are the goals of the world of advertising.

That art should be linked in such a way to consumerism, advertising, the mundane, banal, and commonplace is certainly derived from the tenets of the Dada movement. The British art critic Lawrence Alloway defined the movement in his 1959 essay entitled "The Long Front of Culture."

> Mass production techniques, applied to accurately repeatable words, pictures, and music, have resulted in an expendable multitude of signs and symbols. To approach this exploding field with Renaissance-based ideas of the uniqueness of art is crippling. Acceptance of the mass media entails a shift in our notion of what culture is. Instead of reserving the word for the highest artifacts and noblest thoughts of history's top ten, it needs to be used more widely as a description of "what society does." (Cambridge Opinion, No. 17, Cambridge University, England, 1959)

Pop Art was quickly adopted and expanded by American artists who dominated the style in the late '50s and the decade of the '60s. In the aftermath of World War II, there was an incredible rise in consumer products, advertising, and disposable goods. Billboards, magazines, advertising, brand name items, and so forth, all promoted the notion of "the good life" and "status" as found through consumable goods. In its inception, Pop Art was motivated by the optimism of a rising economy. Commercial culture was the raw material that provided an endless source of subject matter for works of art that combined painting, sculpture, collage, and assemblage. Pop art became a reflection of the society it wished to describe. Values, morality, political and social concerns, popular heroes, and common household objects were reflected in the images of Pop Art.

Unlike Dada, early Pop was not motivated by despair and disgust at contemporary life, but rather poked fun at society and its values. As the optimism of the late '50s and early '60s began to change with the escalation of the Viet Nam War and the accompanying protests to the war, the Civil Rights Movement, the Feminist Movement, and the variety of social changes that came, the Pop movement became more serious and scathing in its review of popular culture.

In the 1950s Robert Rauschenberg and Jasper Johns were influenced by Duchamp and New York Dada. Rauschenberg's assemblages, made of found objects, and his "combine" paintings, and Johns's paintings and sculptures of everyday objects set the foundations for American Pop. Calling attention to the commonplace, Johns transmuted such items as empty beer cans, casing them in bronze, thus insisting that the viewer re-evaluate the definition of art. Rauschenberg created sculpture and collage with the castaway objects of consumer society. Picking trash from the streets of Manhattan, he combined discarded objects in such as way that each lost its individual identity toward the meaning of the "whole" and created a vision of modern life that was both familiar and shocking.

Roy Lichtenstein chose images from popular comic strips and advertisements, enlarging them in oil and acrylic with flat hard-edged designs and precise drawing. These faithfully rendered paintings, which reproduced the panels from comic books, served up to the American public the banal role-models, stereotyped gender roles, and low expectations fed to children through the seeming innocence of these publications. By enlarging them into paintings, which gave them the type of legitimacy reserved for "fine art," viewers were forced to consider the actual power that images have.

Similarly, the work of Andy Warhol examined the power of images and advertising. Coming from an advertising background, Warhol understood the psychology of marketing. Samuel Adams Green, art critic and Director of the Institute of Contemporary Art at the University of Pennsylvania, Philadelphia, wrote about Warhol in a 1965 retrospective catalog:

His pictorial language consists of stereotypes. Not until our time has a culture known so many commodities which are absolutely impersonal, machine-made, and

untouched by human hands. Warhol's art uses the visual strength and vitality which are the time-tested skills of the world of advertising that cares more for the container than the thing contained. Warhol accepts, rather than questions, our popular habits and heroes. By accepting their inevitability they are easier to deal with than if they are opposed. . . . We accept the glorified legend in preference to the actuality of our immediate experiences, so much so that the legend becomes commonplace and, finally, devoid of the very qualities which first interested us.

Warhol's multiple silkscreens of Marilyn Monroe juxtapose the public persona, depicted in color, with the tormented private reality shown in black and white. His repetitive Campbell's Soup cans and Coca-Cola bottles give us the glut of sameness that mass media culture and advertising foist upon us. Warhol's ideas have precedence in the work of the Dada artists like Duchamp, who defaced the sacred image of the *Mona Lisa* by painting a moustache and goatee on her. The icons of popular culture are debunked. Similarly, Warhol's idea of a series of images was not new. Monet had painted in series—cathedrals, haystacks, and water lilies, to name a few. But for Monet, the idea was to examine nuances and differences. For Warhol, the project was to offer up the broken promises of modern consumer culture.

Getting his audience to acknowledge the power of ordinary objects was the concern of Pop artist Claes Oldenburg. Oldenburg converted the world of everyday things by enlarging them to preposterous proportions, thereby changing their meaning. Bringing to light the objects of our own invention, and magnifying them, he robs them of their intent, function, and context. Like the Dada artists, everyday objects become art, and like the Surrealists, these objects are placed in disjunctive and disassociated contexts whereby new meanings and understandings are gleaned.

Post-Painterly Abstraction and Minimalism

The 1960s brought multiple art styles and experimentation. Many of the artists that had been Abstract Expressionists moved toward a much cooler and detached form of painting known as Post-Painterly Abstraction, also called Hard-Edge Abstraction. As the name suggests, "post" means after. So the reference is to a style that comes *after* "painterly abstraction." As Abstract Expressionism was emotional, expressive, and painterly in both Color Field and Action painting, this new style shunned those traits. In Post-Painterly Abstraction, the soft hazy edges, painterly brushwork, and the tonal variations of Color Field painting were given over to strongly defined, flat areas of color with no tonal gradations, and clear sharp edges that delineate complete color separations juxtaposed yet rigidly divided.

This style was the ultimate manifestation of Greenberg's theories of the progression of *Modernism* and purity in painting. The idea of self-reference was fully manifest here. Post-Painterly Abstraction was self-referential in that it truly referenced only those things intrinsic to painting: the flat surface and the pigment. He saw the linear

progression of painting from Manet as a continuum moving toward the elimination of all elements not in keeping with the essence of the medium.

Sculpture in the 1960s was dominated by Minimalism. In keeping with the concept of self-reference, Minimalist artists focused on the formal aspects of sculpture, removing all representation and concentrating on three-dimensional geometric shape and form. The simplicity of the minimalist object without reference to the outside world allowed the viewer to bring his/her own interpretations and meanings to the work. In many Minimalist pieces the "hand" of the artist was removed in a similar way that "painterly" aspects were removed in Post-Painterly Abstraction. Highly reflective materials were machine polished, leaving no trace of the imperfections of hand polishing or individual marks of any kind.

In both painting and sculpture, the work is reduced to its most elemental simplicity with truth to materials remaining dominant and issues of content nonexistent. Paintings and sculptures are self-contained and self-sufficient, existing independently within their own order of rules and materials. In the 1960s the aesthetic concerns and priorities of Modernism—self-reference, self-criticism, purity of form, and nonassociation—became firmly entrenched in the American artistic community as the ultimate statement of "high art." The most evocative forms were represented in the cool intellectualism and reductionist format of Post-Painterly Abstraction and Minimalism.

Nevertheless, not all artists rejected the notion of the figure or the painterly and emotive aspects of paint. A group of artists located in the San Francisco Bay Area, known as the Bay Area Figurative School, rejected Abstract Expressionism, Pop, and Post-Painterly Abstraction and embraced both representational art and the sensual, evocative aspects of paint. Abstracting the figure and the landscape, while still maintaining object recognition, Bay Area Figurative artists such as David Park, Richard Diebenkorn, Elmer Bischoff, and James Weeks created powerfully emotive canvases filled with insight and emotional truth. These artists rejected the powerful "gallery system," "art critic," and "aesthetic" ideologies that dominated the art world at the time.

Post-Modernism

Other art forms began to emerge in the 1960s and '70s that moved art away from the strict linear progression of Modernism into a much more pluralistic group of artistic expressions that reflected the very pluralistic society that we had become. A variety of artistic movements began to replace strict Modernist theory as a response to the issues of social consciousness and humanism that arose from the chaos of the 1960s. Certainly Pop Art dealt more directly with the issues that society was facing, sometimes

poking fun and sometimes seriously attacking our notions of art and life. And, by the mid-1960s there was the desire and the realization that art must reach beyond itself and its small group of artistic literates out into the world at large to begin to incorporate some important issues.

The work of Joseph Beuys combined ritual and performance while incorporating nontraditional materials and expanding the definition of what art is. Eva Hesse experimented with molded and modeled latex surfaces that expressed the sensual and emotional qualities shunned by Modernism. Performance and conceptual art redefined the artist's role. Earthworks moved art out of gallery and museum settings using nature as the raw materials of sculpture. Installations allowed the viewer to interact and be part of the environment of the work of art.

In the 1970s the term Post-Modernism came into use to describe the many divergent tendencies that art was taking. Post-Modernism was first seen in architecture, as the clean rectilinear lines and designs of Modern architecture were deemed sterile in light of the pluralism that the cultural revolutions of the 1960s had instigated. Post-Modernist architecture is inclusive and eclectic. Modern materials are combined with past motifs to create an interactive dialogue between past and present, and to provide an environment that speaks to the diversity of modern urban life. Artists who were disillusioned with the definition of "fine art" and the formalistic and commercialized movements that had dominated the '50s and '60s soon joined in.

In a 1979 article in *Arts Magazine*, Kim Levin wrote that Post-Modernism is

> . . . an art of synthesis rather than analysis. . . . Tolerant of ambiguity, contradiction, complexity, incoherence, it is eccentrically inclusive. It mimics life, accepts awkwardness and crudity. . . . Structured by time rather than form, concerned with context instead of style, it uses memory, research, confession, fiction. . . . Subjective and intimate, it blurs the boundaries between the world and the self. (October, 1979, 54 [2], pp. 90–92)

Post-Modernism is a broad term that includes such diverse movements of the '70s, '80s, and '90s as Pattern Painting, Photo Realism, Neo-Expressionism, and New Technologies like Video and Digital Imagery. It concerns itself with relating to a broader public across class lines, and seeks to combine an awareness of the past with contemporary issues. Springing from a social base, it deals with topics as wide-ranging as gender roles, politics, race, and commercialism. It invites the viewer's participation and speaks to emotional and psychological issues along with the formal elements of design. While Modernist theories were based on self-referential and nonassociative concepts where form was the only content, Post-Modernism speaks to values outside itself concentrating on meaning, message, and context.

DISCUSSION QUESTIONS

1. List the stylistic traits of Neoclassicism and choose a Neoclassic work to illustrate how these traits are manifest in the painting.

2. How does Romanticism differ from Neoclassicism? Pick two works of art to compare.

3. Using a Realist painting of your choice, discuss the change from Romanticism to Realism. What did the Realists artists object to about Romanticism? What two concepts summarize Realist theory? (Be sure to draw reference to examples within the work of art to illustrate your points.)

4. What is Impressionism? What is its relationship to Realism? What are the influences on the development of Impressionism? Explain these influences as they are manifested in Impressionist works.

5. What did Van Gogh and Gauguin object to about Impressionism? Using a painting by one of these artists and another painting by an Impressionist, discuss the change from Impressionism to Post-Impressionism. Illustrate your points with specific examples from the works you chose.

6. Both Cezanne's *Still Life with Peppermint Bottle* and Monet's *Rouen Cathedral* are dated 1894. Though done in the same year, they are very different paintings exhibiting divergent artistic views and concerns. Explain.

7. What is the relationship between the work of Cezanne and the style of Analytical Cubism?

8. What aspects of the Symbolist movement influenced the Expressionist movement of the early 20th century? Cite examples from both styles to illustrate your points.

9. What concepts of Dada were important to the Pop Art movement? Illustrate your points with examples found in both Dada and Pop works.

10. What were the theoretical concepts of Surrealism and how were they manifested in Surrealist work? Give specific examples to illustrate your points.

11. Explain the relationship between the Surrealists and Abstract Expressionism. What influence did Automatic Surrealism have on Action Painting? What are the differences between the two?

BIBLIOGRAPHY

Albright, T. *Art in the San Francisco Bay Area: 1945–1980*, UCB Press, 1985.

Atkins, R. *Artspeak: A Guide to Contemporary Ideas, Movements, and Buzzwords*. Abbeville Press, 1990.

Barrett, T. *Criticizing Art: Understanding the Contemporary*. Mayfield Pub., 1994.

Barron, S. (ed.). *Degenerate Art: The Fate of the Avant-Garde in Nazi Germany*. Los Angeles County Museum of Art, 1991.

Berger, J. *Ways of Seeing*. Penguin, 1978.

Bougault, V. *Paris Montparnasse*. Paris: Terrail, 1997.

Breton, A. *Manifestos of Surrealism*. University of Michigan Press, 1969.

Breton, A. *Nadja*. Grove Press, 1960.

Broude, N. and Garrard, M. (eds.). *Feminism & Art History: Questioning the Litany*. Harper and Row, 1982.

Chadwick, W. *Women, Art, & Society*. London: Thames & Hudson, 1990.

Chadwick, W. *Women Artists & the Surrealist Movement*. Little Brown, 1986.

Chipp, H. *Theories of Modern Art*. UCB, 1968.

Clark, T. *Art and Propaganda in the Twentieth Century*. New York: Abrams, 1997.

Crane, D. *The Transformation of the Avant-Garde*. University of Chicago Press, 1987.

Descharnes, R. and Néret, G. *Salvador Dalí*. Germany: Taschen, Köln, 2006.

Doss, E. *Benton, Pollock and the Politics of Modernism: From Regionalism to Abstract Expressionism*. Chicago: University of Chicago Press, 1991.

Dunning, W. *The Roots of Postmodernism*. New Jersey: Prentice Hall, 1995.

Friedrich, O. *Olympia: Paris in the Age of Manet*. New York: Simon and Schuster, 1992.

Goodyear, F. *Contemporary American Realism Since 1950*. New York: New York Graphics Society, 1981.

Hamilton, G. H. *19th and 20th Century Art*. New York: Prentice Hall.

Harris, A. S. and Nochlin, L. *Women Artists: 1550–1950*. New York: Knopf, 1976.

Herrera, H. *Frida: A Biography of Frida Kahlo*. New York: Harper & Row, 1983.

Herrera, H. *Matisse: A Portrait*. Harcourt Brace, 1993.

Hess, T. B. and Baker, E. C. *Art and Sexual Politics* (Includes Nochlin's essay "Why Have There Been No Great Women Artists?") New York: Collier, 1973.

Hobhouse, J. *Everybody Who Was Anybody: A Biography of Gertrude Stein*. Doubleday, 1975.

Huffington, A. *Picasso: Creator and Destroyer*. New York: Avon Books, 1988.

Hughes, R. *Nothing If Not Critical: Selected Essays on Art & Artists*. 1990.

Hughes, R. *The Shock of the New*. 1981.

Kandinsky, W. *Concerning the Spiritual in Art*, New York: Dover, 1977.

Lippard, L. *Overlay*. New York: Pantheon, 1983.

Los Angeles County Museum of Art, *A Day in the Country: Impressionism and the French Landscape*. 1984.

Lovejoy, M. *Postmodern Currents: Art and Artists in the Age of Electronic Media*. New Jersey: Prentice Hall, 1997.

Mackintosh, A. *Symbolism and Art Nouveau*. Barrons, 1978.

Metropolitan Museum of Art. *Vincent Van Gogh: The Drawings*. 2005.

Museum of Modern Art New York. *Picasso: A Retrospective*. 1980.

Museum of Modern Art New York. *Picasso/Matisse*, 2003.

National Gallery of Art. *Van Gogh's Van Goghs*. Washington, DC, 1998.

Nochlin, L. *Women, Art, and Power*. Harper & Row, 1988.

Perry, G. *Women Artists and the Parisian Avant-Garde*. Manchester, England: Manchester University Press, 1995.

Phillips, L. *The American Century: Art and Culture 1950–2000*. New York: Whitney Museum of American Art, 1999.

Rewald, J. *History of Impressionism*. New York: Museum of Modern Art.

Rewald, J. *History of Post-Impressionism*. New York: Museum of Modern Art.

Rhodes, C. *Primitivism and Modern Art*. London: Thames and Hudson, 1994.

Richter, H. *Dada Art and Anti-Art*. Oxford University Press, 1965.

Sayre, H. *Writing About Art*. Prentice Hall.

Shattuck R. *The Banquet Years: The Origins of the Avant-Garde in France, 1885–WWI*. Vintage Books, 1968.

Slatkin, W. *Women Artists in History*. 1985.

Slatkin, W. *Voices of Women Artists*. Prentice Hall, 1992.

Taylor, B. *Avant-Garde and After: Rethinking Art Now*. New Jersey: Prentice Hall, 1995.

Taylor, J. *19th Century Themes of Art*. University of California Berkeley, 1987.

Varnedow, K. and Karmel, P. *Jackson Pollock*. New York: Museum of Modern Art, 1998.

Venn, B. and Weinberg, A. (eds.). *Frames of Reference: Looking at American Art, 1900–1950*. New York: Whitney Museum of American Art, 1999.

8

Study Skills and Writing Techniques

Two words that come up a lot in an art history class are *recognize* and *analyze*. By the end of the semester, your professor will want to make sure that you can recognize important works of art created by the pivotal artists of the time period you are studying. And, your instructor will also want you to be able to write about art in a way that incorporates the analytical and critical thinking skills that you have developed. Art history tests are usually made up of these two components, so it is important to learn the necessary study habits and skills that will help you to understand the material and do well on the essays and exams. You will probably be in lecture classes, where you will be viewing images of artwork and taking notes. You may be required to participate in discussing the works on view. At some point, you will be tested on the material, via image identification, objective test questions (such as multiple choice and true/false), brief answer essays, or long essay questions, or perhaps a combination of all of the above. It's important to know how to manage the information so that you can do well on essays and exams. It all begins with taking good notes.

Study Skills

Taking Notes

Developing a method for note taking in an art history class can be a daunting task. There is so much new information and visual images being presented simultaneously that it is difficult to know where to begin, what is important, and how much of the

details are necessary to record. It is essential that you stay organized. Most often, you will be provided with a syllabus that at least outlines the weekly topics that will be discussed. Get a notebook dedicated entirely to the class and make sure that every day you are in lecture you start by dating the first page of your notes and writing the subject under discussion at the top of the page. This way, you will always have your notes coordinated with the syllabus.

Many instructors furnish their students with a list of the artists or works of art being considered in the lecture that day, either in a handout or on the screen or board. If you are provided with a list of artists and/or works of art, your task is easier because you have the spellings of the names of the artists and the titles of the works. However, many professors do not, and the student needs to be able to acclimate to any style of teaching. If you do not have a list of artists and/or artwork that is being considered in lecture, you will find it easier to keep up with the discussion if you have reviewed the topic in your text the night before the class. Look at your syllabus to ascertain what subject will be presented. Go through your textbook and write down the last names of all the artists that are mentioned in the chapter pertaining to the topic to be presented in class. The artists' names should be written in your notebook directly under the lecture date and subject heading at the top of the page. This way, you have already become somewhat familiar with the artists, and you know exactly where to quickly look in your notes to find names and spellings.

Most of the major textbooks have artists' pronunciation guides at the back of the book. Look over the proper pronunciation of the artists' last names. Often, a name that looks familiar on paper sounds quite different when correctly pronounced. For example, the name of the Neoclassic painter Jacques Louis David looks easy enough when written out. However, the instructor will pronounce it in French which sounds like "DaVEED." That may throw you off track and slow you down if you are not recognizing what is being said. And then there are the confusing-looking names like "Parmagianino." Spelling the name while you are trying to continue to listen to the instructor will bog you down and you will lose important information. By having the name already written in your notes, you can establish a shorthand version of it, for example: "Parm." You will know what it means when you go back and read your notes because you already have it written in full at the top of the first page of your lecture notes for that day.

It is a very good idea to develop your own shorthand, so that you can write more quickly and not get sidetracked spelling out simple, constantly used words over and over again. For example, the word "within" can be "w/in." Without can be "w/o." The word "because" can be "b/c." "Paint" can be "pnt," and "painting" can be "pntg." Any abbreviations you can come up with that work for you are just fine. You can even develop a "key" to the abbreviations and write that on the inside cover of your notebook for easy reference. Also, as your professor introduces a new artist or work of art, write the last name of the artist and/or the title outside the left margin of the page. Then go on to take notes within the regularly established margins. That way you can

look down the left side of the page and easily locate the discussion about a work of art or an artist without having to read through all your notes. Similarly, your shorthand needs to be a recapping of concepts, rather than a verbatim record of every word the instructor utters. For example, your professor might be talking about Kandinsky's use of color in a particular painting and would say, "Notice how important the use of color is within Kandinsky's work entitled *Composition No. 25*. Red is used in the upper left and lower right to diagonally balance the composition." Your notes might look like this: "Kan. Comp 25: Red up left, low rite = \ bal." You have grasped and recorded the concept without writing out every word your instructor says. You are free to continue listening and taking notes, without losing the next important point because you are still working on the last one.

Another aspect involved in note taking is to try to come up with some method that will help you to remember the pictures shown in lecture. Some images will be in the book and it is easy enough to just write down the title in your notes. However, often the professor will show works that are not illustrated in the book and that you may not have immediate access to. This is necessary because you need to see a wide variety of images from a particular artist or artistic movement, far more than can be illustrated in a textbook, in order to understand style. Certainly, the Internet can be a wonderful tool to locate works of art, and getting the title written down in your notes is important. Additionally, if you can do a quick sketch alongside your notes (stick figures and outlines of shapes within the composition,) that can really be helpful in identifying a work of art later when you are trying to remember the image and find it in a book or on the Internet.

Taking notes from the assigned readings is also important. The reading material works along with the lectures to give you a more in-depth understanding of the cultures and styles that you are studying. However, it is difficult to retain so much information at one time, so it is best to take notes on what you are reading. If you own the textbook, highlight areas in the text that explain styles, theories, or pertinent historical and cultural data relative to the time frame and artwork that you are studying. Also, make notes in the margin to remind yourself when you go back later as to why you highlighted a particular sentence or paragraph. It is very helpful to also take notes on what you have read, and of course, notes are essential to take if you do not own the book. Try to extract the essence of each important idea. Do not copy it, and do not paraphrase. Just write, in your own words, what the important concepts are in a simple sentence or two. Usually, if you will do this, the substance of the idea will come back to you when you review your notes.

Another way to make sure that you are on track with your note taking is to ask questions in class when you want clarity about something that you do not understand. If it does not seem appropriate to ask a question during the lecture, make sure you ask after class or visit your instructor during office hours. If there are teaching assistants for the class, make sure that you avail yourself of their knowledge. They have been through the class before, are familiar with the material, and can be of real help. Also,

the teaching assistants often conduct weekly study sessions. If this is the case, make sure you attend as often as you can. This is a good way to check if you have all the information you need to have in your notes. It is also a great opportunity to discuss art in a small group, which can really be helpful in checking to make sure you have all your facts correctly written in your notes, and to compare and share notes with other students.

If your instructor encourages class discussion, try to participate. It can be daunting in a large lecture hall with lots of students in attendance. However, taking the risk and raising your hand to answer a question is one of the best ways to stay alert and engaged with the material. It also gives you practice in voicing your ideas and opinions in small increments. These small challenges build up your ability to think quickly and are very helpful in preparing you to answer in-class essay questions. If speaking in front of a large group is too difficult, try sitting near the front of the class. This way, when you are answering the questions, you are speaking directly to the professor and are not so aware of people looking at you. It can minimize the self-consciousness you might have in these sorts of situations. But ultimately, it is the practice in participating that eventually alleviates the discomfort.

Organizing and Managing Information

As good as your notes may be you will still have to organize the information in order to study for a test. Most art history exams deal with a number of elements. There may be slide identification which requires you to look at an image on the screen and identify the artist, title, style, date, and perhaps medium and/or location. You will probably be given one minute to identify these components, and if there is also a brief essay question about the image, you will be given another five or ten minutes to write out your answer. There may also be questions (either in objective or essay format) that will require you to identify elements of style. You will be asked to point out the formal properties or stylistic traits in this particular work of art that help you to identify it with a specific culture, time frame, or stylistic category. Often, professors will show an image you have never seen before and ask you to identify the style and justify why you have related it to that style. There may be vocabulary that you are required to give the definition for, or actually incorporate the vocabulary into an essay that relates the words to a particular work of art or stylistic movement. Here are some ideas for successfully gathering and organizing the information you will need to study for exams.

Information/Organization/Interpretation Sheets

On a separate perforated page, you will find a copy of the *Information/Organization/Interpretation Sheet.* You can tear this out and make photocopies. The *Information Organization Sheet* is designed to help you, on a weekly basis, pull together the important information from the lectures, notes, and reading into a single, cohesive page, and to apply the important points to a work of art. Your instructor may ask you

to turn these in on a weekly basis to be checked for accuracy. They are also helpful to compare key points when you are working in study groups.

Begin by writing your name, date, and the culture or stylistic period that you are going to deal with.

Question #1: Simply create a list of the formal elements that group or designate works of art into the particular style that you are working on. List the general stylistic traits that are essential to identifying the piece to the style you are discussing.

Question #2: Apply the stylistic traits listed in question #1 to a work of art from your book. This will help you practice writing about art and help you remember the important aspects of a particular style because you have to repeat the information and apply it in a new way.

Question #3: List the works of art that you think or know will be on an exam. Write the artist's last name (if known), the title of the work, the style (this is repetitive, but necessary to firmly entrench it into your memory), and the date. If your instructor requires it, add location and medium to the list as well.

Information/Organization/Interpretation

Name:_____ Date:_____

The style I will discuss is: _____

Briefly answer questions 1–3 below (use the back if necessary).

1. Some of the stylistic traits that identify works of art of the style listed above are:

2. The following work of art fits into the style listed above because (List a work of art pertaining to the above style and explain why/how it fits into that style. This should be in essay format, applying the list you established in #1 to a work of art described here in #2.):

3. The works of art I am *required* to know, pertaining to the above style are:

Artist	Title/location	Style	Medium	Date

Flash Cards

There is a lot of required memorization in art history. You need to be able to recognize important works by major artists and to contextualize them within the cultural and artistic time frame in which they were created. A very efficient way to manage this part of the task is to create flash cards. Make photocopies of the works that you are required to know. Using the form provided below or index cards, affix the photocopy to the front, and on the back write the following information:

Artist:

Title:

Style:

Date:

(Location/Medium):

Significance: (Why is this artist/work of art important? How does this work exemplify a specific style? What is its historical significance? What contributions does this artist/artwork make toward the history of art?)

Studying in this way allows you to easily quiz yourself. Memorize the images on a weekly basis while the lecture/reading information is still fresh for you. Do not wait until the night before an exam to cram for it. You will not be able to satisfactorily memorize the data. The only way to manage is to do this in small increments on a regular basis, and you will have no problem remembering the information or recognizing the works of art for the identification part of an exam. Furthermore, if you briefly fill in the significant aspects of the artist and/or style, you are also preparing yourself for the essay parts of the exam and making useful connections between works of art within various stylistic periods and time frames.

A note about dates: Depending on your instructor, dates will be emphasized to a greater or lesser extent. Generally speaking, by memorizing a date along with the other information about a work of art, you have created a mental time line for yourself. You will probably not remember the exact date after the semester ends, but you will find that you are always able to place works of art within a relatively accurate period of time and to associate it with a particular style from that time period. Often, professors do not require that you memorize exact dates, but will give you a few year's leeway on either side of the correct date. If this is the case, you can organize works of art by approximate dates, and memorize one date for several pieces. For example, 450 B.C.E. is a good date to remember for High Classical Greek art as many of the pieces illustrated in most textbooks are dated within ten to twenty years of this date.

Using this page, you can create a separate notebook of required works of art that you are required to memorize for a test. Tear out this page and photocopy it. Affix the image of a single required artwork in the area below, and then fill out the information on the back of this page.

Artist:

Title:

Style:

Date:

(Location/Medium):

Significance: (Why is this artist/work of art important? How does this work exemplify a specific style? What is its historical significance? What contributions does this artist/artwork make toward the history of art?)

Writing Techniques

Many students find art history writing assignments to be very challenging. The type of critical thinking and analytical skills required for these papers is often one that students have not developed or had much practice in. The *formal analysis* and *compare and contrast* essays are typical compositions that are often assigned. And there are certain procedures and techniques that can make the task interesting and intellectually stimulating, and produce an excellent outcome.

Formal Analysis Essays

Sometimes called a *descriptive analysis* or *critical analysis,* this type of essay is designed for the student to take a very close look at a work of art and really dissect it to determine its *formal* properties or *elements of style*. In a formal analysis, the writer is breaking down the various components in the work and carefully looking at such things as medium, size, line, shape, color, depth, modeling, brushstroke, interaction between positive and negative space, visual rhythm, subject matter, context, and interpretation. A formal analysis is not simply a description, although it does include that. However, it goes well beyond a description by breaking down, in detail, the individual aspects of a work of art. The process gives thoughtful consideration to every element. It then reconstructs the work by determining how each of the various components works together to create the whole.

Sustained focus, concentration, and careful, close observation are the skills required for this type of writing. We are, perhaps, used to giving the objects that surround us a cursory glance and superficial attention. Having to be so completely immersed in these ways will help you to develop an essential skill-set. It makes you far more aware and sensitive to the details and nuances in all the other aspects of life, and helps you become an analytical thinker and an articulate speaker. After all, the ability to communicate our complex thoughts and ideas gives us great power in the world, allowing us to clearly converse, persuasively discuss, and eloquently express our opinions.

Begin your paper with a documentation of the work of art that you are going to discuss. The first paragraph should state the artist, title, date, medium, location/collection, size, and style. Then, in one or two sentences write your thesis statement. This will be the guide for the rest of the paper and allow you to stay focused and on track, using the "formal" elements to provide proof and persuade your reader as to the validity of your points of analysis. Your thesis will be the consistent thread that runs throughout the essay and will be the focal point from which your analysis will stem. The order of the thesis statement and the documentation can be interchanged—either can precede the other.

Avoid the use of personal pronouns. So rather than writing, "The work of art I am going to discuss is . . ." say instead, "The work of art that will be discussed in this

paper is" This goes for opinions as well. You want to suggest to your reader that your ideas are not eccentric or too personal, but rather more universal and can be proven by the concrete examples that you are going to give to prove your points. So rather than writing, "I get a very sad feeling when I look at this painting," you could say "The painting evokes a sense of sadness due to the blue-gray colors used throughout, and the downcast eyes of the figures." The use of personal pronouns is much more appropriate when you are writing a review of an exhibition, for example. This sort of writing is based on the personal opinion of the writer.

Often, beginning art history students start their paper with a personal "story" or recounting of the events leading up to the actual writing of the paper. It is a way of "warming up" to the subject—of getting ready to write. So, for example, a student might begin the paper something like this: "The assignment was to write a paper on a work of art at the museum. I had never been to the museum before. It was hard to take the bus downtown, but once I got there, it was even harder for me to find a work of art I liked. Finally, after wandering around the museum for an hour, I got to the second floor and saw this really amazing painting. . . ." After all this exposition, the student is finally ready to actually start the real substance of the paper. It's fine if you need to begin like this. Go ahead and do it. Just take it out and get rid of it after writing your first draft.

The next several paragraphs should be a general overview or description of the work of art. The aim is to orient your reader to the subject matter, placement of the figures and objects, and the various interesting attributes of the painting. This is also a place where you can generally discuss and place the work of art within the cultural and/or stylistic context in which it was created. You can also discuss the artist's importance to the movement or period and whatever political, sociological, or religious beliefs or information is important to an understanding and interpretation of the work. For example, if you are writing about a sculpture of an Egyptian pharaoh, it would be important to discuss the concepts of divine kingship and belief in an afterlife, because those two ideas are integrated into the art of that culture. So, placing the art within a framework constructed of cultural and stylistic aspects will help you and your reader understand the way that the formal elements are used.

After you have provided the initial documentation, thesis, and general description of the work of art, you can then begin to discuss the variety of elements that go into the perception and evaluation of the piece. These are the formal elements of style mentioned above. These factors determine how we interpret the work as to intent, content, and meaning. Painting, for example, consists of just two elements: color patches on a flat surface. So how is it that there are so many different types of painting? How can just two elements create such differences in mood? How can groups of paintings be classified into stylistic movements? The answer has to do with the way the formal elements are depicted, utilized, and arranged. By understanding these components, we can understand the work and gain great insight into its interpretation.

In writing about the elements of style, it is essential that you back up your observations with concrete evidence found within the work of art itself. Additionally, any interpretations that you have about meaning need to be backed up with proof derived from the piece you are discussing and the cultural or stylistic context. If you are doing any outside research about the artist or the time period that also leads you to certain conclusions about the work, you must document your sources with citations and bibliography. Any direct quotations or paraphrasing of an author's ideas or material must be acknowledged. Otherwise it is considered plagiarism. There is a lot of information that is general knowledge. It is not necessary to footnote ideas that are stated in every source you read and seem to be agreed upon by most scholars. It is, however, necessary that you cite the sources you used to gain outside information in a bibliography at the end of your paper. There are many good books and Internet sites that can help you with citations, footnotes, and bibliographies.

After you have established the formal elements and how they work together to create the work of art, you can move onto an interpretation. The interpretation is based on your analysis of the formal elements and also relates back to your thesis statement in the opening paragraphs of your paper. Finally, you can finish the paper by restating the thesis and providing a summary of the main points you have mentioned that prove your conclusions.

Students often wonder how to identify and write about the formal elements in a work of art. One of the best techniques for doing this is to pose questions about the piece that will promote careful observation and yield lots of information. The answers do not constitute the essay. They simply provide the groundwork upon which the outline and essay can be developed. Here is a list of questions that will be useful to begin a painting analysis. It is not an all-inclusive list and each painting will generate a set of questions specific to it. However, this will get you started in taking a look at a work of art and determining some of the formal elements that act together to formulate the picture. As you read through the questions, try to answer them based on one of the paintings illustrated on the cover of this book.

1. Composition:
 Where are the figures/objects placed within the composition?
 What is the relationship between figures/objects/background?
 Where are the open spaces?
 Where are the crowded areas?
 What effect does the placement of solids and voids have on the compositional space and the mood of the painting?
 Is the composition symmetrical? Asymmetrical?
 Does it appear visually balanced? Why or why not?
2. Color:
 What are the specific colors?
 Where are they placed within the composition?

Are the same colors reiterated in various parts of the painting?

What effect does color have on how your eye moves through the composition?

What is the emotional impact of color?

3. Lighting:

What part of the painting does the light enter from?

What areas are highlighted?

What areas are in shadow?

Do the light and shadow appear natural? Like stage lighting?

Does the light create a sense of drama, or produce a distancing effect instead?

Is the light interior or exterior light?

What effect does light have on mood and atmosphere within the painting?

Does light help to model the figures and objects? How?

4. Texture:

What are the various textures within the composition?

How does the artist create textural effects? color? brushstroke? light?

What effect does the texture have on our perception of the images? On the mood?

Does the paint have its own texture apart from its descriptive function? If so, what is it and what effect does it have?

5. Modeling:

Do the figures and objects appear three-dimensional? Why or why not?

Are the figures/objects outlined? To what effect?

Are the figures/objects modeled with light, color, and brushstroke? To what effect?

Are the figures and objects made to appear three-dimensional?

Does the artist create convincingly rounded volumes?

Do the folds in the drapery appear to be determined by the body beneath, or are they more about surface patterning?

6. Movement:

Do the figures or objects appear to be in motion, or are they static?

What elements give the impression of action or stasis?

Is there an underlying geometric structure that determines if you perceive the picture as active or static?

What techniques does the artist use to convince you of action and movement?

7. Brushstroke:

Are you able to see the brushstrokes?

Are they consistent throughout the painting?

Are there places where there are thin layers of glazes and areas of thick impasto?

What are the effects in the way the artist applies the paint?

8. Depth:

 Does the work have a sense of three-dimensionality?

 Is there a sense of depth in the painting? If so, how is it conveyed? If not, why not? What perspective devices are used?

9. Gesture:

 What are the main figures doing?

 Are they relating to each other in any way?

 Does anything in their gesture or glance tell us something about them or their relationship to one another?

 Do the gestures tell a story? If so, what?

 How is your eye led through/across the picture with stance, gesture, and glance?

10. Content:

 What, if anything, does the title contribute to your understanding of the meaning of the work?

 What is the content and/or message? What in the painting leads you to this conclusion?

 How do the elements in the painting contribute to the content and your interpretation?

The questions posed above are meant to assist you in making an in-depth examination of a painting. Answering the questions is the starting point in developing an essay. It can help bring subtle aspects to light and get you to think about the painting from a number of different angles, perspectives, and interpretations. However, keep in mind that you must develop your essay around observations that can be backed up by specific aspects found within the work of art. You must give examples to illustrate the points you make. For example, in *The Blue Dancers* by Edgar Degas, illustrated on the front cover, there is a sense of movement and spontaneity. The artist achieves this in several ways: The figures are loosely defined with quick brushstrokes. The ballerinas are composed of arm, leg, and feet gestures that automatically imply movement. They are not looking at the viewer, but seem to be caught in the middle of warming up for a performance and unaware that they are being observed. Their asymmetrical placement in the composition and the cropping of the figure on the right creates a certain amount of spontaneity and the impression that Degas has captured a brief instant that will change momentarily. By calling to mind examples found within the painting that shape your thoughts, you have used factual information to back up your ideas and substantiate your opinions.

Name:_____ Date:_____

Course #_____

Now take a look at the Vermeer painting, and decide how you would handle the issue of movement here. Write a couple of paragraphs on motion and movement in this painting, being sure to substantiate your ideas and opinions with elements found within the work itself.

Many of the questions that were posed for painting can also be used for writing about sculpture. But, here are some other things to consider too:

1. Composition:
 Is the piece symmetrical or asymmetrical? Why?
 Is it visually balanced? How?
 Is it in the round? Is it relief? What is the effect?
 What is the relationship of mass and void, or positive and negative space? How do they interact with each other?
 What is the position of the body? What does this tell you?
 Where are the arms placed in relation to the torso? The hands? The legs?
 Is it completely frontal or not? Explain.
 From what angle are we meant to view it?

2. Modeling:
 Is there texture to the surface? Where? To what effect?
 What parts are smooth? What parts are rough? What is the effect?
 Is it realistic, idealized, stylized, abstracted? Give examples to explain.
 Describe the treatment of the eyes, cheeks, mouth, nose, chin.
 Do you see underlying musculature? Is it realistic or abstracted?

3. Material:
 What is the work made of?
 What is/are the textures?
 What effect does texture and material have on our perception?
 Does light create reflection, articulation, definition?
 Does the color of the material help you to understand the piece better?
 Does color add to the composition or detract from it?
 Is the work left in its natural state or is it painted? To what effect?

4. Interpretation:
 What time period and culture does the work belong to?
 How is it representative of the time frame or culture? Or is it?
 What meaning or content can you derive from it?

Name:_____ Date:_____

Course #_____

Using the piece below, describe how the artist models the figure. Discuss articulation of the body, musculature, stance, and the effects of positive and negative space.

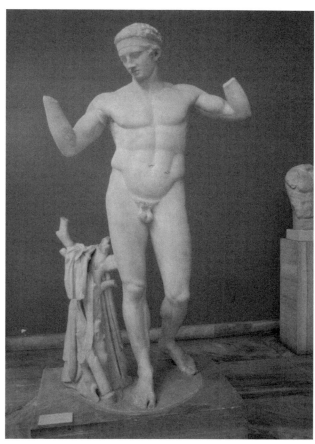

© Image courtesy of Corel

Athlete Binding His Hair (Diadoumenos), c. 100 B.C.E., marble copy of 5th-century B.C.E. bronze by Polykleitos, National Archaeological Museum, Athens, Greece.

Here are some questions to consider when writing about architecture:

1. What purpose is the building meant to serve?
2. Does it seem that the form is related to the function? How?
3. What are the materials? What time period do they call to mind?
4. Do the materials have a variety of textures? What is the effect of texture or lack of it?
5. Does color play a part in the visuals of the building? To what extent and to what effect?
6. When you are inside, what part do natural and artificial lighting play in your understanding and perception of the interior space?
7. Does the exterior space visually correspond to the interior space?
8. What is the scale of the building in relationship to you?
9. Is the building inviting? Why or why not?
10. When you are inside, are you able to have a visual relationship with the outside world? Why or why not, and what is the effect of this?
11. Does the building seem heavy and solid, or is there a sense of lightness and playfulness to it? Why?
12. Are there elements that are repetitive? Do they create a visual rhythm? To what effect?
13. Why might the architect have chosen to create the structure in this way? Can you determine the intent?
14. Does the building reflect any political or social agenda?
15. How do the various elements work toward your understanding of the whole?

Name:_____ Date:_____

Course #_____

Visit a civic building, church, or synagogue. Evaluate the space for the interrelationship between form and function.

A good paper begins with a good outline. The outline is the roadmap that gives direction to the writing. It helps to keep the composition on track with a sustained unity of thought and an even flow. A detailed outline will help to create a logical sequence of ideas, and will keep the focus on the topic at hand, helping to avoid disorganized and tangential communication. Furthermore, taking the time to develop a detailed outline assures the writer that all the important points and small details have been mentioned, and that nothing has been forgotten or left out. If the outline is complete, the paper is already halfway written. Here is an example of a partial outline for the Vermeer painting pictured on the front cover. It is not complete, and there are many more details to be added, but this should give you an idea of the format and structure that an outline has.

I. Introductory paragraph
 A. General information about the painting
 1. Jan Vermeer, *Young Woman Standing at a Virginal*, 1672, oil on canvas, 20" × 17-3/4", National Gallery, London, England
 B. Thesis statement: This painting reflects the social, political, and religious concerns of the Dutch Republic in the Baroque period by emphasizing the material world and imbuing it with secondary symbolism.

II. Overall description
 A. Woman standing at virginal (piano)
 1. cream-colored satin dress, blue collar
 2. hands on keyboard
 3. looking directly at viewer
 B. White-walled room with three pictures
 1. left wall—idyllic landscape
 2. middle: directly behind her head
 3. far right: landscape behind virginal
 C. Light comes in from left-hand side of painting
 D. Blue chair in right foreground
 E. Black and white tiled floor

III. Detailed analysis of formal elements
 A. Position of the figure and other elements
 1. eye contact with viewer invites viewer in
 2. hands on keyboard = music = sensuality
 3. combination of the two creates ambiguous role of viewer
 a. Are we just an observer? Is she waiting for her lover? Is the viewer in the position of the lover?
 b. placement of cupid painting behind her head confirms sensual overtones
 4. idyllic pictures are symbols of peaceful untroubled relationship
 5. chair in right foreground cropped to imply extension into our space

 B. Depth in the painting
 1. linear perspective of receding floor tiles
 2. orthogonal lines of wall on left and painting on right
 3. oblique angle of chair
 4. repeated color
 5. diminutive and overlapping perspective
 C. Color
 D. Light
 E. Textures
 F. Brushstroke
 G. Modeling of the figure
 H. Precision of detail

IV. Interpretation—Ties in with thesis

V. Conclusion—summary

Name:_____ Date:_____

Course #_____

Practice creating the beginnings of an outline by using a painting or sculpture from this book, or your textbook (mention book, edition, and page number). Outline the introductory paragraph (including a thesis statement), the general description, and two formal elements.

After the outline is completed, the writing begins. Be careful not to fall into the trap of writing a simple description. Your outline, if done well, should keep you from this. Begin by making a statement about a particular element of style. Let's take depth, for example. In the outline above, the formal aspect of depth was addressed in the Vermeer painting. Four points were listed: Linear perspective of receding floor tiles, Orthogonal lines of wall on left and painting on right, Oblique angle of chair, and Repeated color. Begin by establishing, in the first line of your paragraph, **what** you will be discussing: depth. Then call your reader's attention to **how** the artist creates it: various perspective devices. Finally, show **where** you see this: floor tiles, and so on. Your discussion might go something like this:

> There are several ways that Vermeer composes a believable sense of depth in this painting. Through the use of linear perspective we are taken from the chair in the foreground, to the woman in the middle ground, and finally to the pictures on the wall in the background. One way this is achieved is in the patterned black and white floor tiles which appear to recede from foreground to background toward a vanishing point at the back of the picture. The orthogonal lines of the tile pattern are reiterated on the left with the recession of the wall and on the right with the recession of the painting placed behind the virginal. Both of these also appear to recede toward a single vanishing point. In essence the lines of the floor, wall, and painting create a visual "box" into which the figure and objects are placed.
>
> Additionally, we are directed toward the depth of the painting by the chair which is placed in the lower right corner of the picture space. Its seat is placed at an oblique angle slanted toward the interior of the room, thus directing our gaze into the space of the picture. Color also serves to enhance the illusion of depth in the painting. The blue velvet seat of the chair is repeated in the same blue of the woman's collar, and the same blue is depicted in the sky of the painting on the left of the wall. This repetitive color forms an implied diagonal line from the lower right foreground to the upper left of the background, thereby leading our eye into the space of the room.
>
> Diminutive perspective further enhances the illusion of depth as can be seen in the floor tiles that become smaller as they move from foreground into the background. The tiles lining the lower back wall appear quite small and provide visual interest as well as a relationship with the floor tile that sets each in relative proportion to the other. Overlapping perspective is also employed to continue the illusion of three dimensions on the flat surface of the canvas. Vermeer sets the woman in the center of the space with her head appearing to be in front of the painting of Cupid.
>
> This also establishes an implied relationship between the woman and Cupid . . .

This example will give you some idea of how to formulate a sequence of reasoning that logically moves from an observation into the specifics. The goal is to describe, explain, and analyze an element of style while synthesizing it toward an understanding of the entire picture. Try this yourself on the next page.

Name:_____ Date:_____

Course #_____

Using the painting on the front cover by Sofonisba Anguissola, discuss how the artist develops the illusion of depth.

Compare and Contrast Essays

Another type of analytical composition is the compare and contrast essay. This type of writing takes two (or more) works of art and looks at them for their similarities (comparisons) and differences (contrasts). This is an excellent way to closely examine each piece as the act of comparing brings out the uniqueness of both works. Basically a compare and contrast essay is an expanded and elaborated formal/descriptive analysis. Each work is described and analyzed for its formal properties and style. Then the various individual elements of both works are analyzed together. There are basically two ways to construct this type of essay. One way is to do a separate formal analysis for each work, then bring them together point by point. With this structure, each piece would be completely dealt with individually in a formal descriptive analysis. Then, the various elements would be compared and contrasted: color, brushstroke, depth, modeling, light, and so forth.

The other way to approach this type of essay is to work simultaneously with each of the formal properties. This approach interweaves commentary on both pieces, switching back and forth between the works in a single paragraph and alternating sentences. In this style, the individual elements of style in both works are taken, one at a time, and dealt with as separate units within the same paragraph. One might consider the use of color in both works, then brushstroke in both works, and so on. The format you choose has to do with your own style of writing. Either one is an acceptable approach and simply depends on what makes the most sense to you.

In doing the exercises above, with regard to movement in the Vermeer, and depth in the Anguissola painting, you were actually making comparisons between Degas and Vermeer in the handling of movement, and between Vermeer and Anguissola with regard to depth and the use of space within each picture. Although you were handling them individually, the assignment asked you to make visual comparisons of individual stylistic elements. Perhaps you noticed that by considering one, then the other, you were more fully able to see and understand the way each artist depicted these properties. When you are analyzing a work of art, it is oftentimes very helpful to try and imagine what the work would look like if the artist did it differently. For example, when you look at the Vermeer, try to imagine how it would feel and look differently if Vermeer had handled the brushstrokes the way Degas did in his painting. What would the effect be? Similarly, what would the Degas look like if he had used the precision of line and the carefully modulated brushstrokes and highlights that we see in the Vermeer painting? You might find that the Vermeer would look far more spontaneous and the Degas would seem far more static. This is how a compare and contrast essay can help you to really take a close and careful look at each of the formal properties of the individual pieces, to make an in-depth analysis of each, and to draw comprehensive conclusions about each work.

Try the two exercises below to practice the compare and contrast essay with just one formal property at a time.

Name:_____ Date:_____

Course #_____

You have several paragraphs above on the creation of dimension and depth in the Vermeer painting. In this next exercise, discuss these same elements in the Gauguin painting *Young Breton Woman*. Then, compare and contrast the depiction of dimension and depth between the two works.

Name:_____ Date:_____

Course #_____

Compare and contrast the modeling of the figures in the Gauguin painting and the Anguissola painting. In your discussion consider how outline, color, light and shadow, and brushstroke are used differently and what effects those components have on how we perceive the way the figure is modeled. Which appears more three-dimensional and which appears flatter. Why?

Name:_____ Date:_____

Course #_____

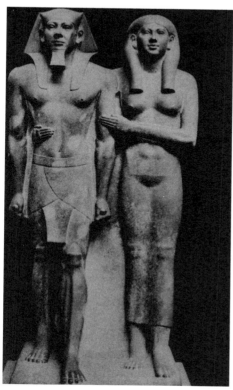

© Image courtesy of Corel

*Menkaure and His Wife, Queen
Khamerernebty*, from Giza, c. 2515 B.C.E.

Discuss articulation of the body, musculature, stance, and the effects of positive and negative space in this Egyptian sculpture with that of the Greek piece illustrated above.

Often, students wonder just what a professor looks for in a paper assignment, and how it is graded. Obviously, not all instructors grade the same or place the same amount of emphasis on each item. However, below you will find a basic list of elements that are most commonly considered when grading an art history paper.

Rubric for Paper Assignments

Does Your Paper Follow the Format Instructions?

Typewritten: Always type your paper. Do not turn in a handwritten paper.

Double Spaced: Unless you are told to do otherwise, always double-space your papers.

Proofread with No Corrections on Final Hard Copy: Do not turn a paper in with handwritten corrections. Always proofread your paper several times to catch any errors. Correct the errors prior to printing out the final copy.

Clear of Spelling Errors: Run your work through spell check so that there are no spelling errors.

Meets the Minimum Page number Requirement: Make sure that your paper at least meets the minimum page number requirement assigned by your instructor. If it is a 5–7 page paper then make sure you have at least 5 pages and not 4-1/2. Also use 10 or 12 pitch type, and nothing larger.

Descriptive Analysis/Comparison: Does It Have the Following?

Appropriate Introduction: Introduce your reader to the work(s) of art that you will be considering. Give all the pertinent information: artist, title, date, style, medium, size, location. If you are working from a piece in a book state the book title, edition number, and page number. If you are working from a piece in a gallery or museum, give the name of the gallery or museum. If the piece is in a museum give the gallery or floor number as well. Within the first two paragraphs make your thesis statement.

Detailed Overall Description(s): The next several paragraphs should be an overview of the work(s) that you will be discussing. This does not need to be in depth because you will be going into the details when you discuss the elements of style. But you do need to orient your reader to the general attributes, main figures, and objects so that when you discuss them you have already given your reader a visual picture that helps him or her conceptualize and contextualize the piece within the framework of your discussion. Give background information that would be useful in analyzing the piece by placing the work within its cultural or stylistic context.

Placement of Artwork/s Within Cultural and Stylistic Context: Anchor the work(s) of art within the cultural and/or stylistic context in which it was created. Discuss how the stylistic aspects of each piece(s) allow it to be classified into the category of style that you have assigned it to, and to the concerns/style of the artist(s).

These next three components will formulate the main body of the paper. They are developed and considered simultaneously in the order below:

1. **Identification of Visual Elements of Style:** The visual elements of style or the formal elements in the work need to be identified and discussed separately. Take one item at a time and fully explore it before moving on to the next. However, sometimes several formal aspects work together to contribute to one another. For example, the implied movement in the Degas painting, on the cover, is made up of line, brushstroke, and figure positioning. So in discussing movement, you would need to address the interaction between those three elements. The flattened picture space in the Gauguin painting on the cover is composed of strong outline and large areas of flat color. So in order to discuss the depth, or lack of it, you would need to deal with the application of color, line, and brushstroke.

2. **Demonstration of How Stylistic Elements Have Been Applied:** Specifically state how each element of style is used in the particular piece you are discussing. For example, if you are speaking about the composition in the Gauguin painting, you might say that "Gauguin creates a very balanced and stable composition."

3. **Support of Observations with Proof:** You must support your statements about how the stylistic elements have been applied by offering your reader specific examples. Point out those items that formulate your opinions and understanding of the piece. In the example above, you would substantiate your observation about a balanced and stable composition by pointing out the strong outlines that construct the figure and the background, the placement of the figure vertically and centrally within the picture space, the heavy black horizontal line at the upper edge that helps to stabilize the piece and, along with the verticality of the figure, create an underlying structure of vertical and horizontal lines which are also factors that tend to immobilize the composition.

Comparisons: Follow the format above and deal with the specific stylistic elements in each work by comparing the way each artist uses them. Identify, demonstrate, and give proof to illustrate and validate your points of comparison. So in the example given above about Gauguin's stable composition, you might contrast it with the Degas and point out the differences in placement and cropping of the figures as well as brushstroke and positions of the figures that create a more spontaneous and less fixed composition. However, you might continue with a point of comparison in the way that Degas does have strong outline around parts of his figures and how that compares with the lines that define the modeling of Gauguin's figure.

Application of Vocabulary Within Appropriate Context: Art history, as an academic discipline, has its own vocabulary that makes it easier and more efficient to express the complexities within a work of art. Study the vocabulary and make sure that you use it, and use it correctly.

Organized Sequence of Presentation: Read over your essay and make sure that you have organized it in such a way that it flows smoothly. Make sure that you finish discussing one item before moving on to the next, and develop logical, fluid transitions between topics. This allows your reader to understand what you are trying to express.

Sustained Relevance to Topic: Keep focused. Stay on topic. Do not get tangential. Make sure that your thesis prevails throughout. Maintain clarity of thought and unity of style and format throughout. The whole idea of writing is to impart to your reader your own complex ideas and understanding of a work of art. If your reader is unable to follow your thinking because of disorganized writing or irrelevant comments that veer off-topic, you are distracting the person from a comprehension of what you are trying to communicate.

Writing Mechanics: Pay attention to grammar and sentence structure. Use proper punctuation and divide your ideas into separate paragraphs. These are essential if you want to get your ideas across to your reader. It will not matter how intelligent and innovative your thoughts and ideas are if you cannot communicate them in a way your reader can understand. By using the appropriate grammar, syntax, punctuation, and paragraphs you will be better able to engage your reader with your ideas and not in trying to untangle a poorly written, grammatically incorrect, sentence.

Interpretation: Discuss meaning(s), symbolism, and iconography.

Draw Conclusions: Recap the thesis and draw conclusions related to it by summarizing your insights and briefly highlighting the relevant points that formulate and substantiate your opinions.

BIBLIOGRAPHY

There are many exceptional books on writing about art. Consult these for more in-depth instructions on writing essays.

Barnet, S. *A Short Guide to Writing About Art.* New York: Pearson/Longman, 2005.

Barrett, T. *Criticizing Art: Understanding the Contemporary.* Mountain View, CA: Mayfield Publishing, 1994.

D'Alleva, A. *Look! The Fundamentals of Art History.* Upper Saddle River, NJ: Prentice Hall, 2004.

Reid, D. K. *Thinking and Writing About Art History.* Upper Saddle River, NJ: Pearson/Prentice Hall, 2004.

Sayre, H. M. *Writing About Art.* Englewood Cliffs, NJ: Prentice Hall, 1995.

Tucker, A. *Visual Literacy: Writing About Art.* New York: McGraw Hill, 2002.

9

Materials and Methods

Although it is not necessary for an Art History student to be a practicing artist, some understanding of the artistic process, the use of materials, and the techniques employed is essential to the ability to fully comprehend and evaluate works of art. This section is designed to give students a general overview of many of the methods used in a variety of media that they are likely to encounter in their studies. (Words in bold print are defined here or in the chapter *Elements of Art—Terminology*.)

Acrylic A water-soluble painting **medium** that is of a plastic-based synthetic resin composition. Used since the 1960s, acrylic paints are nontoxic because the thinning agent is water. They dry quickly and, once dried, these paints are impervious to water.

Additive A method in sculpture or ceramics where areas are built up or added to create the form of work of art. (Also see **subtractive.**)

Air brush A device for spraying paint. Patented in 1893 by Charles Burdick, a British artist, the air brush operates with compressed air. The paint is held in a container and blown in a fine mist, via a hose and compressor, through a hand-held nozzle which allows the artist to control the pressure. Subtle tonal gradations of color as well as smooth continuous fields of color can be achieved.

Alabaster A white **translucent** stone used for sculpture in both ancient and modern times. There are two types: gypsum, which scratches easily, and calcite, which is harder but still easily carved.

Anneal In metal and glass work, the process of heating, then cooling the material to strengthen it.

Anodize The process of coating metal with an electric current to protect and decorate the surface.

Armature The underlying framework for a sculpture in clay, plaster, and so on, used to prevent it from collapsing under its own weight.

Assemblage Sculpture using preexisting, sometimes "found" objects, that may or may not contribute their original identities to the total content of the work.

Automatism A method of painting or drawing where the artist clears the mind and allows the free and instinctive motion of the hands to dictate the outcome of the work.

Braze A technique of joining pieces of metal by soldering.

Bronze A metal used in **casting** sculpture. It is a mixture of copper and tin.

Brownstone A type of sandstone that contains iron and is used for building.

Burnish To polish and smooth a surface through rubbing.

Calligraphy Handwriting in pen and ink or brush and ink that is especially elegant, elaborated, and embellished.

Canvas The cotton or linen cloth that is pulled tightly around **stretcher bars** to create a surface for painting.

Cartoon (1) A full size drawing made as a guide for the artist to complete a painting. The cartoon can also be transferred to a wall or canvas with a **pouncing** technique. (2) A humorous or satirical drawing, a pictorial joke, or a caricature.

Casein A painting medium and adhesive. Evidence of the use of casein goes back to ancient Egypt. It is a product of processed milk curd. When used as a **medium** for paint, it dries quickly into a **matte** finish. As an adhesive, its adhering properties are strong enough to reliably bond wood.

Cast To form into a shape by pouring into a **mold.**

Cement A mixture of limestone, clay, gypsum, and water. It can be used as a **mortar,** and as an ingredient in **concrete.** Cement can also be modeled over an **armature, cast,** or used to create a solid sculpture.

Champlevé This is an enameling technique that can be used more economically for larger objects (whereas **cloisonné** would be used for smaller pieces). A thick metal base is gouged out to create designs. The troughs are then filled with enamel which is then fired. The plain metal areas (between and around the enameled troughs) are then decorated with **gilding, cloisonné,** and/or **incised** designs.

Chasing To finish the surface of a sculpture by removing the flaws.

Chisel A metal tool with a sharp cutting edge used to cut stone, wood, or metal. Chisels come in different sizes and shapes depending on the material they are to be used on and the type of cut desired. They are set against the material and forced into it with pressure from the hand or hit with a **mallet.** (Also see **gouge.**)

Cire-perdue Lost wax process of metal casting. Usually used for casting bronze, this method can be used to produce small *solid* sculptures, or larger *hollow* pieces. In the *solid method*, a model is carved from wax. The wax is then covered with clay and the clay is fired. Thus, the wax will melt out, leaving a mold into which molten metal can be poured. Once the metal hardens the outer clay cover is taken off. The details are then added and enhanced with a variety of tools such as hammers, **chisels, gravers,** and so on. The *solid method* is often used for a single sculpture. In the *hollow method* a core of **clay** is covered with a layer of wax which is sculpted to the general shape of the desired object. The wax is then covered with a layer of clay. Metal rods are inserted through the core and the outer layer, so that when the clay is fired, and the wax melts out, a hollow space is left between the core and outer layer into which molten metal can be poured. When the metal is hardened, the outer layer and core are removed and the object is then **chased** with tools (as above) to create details and finishing. Large sculptures are usually created in sections then welded or riveted together. The *hollow method* can be used to create multiples of an image. Multiple sculptures are labeled with the full number of the edition (as the bottom number) and the number of the piece within the edition (as the top number). For example 3/10 would indicate that the piece was the third casting in an edition of 10.

Clay A type of earth that is easily **modeled** due to its soft, pliable properties when water is added. It is available in a variety of textures, and used to make pottery, sculpture, and tile. (Also see **modeling clay** and **sculptor's clay.**)

Cloisonné Probably of Near Eastern origin, this enameling technique is used in jewelry and to decorate other small items. (**Champlevé** would be more often used for larger works.) Metal strips usually of gold are **soldered** to a metal background to create design compartments called *cloisons* into which colored **enamel** paste is placed. The material is heated to meld the metal with the enamel and form decorative patterns.

Collage A composition of various materials on a flat surface, such as newspaper, photographs, fabric, magazine images, and so on.

Concrete A building material of aggregate (small stones, pebbles, sand, and so on) mixed with a **cement** binder. In ancient times, the Romans discovered that if they added *pozzolana* (a volcanic ash from the town of Pozzuoli near Naples) they could produce a slow-drying, noncracking material that set throughout its entire depth, and would harden under water. This discovery facilitated the enormous building projects of the Roman Empire.

Conté Crayon Nicolas Jacques Conté invented this **medium** during the Napoleonic Wars due to a shortage of **graphite** in France at the time. It was a mixture of powdered graphite and clay which could be used to create delicate textural effects in drawings. The conté crayons available today are made from fabricated chalk.

Diorite A very hard stone ranging in color from gray to black, used especially in ancient Egypt for sculpture.

Earthenware A type of low-fired pottery that is slightly porous.

Easel A stand upon which a canvas is placed to support it during the painting process.

Emboss To create a raised pattern or image onto the surface through pressing, stamping, **modeling,** and so on (Also see **relief.**)

Enamel (1) Glass powder or paste applied to a metal ground and fired in order to fuse the two (see **champlevé** and **cloisonné**). (2) Can also be used to describe a type of **oil** and **varnish**-based paint that dries into a hard glossy surface.

Encaustic Paint created with **pigments** suspended in a **medium** of melted wax.

Faience Developed and used by the ancient Egyptians from the 4th century B.C.E., faience is a non-clay ceramic compound made of powdered quartz, lime, and **natron,** or plant ash. Small amounts of copper or other minerals were added to the mixture to give color to the material during the firing process, or added to a soda-lime-silica glaze prior to firing. The most common color is blue or blue-green. After firing, faience takes on a glass-like luminosity.

Fixative A sealant applied to a work of art to preserve it.

Forge (1) Using heat, a method of shaping metal by first softening it, and then pounding it into the desired shape. (2) A furnace in which to heat metal in order to *forge* it.

Fresco There are two types of *fresco* painting. The first is sometimes called *buon fresco* which is the true fresco technique of painting on fresh, wet lime plaster with **pigments** suspended in a water-based **medium.** The plaster and paint combine so that when it dries, the painting is literally part of the wall. Fresco produces a hard and durable painting that is impervious to direct sunlight. *Fresco secco* is painting on dry plaster. This style is subject to flaking, and was mostly used to touch up details in the *buon fresco* technique. In the early buon fresco technique, the wall was covered with a rough coat of plaster *(arricio)*. The design was sketched out in charcoal, and when the artist was satisfied, the image was outlined in **sinopia.** One small section at a time would be covered over in smooth plaster *(intonaco)* and the artist would complete that part of the painting, often working from a **cartoon.** In later times the entire **cartoon** would be transferred onto the wall in a **pouncing** technique and the sinopia stage would be skipped.

Frottage A method of placing paper over a textured surface then rubbing a pencil, chalk, pastel, and so on, over the paper to pick up the textured image onto the paper.

Gesso A white coating or **ground** used to prepare the surface of a canvas for painting.

Gilded A coat of gold that is applied to surfaces of painting, sculpture, or architecture.

Glaze (1) Thin transparent film of **oil paint,** brushed one layer over another. The translucency of oil glazes allows for layers of paint to glow through one another so that lower layers of color alter the tones of the upper layers. (2) The liquid substance is painted on ceramics prior to firing to give the finished product color, texture, and gloss.

Gouache A type of **watercolor** paint that is less finely ground and made opaque by adding white pigment or some white substance such as chalk. Gouache produces a **matte** finish. Works of art created in this **medium** are called *gouaches*.

Gouge A type of chisel used for working wood, metal, and stone, and designed with a U-shaped tip to carve small concave depressions in the surface.

Graded relief A method of creating the illusion of depth in relief panels by employing various degrees of relief, ranging from very high in the foreground, to extremely low relief in the background, thus giving the illusion of distance. (See also **relief sculpture.**)

Granite A hard stone available in a variety of textures and colors. It is difficult to carve, but extremely durable for outdoor use in building. It also can maintain a highly polished finish.

Granulation A metalworking technique of fusing metal beads or granules to a metal surface.

Graphic arts An all-inclusive term that includes **printmaking,** drawing, and **graphic design.**

Graphic design Designing words and images in preparation for commercial use such as in advertising and book design.

Graphite A crystalline form of carbon. It is the material used in pencils producing a hard, thin gray line.

Graver See *burin* under **printmaking** processes.

Ground A coating applied to a metal plate to prepare it for a printmaking process. Also used to describe the coating put on a canvas to prepare it for painting such as **gesso.**

Hatching In drawing and **printmaking** it is a method of creating the illusion of dimension by shading in a closely set series of parallel lines. *Crosshatching* are two sets of hatching overlaid at an angle to each other.

Impasto Paint applied in heavy, thick brushstrokes that create a texture and dimension on the canvas.

Incise To cut into the surface with a sharp instrument.

Inlay A pattern or image set into the surface of a material such as wood or **marble,** and at the same level as the surface of that material in order to form a smooth, even design.

Intarsia Refers to **inlay** designs created in wood.

Kiln An oven device used to dry, bake, and fire ceramics.

Lacquer A resin-based liquid, clear or colored, used to give wood or metal a high glossy finish, similar to **varnish.**

Limestone Closely related to **marble,** but it is softer and can be more easily worked. However, it does not have the crystalline texture and thus cannot be polished to a glossy finish, but rather has a **matte** finish.

Mahlstick A wooden rod designed to steady a painter's hand and keep it clear of the surface of the painting. The end that rests on the **easel** is padded while the other end is supported and held in place by holding the mahlstick between the forearm and the torso. The mahlstick provides a support for the hand holding the brush.

Mallet A hammer with a head made of softer material, such as rubber or wood, rather than the normal steel.

Marble A stone used for sculpture. It comes in many colors and variations. Carrara and Pentellic marbles are most widely used for sculpture. They are white or cream colored with a smooth crystalline structure that can be polished to a high degree of gloss and luminosity.

Matte (1) A non-glossy, lusterless, and nonreflective finish on a work of art. (2) A border, usually cut from cardboard, which is used to frame a drawing, print, or watercolor, or used to act as a transition between the work of art and the frame.

Medium (1) The fluid into which **pigments** are suspended to make paint such as various oils for **oil paint,** synthetic resins for **acrylic** paint, or egg yolk for **tempera.** (2) The material an artist works with—clay, ink, paint, and so on.

Mixed media A work of art that incorporates two or more **mediums** into the finished product.

Modeling clay A wax- and oil-based clay that will not dry, and is used to make models in preparation for casting.

Mold (1) A form or shape created to hold a liquid substance poured into it, so that the substance will take that shape and hold it when it dries. Also refers to something that has been made in a mold. (2) To model or form a substance into a desired shape.

Mortar A mixture of cement, sand, lime and water used in building to join stone elements.

Mosaic Small pieces of glass or stone **tesserae** set into wet plaster or cement to form a picture or design.

Natron A highly salty natural compound used by the ancient Egyptians in the mummification process and in the making of **faience.**

Oil paint A type of paint where **pigments** are mixed with drying oils such as linseed, poppyseed, or walnut. The slow-drying property of oil paint allows great flexibility to create blending of colors, a great range and intensity of colors, **glazes, impasto,** and so on.

Oxidation The process by which metals change color over time through chemical or electrical means. For example, highly polished bronze will change over time to a greenish **patina** through exposure to the elements.

Palette (1) A piece of nonabsorbent material, such as wood, ceramic, and so on, meant for mixing paints. Often it has a hole cut into it for the thumb, thus allowing it to be held between the thumb and palm while painting. (2) The colors used within a work of art.

Palette knife A tool for applying **acrylic** and **oil** paints. It consists of a thin, flat, and flexible blade inserted into a wooden handle. It is used for spreading paints in a **painterly** and **impasto** fashion creating texture on the canvas.

Pastels Chalk-like crayons made of finely powdered **pigments** mixed with water and a binding **medium.** They are available in a wide range of colors and produce a soft effect that is enhanced by blending with the hand or soft paper. The surface is fragile and is usually sprayed with a **fixative** to avoid the pigments from rubbing off.

Patina (1) The thin layer of tint or color that appears on copper or bronze over time through the process of **oxidation.** (2) The sheen on antique surfaces that appears with time and wear.

Photograph (from Greek *phos* = light, *graphos* = drawing) A **print** image created by the action of light falling on a sensitized surface. There are many techniques for achieving a variety of effects.

> *Albumen print* A photographic print made on paper coated with a mixture of albumen (egg white) and ammonium chloride and coated with a solution of silver nitrate. Albumen paper for photographic prints remained popular throughout the 19th century. However they were eventually replaced by the simpler **gelatin silver prints,** which were easier to produce and did not turn yellow.

> *Calotype* This process, patented by William Talbot in 1841, used treated paper **negatives** in the camera and reduced exposure time to about one minute. Although the process was complex, the use of negatives allowed multiple prints to be made. It was predominantly used until 1851 when glass **wet plate** negatives were developed.

> *Chronophotograph* (from Greek *chronos* = time, *phos* = light, *graphos* = drawing) A photographic study of a body in continuous motion. Early experiments were done by pioneer photographer Eadweard Muybridge. Using several cameras in a row and with a "tripping" device for each camera, Muybridge was able to record the sequence of movements of a trotting horse in 1872. In 1882, Étienne-Jules Marey devised a

multiple-exposure photograph that was able to record continuous motion at short intervals exposed separately on a single **negative.** These photographic experiments greatly influenced the Dada, Cubist, and Futurist artists in the early 20th century.

Daguerreotype Partly based on Niépce's experiments, Louis Daguerre announced his photographic process in 1839. The daguerreotype was the first practical photographic process. It was a complicated procedure that required a treated plate to be exposed for about 30 minutes, and produced a direct **positive** print without the use of a **negative.**

Darkroom A completely dark room illuminated by light sources that do not affect light-sensitive materials. It is used specifically to process and develop photographs while not exposing them to sources of light that would alter them.

Enlarger Used to enlarge or reduce the size of a **negative** when making a print, by projecting light through a lens, then through the negative and onto photographic paper.

Gelatin dry plate Sheets of glass were coated with a gelatin silver bromide compound, placed into the camera and exposed for just a few seconds. Later, the plates could be processed in the **darkroom** and multiple prints made. The technology was developed in 1871 by Dr. Richard Maddox and precoated plates were made available by 1878. From the 1880s onward, until the invention of celluloid film, *gelatin dry plate* prints were the most commonly used method of photography, and mostly replaced the **wet plate** method. A similar gelatin silver emulsion is still used as the coating on modern film.

Gelatin silver prints The most common way to make black and white prints from negatives, this process replaced **albumen prints** by 1900, as they were simpler to produce and did not turn yellow. Paper is coated with a layer of light-sensitive silver salts which have been suspended in gelatin. The paper is exposed under a **negative** then chemically developed in the darkroom. This process remains the standard for developing black and white prints.

Gum print Used until the 1930s, this method allowed the photographer to obtain the effects of painting in the photograph. Variously textured papers were coated with gum arabic, rather than gelatin. Pigments, added to the gum arabic, were absorbed into the paper. Another chemical compound was used to sensitize the gum arabic to light. The exposed areas hardened and the unexposed areas were washed of the solution, revealing the color underneath.

Heliograph The term was applied by Joseph-Nicéphore Niépce in 1826 to an early form of photography dependent on the sun hitting a prepared plate set into a **camera obscura** for several hours. This produced a direct **positive** print without the use of a **negative.**

Negative Used to make **positive** prints or **transparencies,** a negative on glass or film has the opposite **values** as the original object. That is, the darks appear as lights, and the lights appear as darks. First invented by Talbot (see **calotype**), a negative can be used to print multiple positives. A negative can be manipulated in the **darkroom**

through the use of an **enlarger** and varying the developing emulsions and development exposure times.

Positive An image that has the areas of lights and darks **(values)** in their original and normal relationship, as in a print made from a **negative.** In the 1850s direct positive images were made on glass *(ambrotypes)* and on metal *(tintypes)*.

Shutter The mechanism in a camera that opens to expose the film in order to record the image.

Transparency A photographic image on film that is meant to be viewed by projecting a light source through it.

Wet plate Developed by Frederick Scott Archer in 1851, the collodion wet-plate process was used until about 1885 when the **gelatin-silver** or *dry-plate* process was invented. A collodion solution made of a variety of chemicals was coated onto a glass plate and exposed in the camera while still wet. The advantage of this method was that it could capture extremely fine details and exposure time was just a few seconds. However, it required on-the-spot development of the **negatives,** thus photographers were required to carry a portable **darkroom** and developing chemicals with them.

Photogravure A process of transferring a photograph to a metal plate so it can be reproduced in large numbers. It uses a gelatin emulsion which hardens in proportion to the amount of light it is exposed to under a **negative.** Nonexposed areas remain soft and are washed away. The gelatin image is pressed onto a copper plate, and then the plate is dipped into the acid bath and the **etching** process proceeds.

Photomontage An image created by combining two or more photographs into one composite image. Although it was a technique used in the Victorian era, it became particularly popular with the Dada and Surrealist artists. Using photographic **positives** and/or **negatives,** photomontages can be combined with **collage** and are often called *photocollage*.

Pigments Powdered colors made from natural or synthetic materials and mixed with a **medium** to create paint which allows the color to smoothly spread and adhere to a surface. Prior to synthetic manufacturing, pigments were fabricated from a variety of plant, animal, and mineral substances. For example, in the Middle Ages, ultramarine blue was made with powdered lapis lazuli, a semi-precious blue stone.

Plaster of Paris A white powder that, when mixed with water, creates a liquid that can be poured into molds and cast for sculpture. It dries to a permanent hardness that can then be painted.

Pouncing A transfer technique, used particularly with **fresco,** whereby a **cartoon** is punctured at regular intervals, along the main outlines, with a needle or other sharp instrument, then dusted, rubbed, or "pounced" with a fine colored powder to transfer the cartoon to a wall, canvas, or panel.

Printmaking The art of creating an identical image repeatedly on paper or fabric by means of a carved or etched wooden or metal plate, with a stamp, die, or seal, or through photographic methods. Prints are labeled with the full number of the edition (as the bottom number) and the number of the print within the edition (as the top number). For example 3/10 would indicate that the piece was the third print in an edition of 10. There are many methods for creating a print. Below are some of the most common methods and associated words (Also see **photograph.**)

Aquatint An **etching** technique that produces tonal gradation effects similar to watercolor washes. Areas that are to remain white are brushed with **varnish.** The design or image areas are covered with a dry resin dust. The plate is then heated so that the separate grains of resin melt and adhere to the plate. The plate is immersed in an acid solution so that the areas between the resin particles are etched into the metal. This produces a fine network of tiny lines and dots. The plate is then cleaned of the resin and ink is applied. The plate is run through a **press.** The final result is an effect of a soft wash. Because the process cannot produce strong lines and definition, it is often combined with etching.

Brayer The rubber, gelatin, or plastic hand-roller used to apply ink to the surface of a **relief block.**

Burin An **engraving** tool that is used to incise lines onto a metal plate. The steel rod, fitted into a wooden handle, is sharpened to a point on the end. The point is pushed through the metal to create grooves of various width and depth depending on the width of the point and the pressure applied. (Also called *graver.*)

Burr This is the sharp metal ridge created by a **drypoint** needle or a **burin** being pushed through the metal to create a design during the **intaglio** printmaking process.

Collagraph A technique whereby a plate or block is built up with three-dimensional elements that are glued or attached to it. It can be inked or not, then run through a **press** so that the image is **embossed** onto the paper. Other print techniques can also be applied before it is run through the press.

Drypoint An **intaglio** technique created by scratching into a metal plate with a steel-needle pencil. The **burr** is not scraped away, but is left on the plate to pick up extra ink that leaves rich, blurred, and atmospheric lines. A **press** is used to transfer the image to the paper.

Engraving The process of incising, by hand with the use of a **burin,** a design into a metal plate, usually copper. The lines created by the incising process are then smoothed of **burrs.** The plate is inked, and **incised** areas fill the ink. The surface of the plate is then usually wiped clean. The paper is set upon the plate, and it is run through a **press** so that the inked areas transfer the design onto the page. (An **intaglio** technique.)

Etching An **intaglio** technique whereby a metal plate, usually copper, is covered with a wax or **varnish ground.** The design is then **incised** or scratched into the ground with a steel-needle pencil. The plate is dipped into an acid formula, and the parts of the plate exposed are *etched* or "bitten" into by the acid. The plate is then inked, covered with paper, and run through a **press** to transfer the design to the page.

Intaglio A term that is applied to both **engraving** and **etching.** It is the hollowing-out or **incising** print process as opposed to **relief.**

Linocut A print made from **incised** linoleum which has been mounted on a board.

Lithograph This process is based on the principle that oil and water do not mix. A specially prepared lithographic stone, made of **limestone,** is drawn on with greasy lithographic crayons, pencils, or paints. The surface of the stone is then brushed with water and rolled with greasy lithographic ink. The ink adheres only to the design and is repelled by the water on the blank stone surfaces. Paper is placed over the stone and rolled through a **press** to pass the inked image onto the paper.

Mezzotint This is a method of **engraving** in which a metal plate is worked with a **rocker.** Thus the entire plate is covered, to a greater or lesser extent, with **burrs.** If it were to be printed at this point, the plate would produce an intense velvety black print. The designs or images are created by smoothing certain areas so that they hold less ink and **burnishing** other areas so that they hold no ink. Engraved or etched lines can be added as well. The printed result is a very **textured** and **painterly** print.

Monoprint A single unique print created in a traditional printmaking technique.

Monotype This is a print made on an untreated metal plate by drawing or painting directly onto the plate. A paper is placed on the plate and then run through a **press** (or pressed by hand). It produces a single image. Subsequent pressings are called "ghost" images and rely on whatever paint is left on the plate after the first pressing. The artist can repaint the plate again, but obvious natural variations will occur, thus making each print unique.

Press The concept of using two rollers that are tightly aligned in order to exert extreme pressure onto a paper-covered metal plate or lithographic stone, thus transferring the image onto the paper to create a **print.**

Relief print Any type of print where the background of the design is cut away from the surface leaving the image raised as in **relief.** A **woodcut** is a type of relief print. The raised image is inked and pressed against paper, fabric, and so on. Surfaces for relief prints can vary from rubber (as in a rubber stamp), to metal, to the flat side of a cut potato.

Rocker A tool used for **mezzotints.** It is **chisel**-like and has a fan-shaped edge which is grooved to create a series of sharp metal points.

Silkscreen (Also called screen print.) A **stencil** is placed on a piece of fine mesh or silk that has been stretched across a frame. The frame is placed upon the surface to be printed (paper, fabric, etc.). Paint or dye is then pressed through the mesh or silk with the use of a squeegee to create the image of the stencil onto the surface.

Stencil A *stencil* is a design cut into a thin, rigid material for use in creating multiple images.

Stenciling A technique in which a material, such as paper or fabric, is overlaid with a **stencil.** Paint, ink, or dye is applied through the openings in it to create the stencil image onto the material.

Soft-ground etching A technique whereby the plate is prepared with a soft, sticky mixture. A sheet of paper is laid on top and the artist draws directly onto the paper. The

ground adheres to the paper in the places where the images have been drawn, so that when the paper is peeled off, the ground is removed. The plate is then treated in the same manner as an etching. The images produced with soft-ground are more like drawing and have the effect of crayon.

Sugar-lift aquatint The plate is painted with brushstrokes of a sugar solution. It is varnished, and then set into a water bath where the sugar areas lift off the plate. Resin particles are then applied as described above. The result is a very painterly print which has the effect of brushstrokes. (Also see *sugar-lift etching*.)

Sugar-lift etching The plate is painted with brushstrokes of a sugar solution. It is **varnished,** and then set into a water bath where the sugar areas lift off the plate. Ink is applied and the plate is printed. The result is a very painterly print which has the effect of brushstrokes. (Also see *sugar-lift aquatint*.)

Woodcut (Also called *woodblock*.) A print made on a block of wood in a **relief** process (opposite of the **intaglio** process). The wood is cut away from the areas not intended to be printed using knives, and V- and U-tipped gouges are used to make more delicate lines. The result is that the design is raised from the surface of the block (rather than cut into it) and is the part that is inked and pressed onto the paper.

Wood engraving Lines of design and images are cut into the end-grain of a very hard block of wood, using an engraving **burin.**

Rasp A metal file covered with sharp pointed projections and used for forming or smoothing objects in stone, wood, or metal.

Relief sculpture Sculpture that is raised from the surface from which it is carved, but still attached to it. (See also **graded relief.**)

Repoussé Relief formed by hammering a metal plate from the back to create an image on the front. The image is then in "relief" and details are **incised** into it. (Also see **emboss.**)

Resist Any compound that creates a resistance to another substance, not allowing it to pass through, such as wax or **varnish** used in the **etching** process.

Sandstone A porous sedimentary rock. It comes in colors ranging from tan to yellow, and red to white. Some sandstone is weather-resistant and easy to work with and can be used for sculpture, building, paving, and for making grinding stones.

Sculptor's clay Moist and pliable natural **clay,** which will dry if not kept moist, and is used to make models which will be cast in other materials.

Silverpoint A method of drawing on a prepared **ground** of **gouache** or **gesso.** A piece of silver wire is used to draw onto the surface, slightly cutting into it and leaving a little of the silver as the point is moved, resulting in a very delicate drawing.

Sinopia Composed of iron oxides, it is a reddish-brown **pigment** used in **oil painting** and as the **underpainting** for a **fresco** as a guide for the final application of color.

Soapstone A soft stone that is easily carved. It is used for sculpture and for inlaid (see **inlay**) designs. Ancient peoples also used it for making implements and cooking utensils as it absorbs and easily distributes heat.

Solder Melting fusible alloys, such as tin or lead, to join two pieces of metal together.

Stain A dye or **pigment** that is allowed to soak into and penetrate an untreated surface, thus coloring it.

Stipple To create a shadow effect by making a series of small dots.

Stretcher bars The durable wooden frame upon which canvas is stretched and attached in preparation for painting.

Stucco A **plaster** used on the exterior of buildings.

Stylus A sharp pointed needle-like tool used for writing, **incising,** and marking.

Subtractive A method in sculpture or ceramics where areas are cut away or subtracted from the stone or clay to create the form. (Also see **additive.**)

Tempera A type of paint where the **pigments** are mixed with an egg yolk **medium** producing bright, durable colors. It dries quickly to a **matte** finish and does not blend easily so that **glazes** are very difficult to achieve in this **medium.**

Template A pattern used repeatedly to create the same design (see Printmaking; *stencil*).

Terracotta An orange-brown clay used in sculpture and ceramics. It can be sun dried or glazed and baked and produces waterproof vessels and pipes as well as tiles and other decorations.

Underpainting The preparatory or preliminary painting that is then covered with other layers of paint. When semi-**transparent glazes** are used, the underpainting is allowed to show through and combines with those overlays of color.

Varnish A clear paint-like substance, derived from resin, which dries to a hard, smooth, glossy finish. Used to coat a surface with a thin, shiny, protective layer similar to **lacquer.**

Wash A broad, thin layer of highly diluted ink or **watercolor.** Successive applications of washes can create **value, saturation, modeling,** and a variety of tonal gradations.

Watercolor Super-finely ground pigments mixed with a water-gum **medium.** The paints are mixed with various amounts of water to create a variety of **translucencies** on white paper. The white paper and pale **tints** serve as highlights. **Opaque** watercolors, called **gouache** are used for accents.

10

Art and Art-Related Terminology

Abstraction To extract the essence of a thing or idea. To change or distort the natural appearance of the subject in order to emphasize or reveal certain qualities or content.

Acropolis The sacred rock outcropping in ancient Greek cities where the main temple was placed. The most famous is in Athens where the *Parthenon* was built.

Aesthetics A branch of philosophy that studies the arts and seeks to establish general principles of art. Theories about the nature of art and artistic expression.

Agora In an ancient Greek city, the open public space for gatherings, meetings, and business.

Allegory The description of one thing under the image of another. A symbolic description.

Amorphous Shapeless, undefined forms.

Anamorphic image An image that is unrecognizable until it is viewed by some special means (such as a mirror).

Animal style A style of nomadic art originating in Mesopotamia with the Scythian tribes and other peoples of the regions north of the Black Sea. Portable and in metal, the art emphasizes images of animals, both realistic and fantastic. This style was transmitted to the west and merge with indigenous interlace patterns. Forms the basis for **Hiberno-Saxon** design.

Anthropomorphic Ascribing human form or attributes to a being or thing that is not human.

Appropriation The use of images or objects taken from one context and inserted into another.

Archaic smile The facial expression on Archaic Greek statues, consisting of a blank stare and slightly upturned mouth.

Architectonic Pertaining to architecture. It is often used to describe works of art that are built or constructed in such a way as to appear architectural. In painting, it is used to describe a strongly constructed set of images that seem immobile, somewhat geometric, and highly structured.

Assemblage Sculpture using preexisting, sometimes "found" objects that may or may not contribute their original identities to the total content of the work.

Atelier The studio of an artist.

Avant-garde Artists whose work is in the most advanced stylistic expression.

Axis An imaginary straight line passing through the center of an object or figure around which the various components of the image are organized.

Balance A visually pleasing equilibrium of images and objects in a composition.

Baldacchino A canopy supported by columns and placed over an altar.

Biomorphic An abstract representation that has the form of a living organism. Usually characterized by free-flowing curvilinear forms.

Black-figure The decorative technique of Greek vase painting in the 7th and 6th centuries B.C.E. The objects and figures were painted onto the clay in a black glaze. The details were incised into the glaze prior to firing. The background was left in the natural color of the clay which turned red-orange after firing. (See also **red-figure** and **Greek vases.**)

Book of Hours A private devotional book containing prayers for the seven canonical hours of the day of the Roman Catholic Church. Books of Hours were often **illuminated** for use by persons of wealth and nobility.

Breviary A Christian religious book of selected daily prayers and psalms.

Bust A sculpture of a person, showing only the upper chest, shoulders, and head.

Camera obscura A drawing aid used by artists in the 17th, 18th, and 19th centuries. A tiny hole and a lens are fitted into a light-proof box so that the image can be projected onto a screen for tracing.

Carolingian Of or pertaining to the reign of Charlemagne and his empire.

Canopic jar A vessel in which the ancient Egyptians preserved the internal organs of the dead.

Carpet page Decorative pages in **illuminated manuscripts** that resemble textiles and usually appear as introductory pages.

Cartoon A full-size drawing for a painting.

Cartouche In ancient Egypt, royal names written in hieroglyphics and enclosed in a ring.

Chiaroscuro The gradations of light and dark within a picture in which the forms are largely determined not by sharp outlines, but by the subtle gradations of dark to light to create the illusion of volume, three-dimensionality, and light and shadow in a painting.

Chinoiserie In the 18th century, the interest and stylistic application of Chinese **motifs** and designs in objects and architecture, and the collection of Chinese items in European and American cultures.

Chi-Rho monogram The initials in Greek of the first three letters of Christ's name, Chi-Rho-Iota.

Christian Symbols and Iconography:

Annunciation Story in the New Testament of the Angel Gabriel appearing to Mary and announcing that she will be the mother of Jesus Christ.

Chalice A drinking goblet used to hold the wine during the Eucharist (taking Holy Communion). It refers to Christ's "Last Supper" and the sharing of the wine among the apostles. (A basket can indicate the taking of the wafer during Holy Communion.)

Dove Symbol of the "Holy Spirit," the third part of the Trinity.

Keys Attribute of St. Peter to whom it is said that Christ gave the "keys" to his heavenly kingdom. Peter is considered to be the first pope, thus the keys are a feature of the papal coat of arms.

Lamb The lamb can symbolize Christ as the "Lamb of God." This represents Christ as "God's sacrifice" toward redemption. In the ancient world, the lamb was the preferred sacrifice because it was seen as young, innocent, and pure.

Lily Symbol of purity and the Virgin Mary.

Maestà Image of the Virgin Mary enthroned as Queen of Heaven and surrounded by angels.

Magi Three kings or wise men from the East who visited the infant Jesus, brought him gifts, and knelt before him in acknowledgment of his divinity. Also called the *Adoration of the Magi.*

Pantocrator Christ as ruler of heaven and earth.

Pietà Image of Mary holding the dead Christ in her arms or lap.

Shepherd Christ is represented as the "Shepherd" or guide of God's flock. Often called the "Good Shepherd."

Stigmata The nail wounds in the hands and feet that Christ received during the crucifixion. These are often depicted on images of saints to indicate their holy status.

Visitation The story in the Bible of Mary going to visit her cousin Elizabeth, to tell her of her pregnancy with the Christ child. Elizabeth announces that she too is pregnant with a child who will become John the Baptist, cousin to Jesus Christ.

Cinerary urn An urn or vase in which the ashes of the deceased are kept.

Classical calm Describes the calm, unemotional facial expression on classical Greek sculpture.

Classical Ideal Combination of real and ideal in classical Greek sculpture and architecture.

Codex (codices) The predecessor of the modern book. A codex is made up of pages of **vellum** or **parchment,** bound together at one side with a cover.

Collage A composition of various materials on a flat surface.

Color:

> *Hue* The actual name of a color (i.e., red, green)
>
> *Value* The property of color that distinguishes it as light or dark
>
> *Saturation* Intensity of vividness of a color
>
> *Primary Colors* Red, yellow, blue
>
> *Complementary Color* Hues which are opposite on the color wheel
>
> *Cool Colors* Blue and associated hues (cool colors appear to recede)
>
> *Secondary Color* Colors produced by mixing two primary colors
>
> *Shade* Colors made darker in *value* by adding black to the pure *hue*
>
> *Tint* Colors made lighter in *value* by adding white to the pure *hue*
>
> *Warm Colors* Reds, yellows, oranges (warm colors appear to project)

Comma brushstroke The short, quick, comma-like brushstroke used by the Impressionists to create a sense of spontaneity.

Composition The arrangement of all the elements and forms within a work of art.

Contour Outline or shape of an object. In painting, volume can be created by breaking or blurring contour lines to suggest disappearance of the surface as it curves out of sight.

Contrapposto The human figure's weight rests on one leg (engaged leg) and is balanced by the other leg (free leg). This creates a weight shift that causes the hips and legs to turn in one angle while the torso and shoulders turn in opposition, creating an "S" curve to the body.

Cruciform In the form of a cross.

Cuneiform The form of writing used in ancient Mesopotamia consisting of pressing a wedge-shaped object into soft clay to create of variety of shapes representing words and sounds.

Diptych A two-paneled painting or altarpiece.

Disguised Symbolism In painting, when common everyday household objects have an implied meaning beyond their utilitarian function. Usually the symbolic nature of the object references religious or moral concepts. These concepts were easily understood within the context of the culture and society in which these

works were created, and yet to the uninitiated, they would seem to be everyday objects of no particular meaning.

Dorians A group of people from Northern Greece and Macedonia. The Dorians began to migrate south in about 1150 B.C.E. Many scholars believe that the Dorian Invasion brought about an end to the Bronze Age and ushered in a 300–400-year period of decline known as the "Dark Ages." There is some evidence, however, that the Dorians migrated south during the "Dark Ages" instead of being the cause that brought this period of cultural atrophy into being.

Drapery Refers to draping qualities of fabric, or classical Greek and Roman clothing.

Drôleries Whimsical designs and lively characters added to the margins of **illuminated manuscripts.**

Evangelists Matthew, Mark, Luke, and John, authors of the gospels. Their symbols: Matthew = man or angel; Mark = winged lion; Luke = winged ox; John = eagle. These symbols can be used to represent the evangelists.

Fête Galante Elegant entertainment. Refers to the paintings of the Rococo period (18th century) which describe the lavish amusements of the French aristocracy.

Fin de siecle End of the century. Signifies a melancholy felt at the turn of a century or millennium. Specifically pertains to some of the artwork of the late 19th and early 20th centuries.

Foreshortening Method of representing objects or parts of objects as if seen at an angle receding into space.

Formal elements or principles The components that go into creating a work of art and define the forms of the images within it (example in painting line, color, depth, modeling of the figure, brushstroke, texture, etc.).

Form and content Form is what we see and includes such elements as color, shape, line, and composition. Content is the interpretation, message, or meaning.

Found objects Objects found in everyday life that are appropriated into works of art.

Fresco Italian word for "fresh." A technique of painting onto wet plaster.

Frieze Refers to any long horizontal ornamented band with painted or sculpted images. (See also **Architectural Terms.**)

Frontal An object which faces the viewer directly and is not set at an angle or foreshortened.

Genre (1) Representations of everyday life. (2) A classification or category in the visual arts of style, form, or content.

Gisant A tomb effigy of the deceased carved in **high relief** on the coffin lid, with hands usually in prayer or with arms folded across the chest, appearing at the beginning of the 14th century. Sometimes the images were macabre, showing the deceased in a state of decomposition as a **memento mori.**

Golden mean or section A system of proportion developed by the Greeks in which an object is subdivided into two uneven sections. The shorter section is related to the longer section in the same proportion as the longer section is related to the whole.

Gothic International style A style of 14th- and 15th-century painting begun by Simone Martini displaying brilliant color, lavish costume, intricate ornament, and themes involving splendid processions of royal courtiers.

Greek vases Greek vases were made in several basic shapes. Each vase shape had a specific use and lent itself to a variety of images and decorative motifs. When referring to the various areas of the vase, we speak of it as a human body, that is, mouth, neck, shoulders and so forth. (See also **black-figure, red-figure,** and **white-ground.**) The main shapes are:

Amphora Used as a storage jar, it has an oval-shaped body and two handles attached to the shoulder and neck of the vase for carrying.

Hydria A jar for carrying water. It is full-bodied, has two handles attached to the shoulders for carrying, and a third handle attached from the shoulder to the neck for pouring.

Krater A large, broad vase with a wide mouth and two small handles on the lower portion. Used for mixing wine with water.

Kylix A shallow broad vase with two handles near the rim. Used as a drinking cup, it usually stands on a slender stem with a small base.

Lekythos A cylinder-shaped vase with a tapered bottom, small base, square shoulder area, long slender neck, and small mouth. Used for storing and pouring oil.

Oinochoe A vase for dispensing wine. This vase has an egg-shaped body and long neck. The mouth is shaped for pouring and the handle starts at the rim and is attached to the shoulder.

Pelike A pear-shaped two-handled variant of the amphora, used to store water or wine.

Grisalle Painting done in neutral grays to simulate sculpture.

Groundline A line used in paintings and reliefs to indicate the level of the ground upon which figures are placed. Groundlines can be smooth horizontal lines on the picture plane or can undulate to indicate topography. They can be placed diagonally on the picture plane to suggest height, while several groundlines placed at various spots on the picture plane might indicate depth. The ancient Egyptians and Mesopotamians used groundlines in these ways in their paintings and reliefs.

Helladic Refers to the pre-Greek cultures of the Aegean and particularly of the Greek mainland.

Heraldry Designs and insignias designating a royal family or house as in a coat of arms.

Hiberno-Saxon (Insular) Irish/English art of the Early Middle Ages (also called Insular Art).

Hierarchy of scale The larger size of a figure indicates greater importance.

Hieratic Ancient Egyptian form of writing developed from **hieroglyphics.** The pictographs of hieroglyphic writing are dispensed with in hieratic script, thus creating a form of writing that is fast and more easily accessible.

Hieroglyphics A form of Egyptian writing composed of picture symbols and phonetic characters. Can be written in vertical columns or horizontally. The direction in which the characters should be read is indicated by the direction in which they face. This elaborate and complicated writing system was only understood by a small fraction of society and was mostly used on monuments, tombs, and in sacred texts. (See **hieratic.**)

Highlights In sculpture, those parts of the object that reflect the most light. In painting, a method of **modeling** that is determined by the imaginary light source. Objects are highlighted at the points where the light would naturally hit, and then subtle tonal gradations are used to create dimensionality. Highlights can be manipulated for dramatic effects.

Historiated initials In **illuminated manuscripts** the first letter of the first sentence on a page is decorated with images that produce a message or narrative.

Horizon line A horizontal "line" formed by the actual or implied meeting point of earth and sky. In linear perspective, the vanishing point or points are located on his line.

Horror vacui Treatment of space in sculpture and painting where there are no empty areas. All parts of the surface are filled with images, designs, details.

Icon Painting of Christ, Mary, or saints venerated in the Orthodox religion.

Iconoclasts A word used to describe the "image breakers," or those who destroyed the **icons** in the Byzantine Empire during a ban on icons in the 8th and 9th centuries C.E. (Also see **iconophiles.**)

Iconography The analytic study of the symbolic meaning of objects, persons, or events depicted in works of art.

Iconophiles Those who opposed the ban of **icons** in the Byzantine Empire during the 8th and 9th centuries C.E. (Also see **iconoclasts.**)

Idealism Treatment of subject matter in which a mental conception of beauty or form is stressed according to a standard of perfection.

Illuminated manuscript An elaborately illustrated manuscript (usually some portion of the Bible or book of prayer).

Illusionism The attempt by an artist to create a work of art that represents the natural world as completely as possible to create the illusion of reality, by using optical techniques such as various forms of **perspective** in a painting.

Impasto Paint applied with the consistency of thick paste.

In situ In the original position or place.

Installation A work of art conceived for a specific space in a museum or gallery, and creating an environment within that space.

Interlace Patterns found in the Migratory art of Northern European tribes and in Hiberno-Saxon illuminated manuscripts. It consists of intricate intertwining of floral, geometric, and animal elements into complex puzzle-like patterns.

Inverse perspective Images are painted against a solid background thus cutting the viewer off from recessional depth. The figures and objects appear to converge toward a vanishing point located in the real space occupied by the viewer. It was typical of Byzantine holy images and was carried into Gothic altarpieces.

Japonisme (Japonaiserie) A term coined in the 19th century to describe the wide range of Japanese influence on western art and culture. Japanese **aesthetics** influenced all aspects of Western-European culture as goods from Japan flowed into Western Europe following the reestablishment of trade with Japan in 1853.

Kinetic art Art that can or does incorporate motion into it, such as a **mobile.**

Kore Archaic Greek statue of a draped maiden.

Kouros Archaic Greek statue of a standing nude youth.

Lamassu Monumental sculpture found in Assyrian art and taking the shape of a man-headed bull or lion with wings. Usually used as guardians at gateways.

Lectionary Passages from the Bible arranged as they are to be read during religious services during the year.

Limner Anonymous portrait painter in the American colonies in the 16th and 17th centuries.

Linear perspective A method of representing three-dimensional objects on a two-dimensional surface. Developed in the 15th century, all parallel lines (orthogonals) and edges of surfaces recede at the same angle and converge at a single vanishing pointing in the picture and are the basis for a grid that maps out the internal space of the painting. Renaissance artists used single point perspective (construzione legittima) which assumes the viewer is located in a fixed position and all the orthogonals converge at the vanishing point located in the center of the horizon line. (See also **perspective.**)

Local color The actual color of things as they appear in nature.

Mandorla An almond-shaped nimbus around the figure of Christ or images of saints indicating divinity.

Maquette A small model made as a preliminary for a larger sculpture.

Mass and volume In contrast to a plane, mass and volume describe three-dimensional space (height, width, depth). In painting, the concept is used to describe the illusion of three-dimensionality on the flat surface. In sculpture, the concept is used to describe the actual body of the work that takes up physical space.

Medium (pl. **mediums/media**) The material with which an artist works (marble, clay, paint, film, etc.).

Memento mori The symbol of human mortality often represented by a skull.

Mixed media A work of art that incorporates two or more **mediums** into the finished product.

Mobile Developed by Alexander Calder, a mobile is a construction that is balanced in such a way that it is set into motion by the movement of air, and is suspended from above. (See also **stabile.**)

Modeling The shaping of a form in painting or sculpture and the various amounts of **mass and volume** that it displays.

Monochrome (From Greek *mono* = one, *chroma* = color.) A work of art done in various **values** of the same **color**. (See **color.**)

Moralized Bible Bibles that are illuminated with pairings from Old and New Testament stories that illustrate moral values or prefiguration.

Motif A recurrent image, theme, or element in art or architecture.

Naturalism Treatment of forms, color, space, and so on, as they appear in nature.

Odalisque A female harem slave.

Oeuvre The entirety of an artist's work.

Opaque As opposed to **transparent** and **translucent,** opaque material does not allow light to pass through it.

Optical afterimage After staring at an object, the image visualized in the complementary color of that object. Principles of optical afterimage were used by Georges Seurat in depicting light, shadow, and reflection.

Optical mix A method of mixing a secondary color by placing two primary colors next to one another on the canvas and then, using a quick brushstroke, slightly mixing the two. An optically mixed color appears brighter to the eye than a palette mixed color.

Orientalizing A term used to refer to ancient art that took its inspiration or motifs from ancient Near Eastern artistic conventions. Specifically refers to a phase of Archaic Greek art that incorporated some stylistic aspects of Near Eastern artwork.

Orthogonal Any line running back into the represented space of a picture and perpendicular to the picture plane. In linear perspective all orthogonals converge at a single vanishing point in the picture and are the basis for a grid that maps out the internal space of the painting.

Painterly In painting, using the qualities of color and texture, rather than line, to define form. Also, painting that exhibits a lot of paint texture and brushstroke, so that the "hand" of the artist in the "act of painting" is apparent.

Palette A surface for mixing pigments.

Papyrus Paper-like material made from the inner core of the papyrus plant which grows along the Nile River in Egypt. Used in scroll form, it was a primary writing material for the ancient Egyptians, Greeks, and Romans.

Parchment Paper-like material made from bleached lambskin and used in illuminated manuscripts.

Pastoral An idealized landscape.

Pectoral A large piece of jewelry worn on or across the chest.

Peplos A long garment belted at the waist and worn by women in Ancient Greece that gives the body a column-like appearance.

Perspective Creating the illusion of depth on a flat surface. (See **linear perspective**)

 Atmospheric Distant objects appear bluish and hazy due to intervening layers of atmosphere between foreground and background

 Diagonal Objects farther from the observer or placed higher on the picture plane and aligned along a diagonal axis

 Diminutive Objects farther in the background are made to appear smaller

 Herringbone Several unrelated vanishing points within a picture space

 Linear All parallel lines and edges of surfaces recede at the same angle, and are drawn on the picture plane in such a way that they converge toward a single vanishing point

 Overlapping Objects overlap so that one is partially hidden by the other

 Vertical Objects farther from the observer are shown higher on the picture plane

Picture plane The flat two-dimensional surface upon which a picture is painted or a relief is carved.

Picture space Space that appears to extend back beyond the picture plane through the use of perspective devices. Divided into foreground, middle ground, and background.

Plasticity In the visual arts, the three-dimensional quality of a form, its roundness, palpability, apparent solidity.

Plein-air Painting out of doors. The term typically is used in conjunction with the Impressionists who advocated a quick and spontaneous capturing of qualities of light and atmosphere, but it is associated with the Barbizon painters.

Pointillism A method of painting developed by Georges Seurat whereby tiny dots of color are juxtaposed to create an overall image.

Polis City-state in ancient Greece.

Polychrome (From Greek *poly* = many, *chroma* = color.) A work of art created with many colors.

Positive/Negative space Positive space is the actual mass and volume of a sculpture. Negative space describes the voids within and/or around the sculpture. The terms can be applied to painting as well.

Predella The lower part of an altarpiece segmented from the main panel(s) and often decorated with topics related to the main image.

Proportion The ratio and relationship of one part of an object to another, and of the object to the entire composition.

Provenance The history of the origin and ownership of a work of art.

Psalter Illustrated book of Psalms (book in the Old Testament of the Bible).

Putti Small cherub-like images of male infants with wings.

Quatrefoils An ornamental element composed of four lobes radiating from a common center.

Realism Interest in/concern for the actual or real, as distinguished from the abstract or ideal.

Red-figure A style of Greek vase painting developed at the end of the 6th century B.C.E. Black glaze was used to outline the figures and objects, and to paint in the details and the background. The figures were left in the natural red-orange color of the clay. This afforded greater expression in line, texture, and details as they were painted on with a brush rather than an incising instrument.

Refectory The dining hall in a **monastery.**

Register A horizontal band in painting and relief sculpture into which decoration is placed.

Relief sculpture Sculpture that is raised from the surface from which it is carved, but is still attached to it. "Low relief (bas)" indicates a minimal rise from the surface, whereas "high relief" indicates a significant elevation from the surface. "Sunken" relief indicates the design is cut or hollowed into the surface. (See also **Materials and Methods.**)

Reliquary A container for the keeping of relics. (In Christianity, relics are the body parts, clothing, or objects associated with a saint or Christ.)

Renovation imperii Romani Latin for "Renewal of the Roman Empire," as seen in the Carolingian Renaissance under Charlemagne.

Rhyton An ancient decorated ceremonial vessel used for sacred libations.

Rosette A circular design resembling a flower.

Salon The annual juried exhibition held in Paris by the Royal French Academy of Art.

Sarcophagus A decorated coffin.

Scale The relative relationship of size between images within a composition.

Scriptorium Monastic centers of manuscript illumination.

Scumble Layering several colors of wet paint, then pulling a dry brush through the layers in short quick strokes to bring up.

Sfumato Literally means "vanished" or "gone up in smoke." The term refers to the hazy dream-like atmosphere in Leonardo's work.

Soul portrait Portraits dating from Early Christian and Medieval times that distort the features and enlarge the eyes in order to emphasize the sitter's relationship and rapture with the divine.

Stabile A **kinetic** sculpture, developed by Alexander Calder, that is set directly on a base and is set into motion by air currents. (See also **mobile.**)

Stele An upright slab carved with decorative and/or commemorative reliefs and inscriptions.

Stereometric In art, the creation of forms so that the images appear to be solid and immobilized in strict geometric construction. The work of Uccello and della Francesca are often referred to in this way. The word references "stereotomy" which is the cutting of stones into geometric forms.

Style Consistent and characteristic handling of techniques, elements of form, and principles of design that make a work identifiable as the product of a particular person, group, period, or place.

Symmetria A concept from ancient Greece mapping out the proper relationship and proportion of one part of a structure (or a human body) to the adjoining parts and to the whole. This was said to be described in the *Canon* of Polykleitos.

Symmetry/Asymmetry Visual balance (symmetry) achieved by correspondence of parts on either side of a central axis. Lack of visual balance (asymmetry).

Tactile The impression of tangibility and texture in a work of art.

Terracotta Baked clay.

Tesserae The individual stones or glass used to make a mosaic.

Texture The varying degrees of smoothness or roughness on a surface.

Translucent The quality of material that allows light to pass through but sufficiently diffuses it so that perception of distinct images is eliminated.

Transparent/Transparency The quality of a material that allows light to pass through it so that objects can be seen beyond it, thus appearing that there is no intervening material between the viewer and the object. A clear glass window is transparent.

Trefoils A design with stylized leaves or lobes in groups of three. Can indicate the three aspects of the Holy Trinity.

Triptych A three-paneled painting or altarpiece.

Trompe l'oeil Literally means "to fool the eye." Painting that "fools the eye" with its realistic appearance.

Turret A small tower projecting from the surface of a building.

Ushabti In ancient Egypt, a small figurine placed in a tomb to be a servant to the deceased.

Vanishing point In linear perspective, the point or points of convergence for the **orthogonals.** In one-point perspective, the vanishing point lies directly opposite the eye of the observer at the level of the horizon. In two-point perspective there is a vanishing point on the horizon on either side of the object.

Vanitas An image especially popular in Northern Europe in the 17th century in which the objects symbolize the transience of life, usually still lifes and genre subjects.

Vellum Paper-like material made from calfskin and used in illuminated manuscripts.

Viewpoint The observation point from which the artist presents the subject to the viewer.

Visual rhythm The regular repetition of form. The intervals between repetitions determine whether the visual rhythm is slow and measured or rapid. A **colonnade,** for example, can be said to have visual rhythm.

Volute A scroll-like architectural ornament on **Ionic capitals.**

Vulgate A Latin version of the Bible prepared by St. Jerome in the 4th century, serving as the authorized version of the Roman Catholic Church.

White-ground A method of vase decoration in ancient 5th-century Greece where a fine white coat of clay was applied to create the background, then the images would be painted on with black glaze.

Zoomorphic Objects conceived of as having the form of an animal.

Architectural Terms

Abacus In the **Doric** order the top rectangular slab of the **capital.**

Adobe A building material made of a clay, sand, and water mixture, and used in the American Southwest by both Native Americans and Europeans. Native Americans used a "puddling" technique which was to build the structures through successive hand-applied layers, allowing each layer to dry prior to applying the next. Europeans, in the Americas, used adobe to make molded sun-dried bricks for construction.

Alternate support system Architectural supports of alternating form.

Ambulatory The passageway around the **apse** of a church allowing circulation behind the high altar.

Amphiprostyle A type of Greek temple that is not **peripteral,** but rather has a **colonnade** only in the front and back, but not along the sides.

Apadana The audience hall in Persian palaces.

Apse A single semicircular indentation and extension in a Roman **basilica** or at the east end of a Christian church, and covered by a half or full dome.

Arcade A series of arches upheld by columns or piers.

Arch A curved architectural structure spanning an opening and composed of wedge-shaped blocks **(voussoirs)** that transfer downward pressure laterally.

Architectural orders Doric, Ionic, Corinthian Orders.

 Doric Oldest and stylistically most somber and unadorned

 Ionic Capitals have scrolls or volutes on each side

 Corinthian Capitals have acanthus leaves and floral designs

 Composite A combination of Ionic and Corinthian

Architrave In the Greek **architectural orders,** the first horizontal beam above the **capital.** Located between the capital and the **frieze.**

Archivolt The molding framing an arch.

Arena The central sandy area in a Roman coliseum where the fights, battles, action, and activities took place.

Armature The skeletal framework for a **vault.**

Ashlar blocks Carefully cut blocks of stone used in construction and usually fitted together without mortar.

Atrium An open central courtyard in a house or other building.

Balustrade A row of short pillars or columns supporting a handrail.

Baptistery A separate building next to the church where the ritual of baptism is performed.

Barrel vault A tunnel-like semi-cylindrical extension of an arch, which may be thought of as an unbroken series of arches pressed together, one behind the other (also called **tunnel vault**).

Basilica Rectangular three-aisled building with **apse.** Common in Roman architecture, this form was adopted by the Christian church.

Bay The space between any two of a series of similar architectural members (usually principal supports).

Blind arcade A decorative arcade attached to a wall and having no actual openings.

Buttress An exterior masonry that counteracts the lateral thrust of an **arch** or **vault.**

Campanile The bell tower outside a church and usually detached from it.

Cantilever A protruding beam or other structure supported on only one end.

Capital The decorative top of a column, pilaster, or pier.

Caryatid Column in the shape of the female figure.

Cella The interior and most sacred part of an ancient temple, usually where the cult statue, sacred objects, and treasure would be kept. (Also called a **naos.**)

Chancel That part of the east end of a church in which the main altar is placed; reserved for the clergy and choir.

Chevet In Gothic architecture, the term for the developed and unified east end of a church, including the **choir, apse, ambulatory,** and **radiating chapels.**

Choir The sacred space in the church reserved for the clergy. It is at the east of the building near the altar. (Choir and **chancel** are often used interchangeably.)

Choir screen An elaborately painted and carved screen separating the **nave** and **side aisle** area from the **choir** area in a church.

Clapboard Long boards, thicker on one side than the other, and overlapped to cover the exterior walls of houses.

Clerestory The area of a basilica or church nave wall containing the windows.

Cloister An open court attached to a church, monastery, or nunnery surrounded by a covered arcaded walkway or ambulatory. Used for study and meditation.

Coffered ceiling Recessed square patterning in a ceiling.

Colonnade A series or row of columns.

Column A circular vertical, weight-carrying architectural member, consisting of a base (sometimes omitted), a shaft, and a **capital.**

Compound pier A pier embellished with a group or cluster of other architectural forms.

Corbeled arch An arch formed by two structures where courses of stones are layered so that each horizontal course projects slightly beyond the one below it, and the two sides meet at the topmost course, thus creating a triangular arch.

Cornice The projecting, crowning member of a building.

Crenellation The notched or indented pattern at the top of a wall.

Cromlech A prehistoric monument constructed of gigantic stones arranged in a circle.

Crossing The area where the **nave** and **transept** cross at right angles.

Crypt A vaulted chamber under the eastern end of a church.

Diaphragm arches A wall-bearing arch that divides or compartmentalizes a vault or ceiling.

Dipteral A double row of **colonnades** around a Greek temple.

Dolmen A prehistoric structure composed of **megaliths** supporting a massive slab forming a chamber most likely serving as a tomb.

Dromos The passageway leading to a beehive tomb, most typically found in Mycenaean culture.

Drum (1) The circular wall supporting a dome. (2) A section of a column.

Enchinus In the **Doric Architectural Order,** the rounded part of the capital below the **abacus.**

Engaged column A column-like, nonfunctional form projecting from a wall and articulating it visually.

Entablature The part of a building above the capitals of columns and below the roof.

Entasis Column appears to swell and widen.

Extrados The exterior side of an arch or vault (see **intrados**).

Facade The front of a building.

Flamboyant style Following the Gothic **Rayonnant** style and named for the flame-like appearance of its pointed decoration.

Fluting The ornamental grooves channeled vertically in the shaft of a column, pilaster, or pier.

Frieze A long horizontal band above the columns and decorated with relief sculpture. In the Doric order the frieze area is decorated with triglyphs and metopes. (See also **Art Terms.**)

Gable The triangular area formed by the slant of the roof at the end of a building. In ancient architecture, a **pediment.**

Gothic arch Pointed arch used in Gothic architecture.

Groin vault A groin (or cross vault) is formed at the point at which two barrel vaults intersect at right angles.

Hypostyle In Egyptian architecture, a hall with a roof supported by columns.

Intrados The underside or inside of an arch or vault. (See **extrados.**)

Jambs The side of a doorway or window frame.

Keystone The uppermost stone at the crown of an arch. It is wedge-shaped and is inserted as the last stone to be set in place, thus locking the other stones into place.

Lancet A tall narrow window ending in a pointed arch seen in Gothic architecture.

Lantern The circular structure at the top of a dome that can be used to admit light into the interior of the structure.

Lintel A horizontal beam used to span an opening (See **post and lintel.**)

Lunette The semicircular area above a door or window.

Mastaba (From Arabic = stone bench.) An early form of Egyptian tomb that continued to be used for burials. It consists of a flat stone top with sloping sides. A mastaba covers an underground burial chamber and may also contain a small interior chapel and compartment for a statue of the deceased.

Megaliths (From Greek *megas* = large, *lithos* = stone.) The gigantic stones used in prehistoric architecture "megalithic structures." (See also **monolith** and **menhir.**)

Megaron A rectangular hall supported by columns and fronted by a porch. Usually used as a reception hall in Minoan and Mycenaean palaces and the model for later Greek temples.

Menhir (From Celtic *men* = stone, *hir* = long.) Individual standing stones (monoliths) in prehistoric architecture. Most often used to refer to single free-standing stones, but can also refer to individual stones grouped together.

Metope The space between **triglyphs** in a **Doric frieze,** usually containing **relief sculpture.**

Mezzanine In the elevation of a building, a low-ceiling story that is placed between the ground floor and the second story.

Molding The ornamental and decorative bands on a building, either projecting or recessed.

Monolith (From the Greek *monos* = one, *lithos* = stone.) A large, single, free-standing stone set vertically. *Columns* and *obelisks* which are carved from a single stone are "monolithic." (See also **megalith** and **menhir.**)

Mullion A vertical element that divides a window or that separates two or more windows.

Naos See **cella.**

Narthex A porch-like structure in Early Christian church architecture.

Nave The middle aisle of the church between the entrance and choir area. It is set apart from the **side aisles** by **colonnades** or **arcades.**

Niche Recessed area in a wall.

Oculus Round opening in the center of a dome.

Pediment The triangular space **(gable)** at either end of a Classical building, formed by the two sides of the ends of the sloping roof and the cornice at the bottom. Also, an ornamental architectural feature having this shape.

Pendentive A structural method of placing a dome on a square ground plan by filling in, with masonry, the triangular areas formed by the four corners of the square until they meet to form a circular base for the dome.

Peripteral An adjective used to describe a building with a **colonnade** surrounding its entire perimeter.

Peristyle A noun used to describe the colonnade around a **peripteral** temple. Also used to describe an open garden or court area surrounded by a colonnade.

Perpendicular style The final stage of English Gothic style architecture. It had a strong vertical emphasis and dense clusters of nonstructural ornamental ribs in the vault area.

Pier A vertical, rectangular weight-carrying architectural support member.

Pilaster A flat, rectangular, and vertical structure that is attached to a wall and projects from it. Not usually load-bearing, but rather a decorative, articulating device.

Pilgrimage choir The unit in a Romanesque church composed of the apse, ambulatory, and radiating chapels.

Portal Doorway.

Portico A porch supported by columns at the entrance to a building.

Post and lintel An architectural structure consisting of two upright vertical members (posts), topped by a horizontal beam (lintel).

Pronaos The porch or chamber preceding the **cella (naos)** of a Greek temple. The walls of the pronaos are a continuation of the cella walls and are screened by a front **colonnade.**

Pylon (From Greek = gateway.) In Egyptian architecture, the gateway to the forecourt or courtyard of a temple. Usually it consists of two flat, sloping, and separated walls in front of which monumental sculptures are placed.

Radiating chapels Chapels arranged around the ambulatory and sometimes the transept of a medieval church.

Rayonnant style The "radiant" style in 13th-century architecture that is associated with the royal Paris court of Louis IX.

Rib/rib vault Slender masonry projecting from the surface of an arch or vault. Ribs can form the framework for the vaulting or can be purely decorative. A rib vault is a vault displaying ribs for either structural or decorative purposes.

Romanesque arch Rounded arch used in Romanesque architecture.

Rose window A large, circular window with stained glass and stone tracery, frequently used on facades and at the ends of transepts of Gothic churches.

Rustification In building, the rough, irregular, and unfinished effect given to the exterior facing of a stone edifice. Rusticated stones are often large and used for decorative emphasis around doors or windows, or across the entire lower floors of a building, probably deriving from fortifications.

Sacristy A room in a church or near the church where vestments and vessels used in church rituals, church treasures, and other sacred objects are kept.

Side aisle The aisles bordering either side of the nave.

Span The distance between supports for a lintel, arch, vault, and so on.

Spandrel The triangular space formed by the curves of adjacent arches.

Square schematism Crossing square formed by nave and transept used as the standard unit of measurement for the rest of the church.

Staff A building material, resembling **stucco** and made of plaster and fiber. It is used as a wall covering over the **armature** of temporary buildings, such as those used in expositions.

Stereobate In the stepped base of a Greek temple, all the steps, with the exception of the final step that forms the base upon which the columns rest. (See **stylobate.**)

Stringcourse A continuous horizontal band, such as a **molding,** decorating the surface of a wall.

Stucco A plaster or cement compound used to coat the exterior walls of a building.

Stylobate In the stepped base of a Greek temple, the top area where the columns rest (See **stereobate.**)

Tabernacle A sanctuary, holy place.

Tholos The beehive tombs found in Aegean architecture.

Tracery In stained glass, the ornamental metal or stonework that creates the design into which the glass is placed.

Transept The architectural structure of a church that crosses the **nave** at right angles to form the sign of the cross.

Tribune gallery The level of elevation above the nave and built over the side aisles in a Romanesque church that provides space for the congregation to walk and/or observe the services.

Triforum The section of the nave wall above the arcade and below the clerestory. It often is a blind arcade with three openings in each bay. In Early Gothic it appears above the tribune gallery and creates a four-part elevation. Also can be placed in transept and choir walls.

Triglyph In a **Doric frieze,** the sections of vertical rectangles (grouped in threes) that alternate with the **metopes.**

Trumeau A pillar in the center of a Romanesque or Gothic portal, often decorated with relief sculpture.

Tympanum The semicircular space between the **lintel** and **arch** over a doorway. Often decorated with relief sculpture in Romanesque and Gothic churches.

Vault A ceiling or roof using the principle of the **arch** in its construction. (See **barrel vault, groin vault.**)

Voussoir One of the wedge-shaped stones used in the construction of an arch.

Westwork The western end of a church, including the façade and towers.

Ziggurat In Mesopotamian architecture, a mountain built of mud brick with a temple or sanctuary at the top. Stairs or ramps carved into the mud brick allow ascension to the temple.